CAI

EOS 50D

THE EXPANDED GUIDE

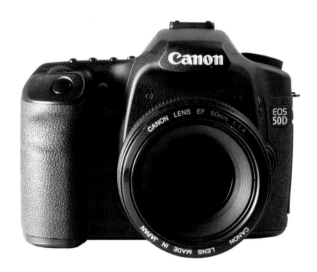

AMMONITE
PRESS

CANON
EOS 50D
THE EXPANDED GUIDE

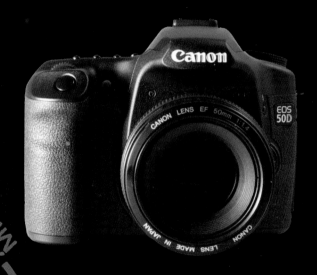

Andy Stansfield

AMMONITE
PRESS

First published 2009 by
Ammonite Press
an imprint of AE Publications Ltd
166 High Street, Lewes, East Sussex BN7 1XU

Text and images © Andy Stansfield
Product photography © Canon
© Copyright in the Work Ammonite Press

ISBN 978-1-906672-39-3

British Library Cataloguing in Publication Data:
A catalogue record of this book is available from the British Library.

Editor: Tom Mugridge
Design: Fineline Studios

Typefaces: Frutiger and Palatino
Colour reproduction by GMC Reprographics
Printed and bound in China by Hing Yip Printing Co. Ltd

Contents

Chapter 1

Overview

The EOS 50D is the latest offering in Canon's semi-professional range of digital SLRs. This outstanding camera evolved from the EOS D30, picking up technical developments from the EOS-1 range along the way.

First announced in the spring of 2000, the D30 offered a resolution of just over 3 megapixels, 3-point autofocus, 3 frames per second and a burst of three JPEGs. Its monitor back then was just 1.8in (4.5cm) and could only be used for reviewing images already captured.

The new norm is 15 megapixels, 9-point autofocus, up to 6.3 frames per second and a burst of over 100 frames if shooting small JPEGs. The 3in (7.6cm) monitor is now almost twice as large, with Live View for detailed composition. These are not the only improvements, but they illustrate the progress Canon has made in terms of speed and flexibility in the semi-professional DSLR market. The professional EOS-1 series is also leaping ahead in specification, but this involves a significantly higher outlay.

EOS history

Back in the mid-1980s, when camera and lens designers were suddenly making huge inroads in forging new links between electronic and optical components, Canon designers were pre-empted by autofocus SLRs from first Minolta, then Nikon. An intense two-year period of research and development followed for Canon who saw that these new cameras would ultimately form the basis of an extensive and flexible system, so every aspect of the camera needed to be stylish as well as practical.

The early Canon EOS models were designed with three criteria in mind: that the introduction of an AF system should not increase the price point; that the camera should

EOS 50D
The EOS 50D with Battery Grip BG-E2N and EF 50mm f/1.4 lens attached.

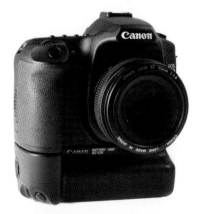

be capable of shooting sports events handheld with a 300mm f/2.8 lens or similar; and that autofocus capability should match exposure sensitivity in low-light situations.

In March 1987 they put their ideas to the test with the launch of the first EOS model. EOS stood for Electro Optical System and the camera in question was the EOS 650, which was soon to receive the accolade of European Camera of the Year. Eos was also the Greek goddess of the dawn, described by the ancient writer Hesiod as 'Eos, who brings light to all the mortals of this Earth'. Fanciful perhaps, but an altogether more appropriate explanation of the name that heralded the most successful series of developments in the history of photography. Ironically, the goddess Eos was the daughter of two Titans. Minolta and Nikon, perhaps?

During the next two years, new models appeared in the form of the EOS 620 and the EOS 630, but the most significant launch was reserved for the EOS 1, which was specifically designed to lure professionals away from other manufacturers' models. To support this drive to attract the high-end user, Canon also had to develop its lenses and worked hard to reach the forefront of lens technology. In particular, they needed to develop a superfast

autofocus system that would work in all lighting conditions with the large aperture lenses favoured by press and sports photographers.

By late 1994, Canon was ready to introduce a new top-of-the-range model in the form of the EOS 1N, which introduced much quieter operation, 5-point AF and a 16-zone evaluative metering system. Its high-speed sister, the EOS 1N RS, boasted a drive capable of ten frames per second. While Canon continued the evolution of its amateur SLRs, introducing innovations such as eye-control focusing, the EOS 1N continued to serve professionals well for half a decade.

A new flagship model, the EOS 3, was launched in November 1998, by which time the key areas of metering and autofocus were undergoing rapid

EOS 30D

The EOS 30D featured an 8.2-megapixel CMOS sensor and DIGIC II Image Processor. The Canon EOS 50D is a much more sophisticated tool.

development and Canon were about to embark on a decade of model upgrades every 18–24 months.

The EOS 3 utilized a 21-zone metering system linked to AF points, of which there were eventually 45. This increased the speed of operation further, especially when combined with the eye-control system. A top shutter speed of 1/8000 sec was also included, along with a claimed lifetime of at least 100,000 shutter operations.

The EOS 1V was introduced in the spring of 2000 with high-speed continuous shooting of up to 9 frames per second and 20 custom functions that could be tailored to each individual. The EOS D30, also launched in 2000, brought into play an affordable digital SLR aimed at the non-professional enthusiast. With its Canon-developed CMOS sensor, the EOS D30 could boast the smallest and lightest body in this sector of the market.

It also heralded a new approach to photography in which those with little experience could access the capabilities of a complex tool using the now-familiar Basic Zone settings indicated by symbols on the Mode Dial. Further foolproofing was added in the form of a 35-zone evaluative metering system and E-TTL (electronic through the lens) metering for its built-in flash. Canon RAW image files could now also be selected instead of JPEG files.

The EOS 1D was introduced in 2001, followed in 2002 by the EOS 1Ds. These took specifications and speed to staggering new levels, and recent updates have continued the trend. Today we can expect to find superfast processors like the 50D's DIGIC 4; an Integrated Cleaning System on the camera sensor; sophisticated exposure adjustments like Highlight Tone Priority, and the ability to download a range of Picture Styles, even on entry-level models.

Those interested in the history of camera technology are advised to visit Canon's fascinating website at www.canon.com/cameramuseum.

EOS 1D MK III
The professional-level EOS 1D Mk III was heralded as 'the fastest, most powerful digital SLR in the world' when it was launched.

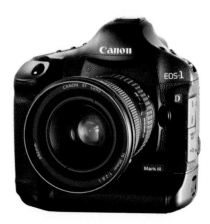

New features of the Canon EOS 50D

- 15.5 (total) megapixel CMOS sensor (40D: 10.5 total megapixels)
- DIGIC 4 processor (40D: DIGIC III)
- 4752 × 3168 maximum pixels (40D: 3888 × 2592)
- sRAW 1 (3267 × 2178) and sRAW 2 (2376 × 1584) (40D: SRAW 1936 × 1288)
- New folders can be created and selected manually
- Autofocus micro-adjustment of +/- 20 steps. Up to 20 different lenses can be individually adjusted
- Auto ISO 100–1600 (40D: 100–800); Manual ISO 100–3200 (40D: 100–1600); ISO can be expanded to 6400 (H1) or 12800 (H2) (40D: 3200)
- Highlight Tone Priority now displayed in viewfinder
- LCD monitor: 920,000 dots (40D: 230,000); viewing angle 160° (40D: 140°); dual anti-reflection coating
- Shooting settings LCD monitor display replaced by Quick Control Screen
- Addition of Creative Auto shooting mode
- Auto Lighting Optimizer now has four settings
- High ISO noise reduction now has four settings
- Auto-correction of lens peripheral illumination
- Live View: two new autofocus modes in Live View – Live mode and Live Face Detection mode; two grid overlays (40D: one)
- 25 Custom Functions with a total of 74 settings (40D: 24/62)
- User copyright information in Metadata tag
- Slide show: Selectable Playback time of 1, 2, 3 or 5 seconds; Additional Slide Show options: By date; By folder
- 25 languages (40D: 18)
- HDMI mini output
- UDMA compatible
- Compatible with Windows XP (SP3), Windows Vista (SP1) (excluding Starter Edition) and Mac OS X v10.4–10.5
- Weight 730g (40D: 740g)

Main features

Body
Dimensions: 145.5 × 107.8 × 73.5mm
Weight: 730g
Construction: magnesium alloy
Lens mount: both EF and EF-S lens
mounts are supported.
Caution: operating environment:
0–40°C at maximum 85% humidity

Sensor & processor
Uses the new DIGIC 4 processor.
The sensor is a 22.3 × 14.9mm CMOS
type with 15.1 effective megapixels
and a self-cleaning low-pass filter.

Focusing
Three different autofocus modes,
including predictive autofocus, can
be selected to suit static or moving
subjects: One Shot, AI Focus or AI
Servo. Both automatic and manual
selection of an AF point is possible
from the nine '+' type sensors which
are more sensitive to the horizontal
and vertical characteristics of the
subject. The centre AF point has
double the sensitivity of the other AF
points. The AF system's working range
is from EV -0.5 to EV 18 at 23°C at
ISO 100. Autofocus Lock is possible
in One Shot mode and, when using
flash, an AF-assist beam is triggered if
selected within the Custom Functions.

AF micro-adjustment allows minute
focus corrections on up to 20 lenses.
Autofocus is not possible on lenses
slower than f/5.6, or effectively slower
than f/5.6 when using a teleconvertor.

Exposure
The 50D's 35-zone silicon photocell
sensor provides four full-aperture
TTL metering modes: Evaluative,
Partial (9% at centre), Spot (3.8% at
centre) and Centre-weighted Average
metering. Evaluative metering can be
linked to any AF point. The metering
range is EV 0 to EV 20 at 23°C at
ISO 100 using a 50mm f/1.4 lens.
Both exposure compensation and
three-shot auto-exposure bracketing
are possible to a maximum of +/-2
stops using either ½- or ⅓-stop
increments. Automatic ISO setting can
be selected between ISO 100 and ISO
1600, or manual ISO settings can be
used between ISO 100 and ISO 3200
in ⅓-stop increments, expandable
to 6400 (H1) or 12800 (H2).

Shutter
The EOS 50D uses an electronically
controlled focal-plane shutter,
providing shutter speeds from 1/8000
sec to 30 sec and bulb; the range
available depends on the selected
shooting mode. Drive options
include single frame, low-speed

12

continuous shooting at up to 3fps,
high-speed continuous shooting at
up to 6.3fps, a 10-second self-timer
and a two-second self-timer.

File types and sizes

JPEG file sizes range from large/fine
4752 × 3168 pixels to small/normal
2353 × 1568 pixels, with a choice of fine
or normal for each of the large, medium
or small settings. RAW files are recorded
as 4752 × 3168 pixels, sRAW 1 files as
3267 × 2178 pixels and sRAW 2 as 2376
× 1584 pixels. The two sRAW options
provide all the advantages of RAW but
with smaller files. The 50D retains the
simultaneous recording of RAW and
JPEG files, and both sRGB and Adobe
RGB colour spaces are supported. The
50D records 14 bits per channel for
improved tonal gradation.

Flash

Using the established E-TTL II metering
system, the built-in flash has a guide
number of 13 (metres) at ISO 100 and
synchronization is 1/250 second with
selectable high-speed synchronization
above that figure. Auto and manual
modes are provided along with
selectable red-eye reduction. Flash
exposure compensation, flash bracketing
and second-curtain synchronization are
all supported. Wireless multiple-flash is
possible with EX series Speedlites.

LCD monitor

The 50D's new high-resolution 3in
(7.6cm) monitor with 920,000 dots is
a vast improvement on the 40D's
monitor. It provides seven selectable
levels of brightness, making it easy to
review captured images, and is used
in Live View mode for composing and
checking fine detail. Magnification of
×5 and ×10 plus vertical and horizontal
scrolling of the magnified portion of
the image assist this process. As such,
it will be of benefit to photographers
working on a tripod in studio
conditions or with static subjects in
stable lighting conditions. Manual
focus or three AF modes are possible
in Live View mode; flash exposure,
continuous shooting, and depth-of-
field preview can also be used.

Custom Functions

25 Custom Functions are supported,
with a total of 74 different settings.

Memory card

Compact Flash Type I/II (Microdrive
and UDMA compatible).

Software

ZoomBrowser EX/Image Browser,
PhotoStitch, EOS Utility including
Remote Capture, Picture Style Editor,
Digital Photo Professional (for RAW
image processing).

Full features and camera layout

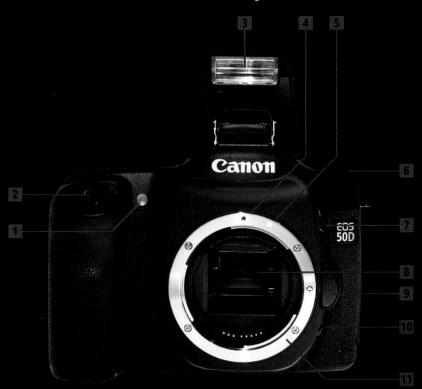

FRONT OF CAMERA

1 Self-timer light
2 Shutter-release button
3 Built-in flash
4 EF lens mount index
5 EF-S lens mount index
6 Mode Dial

7 Flash pop-up button
8 Reflex mirror
9 Lens-release button
10 Depth-of-field preview button
11 Lens mount

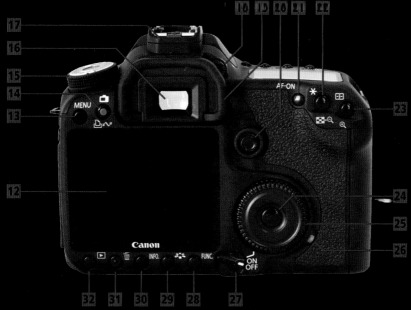

BACK OF CAMERA

12 LCD monitor

13 MENU button

14 Print/share button

15 Mode Dial

16 Viewfinder eyepiece

17 Hotshoe

18 Dioptre adjustment

19 Eyecup

20 Multi-controller

21 AF-ON button

22 AE lock/FE lock/Reduce button

23 AF point selection/Enlarge button

24 Setting button

25 Quick Control Dial

26 Access lamp

27 Power on/Quick Control Dial switch

28 Function button

29 Picture Style selection button

30 INFO button

31 Erase button

32 Playback button

TOP OF CAMERA

33 Mode Dial

34 Camera strap eyelet

35 Lens-release button

36 Hotshoe

37 LCD top panel illumination button

38 Metering mode/White-balance selection button

39 AF mode/Drive mode selection button

40 ISO/Flash exposure compensation selection button

41 Shutter-release button

42 Main Dial

43 LCD top panel

44 Focal plane mark

45 Dioptre adjustment

LEFT SIDE

46 PC terminal

47 Digital terminal

48 Remote control terminal

49 Video out terminal

50 HDMI mini out terminal

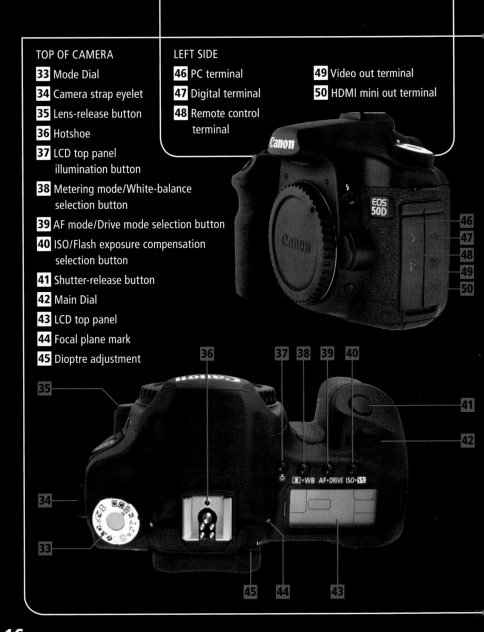

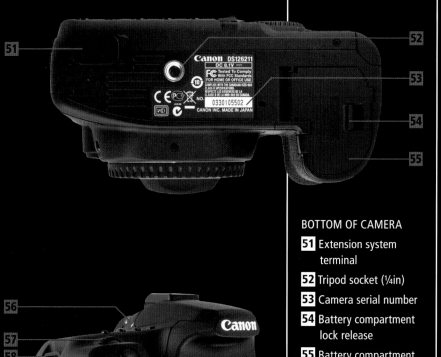

BOTTOM OF CAMERA

51 Extension system terminal

52 Tripod socket (¼in)

53 Camera serial number

54 Battery compartment lock release

55 Battery compartment

RIGHT SIDE

56 Focal plane mark

57 Main Dial

58 Camera strap eyelet

59 Shutter-release button

60 Compact Flash card cover

Viewfinder display

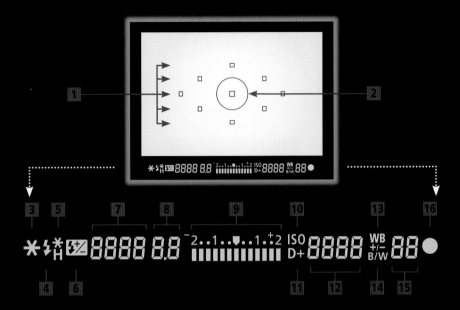

1. Focus points
2. Spot metering circle
3. AE lock/AEB in progress
4. Flash ready indicator
5. High-speed sync indicator
6. Flash exposure compensation
7. Shutter speed/Flash exposure lock/ Busy indicator/Built-in flash recycling/ CompactFlash card full indicator/ CompactFlash card error indicator/ No CompactFlash card indicator
8. Aperture value
9. Exposure level indicator/Exposure compensation indicator/Flash exposure compensation indicator/Auto exposure bracketing display/Red-eye reduction lamp-on indicator
10. ISO indicator
11. Highlight Tone Priority
12. ISO speed
13. White-balance correction
14. Monochrome shooting
15. Maximum burst indicator
16. Focus confimation indicator

LCD control panel

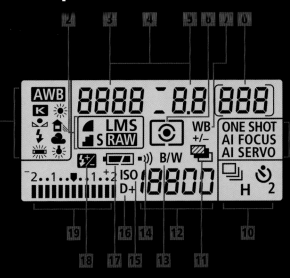

1 White-balance preset

2 Image format, size and quality

3 Shutter speed/Busy indicator/
Built-in flash recycling

4 Autofocus point selection/
CompactFlash card full indicator/
CompactFlash card error indicator/
No CompactFlash card indicator/Error
indicator/Cleaning sensor indicator

5 Aperture

6 Metering mode

7 White-balance correction

8 Shots remaining on card/Shots
remaining during white-balance
bracketing/Self-timer countdown/
Bulb exposure time

9 AF mode

10 Drive mode

11 Auto exposure bracketing icon

12 ISO speed

13 Monochrome shooting

14 Beeper

15 ISO speed

16 Highlight Tone Priority

17 Battery check

18 Flash exposure compensation icon

19 Exposure level indicator/Exposure
compensation indicator/Auto exposure
bracketing display/Flash exposure
compensation indicator/CompactFlash
card writing status

Menu displays

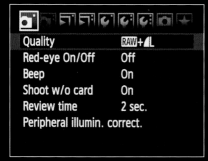

SHOOTING MENU 1
Quality
Red-eye On/Off
Beep
Shoot without card
Review time
Peripheral illumination correction

SHOOTING MENU 2
Exposure compensation/Auto exposure bracketing
White balance
Custom white balance
White-balance shift/bracketing
Colour space
Picture style
Dust delete data

PLAYBACK MENU 1
Protect images
Rotate
Erase images
Print order
Transfer order

PLAYBACK MENU 2
Highlight alert
AF point display
Histogram
Slide show
Image jump with ⚙ Main Dial

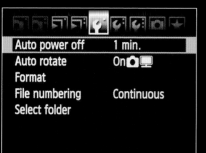

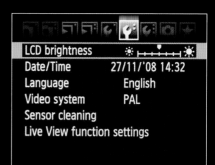

SET-UP MENU 1 ፔ
Auto power-off
Auto rotate
Format
File numbering
Select folder

SET-UP MENU 2 ፔ
LCD brightness
Date/Time
Language
Video system
Sensor cleaning
Live View function settings

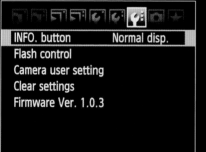

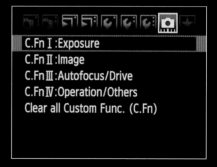

SET-UP MENU 3 ፔ
INFO button
Flash control
Camera user setting
Clear settings
Firmware version

CUSTOM FUNCTIONS MENU 📷
Exposure
Image
Autofocus/Drive
Operation/Others
Clear all Custom Functions

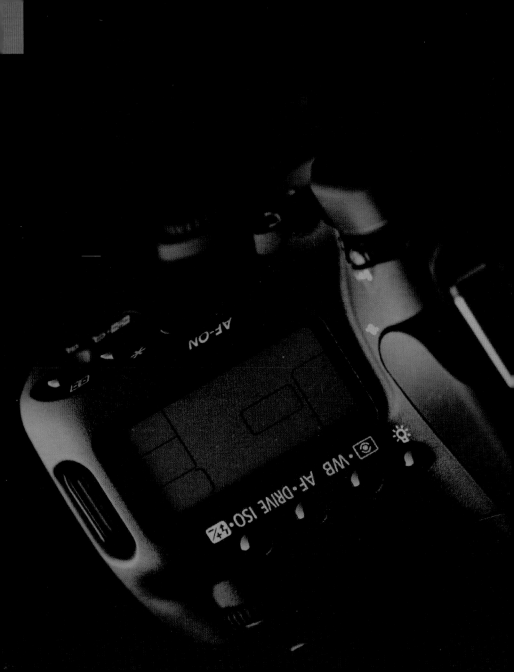

Chapter 2

Functions

If you're graduating from a compact digital camera to the Canon EOS 50D, you may at first feel daunted by its large array of buttons and dials. Fortunately, Canon offer Full Auto, Creative Auto and Program modes that you can work with while you're getting to know the camera layout and its many functions better.

Those upgrading from other Canon digital models will be familiar with some of the 50D's design concepts, if not the actual placement of the controls. In particular, the 3in (7.6cm) LCD monitor has placed limitations on the arrangement of the buttons on the back, and the layout is almost identical to that of its predecessor, the EOS 40D.

This chapter explores the EOS 50D's potential, step by step, by presenting basic information first and examining more complex issues in subsequent sections.

EASY ON THE EYE
The Canon EOS 50D isn't just stylish to look at; its new 920,000-dot, 3in (7.6cm) LCD monitor provides exceptionally sharp and colourful playback images too.

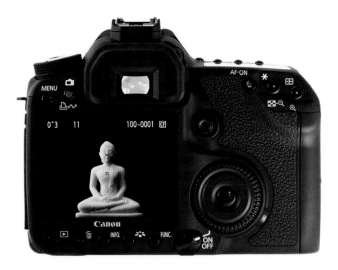

Camera preparation

Sometimes it is necessary to change lenses or memory cards in the dark or while holding a conversation with a subject with whom it is important to maintain eye contact. Long before that situation arises, those actions will need to have been practised time and time again until they can be performed automatically. Your camera should function almost as an extension of your body.

Attaching the strap

A camera strap should be used at all times to ensure the safety of your camera. To attach it, pass the end of the strap through either the left-hand or the right-hand eyelet, situated at the top of the camera. Then pass the end of the strap through the buckle, under the existing length of strap that is already threaded through the buckle. Repeat the operation on the other side. Pull lightly to remove most of the slackness, position the buckle as desired, then pull more firmly to ensure the strap will not loosen within the buckle.

Fitting and removing a lens

Remove the rear body cap of the lens to be fitted, and the camera body cap or the lens already fitted to the camera. This is done by depressing the lens-release button while turning the cap or lens anti-clockwise as it is facing you. Align the lens to be fitted, insert it into the camera and turn it clockwise until a faint click can be heard. Check that the AF/MF switch on the lens is set to the desired position.

Both Canon EF and EF-S lenses can be used on the EOS 50D. The field of view will be 1.6× less on the EOS 50D than is quoted for the focal length of the lens.

After removing a lens, ensure that the lens cap is fitted and put it down safely with the rear end up. Fit the rear lens cap as soon as possible. Avoid touching the lens contacts, because dirty contacts can cause a malfunction.

Common errors
Before you attempt this operation, always ensure that there is as little risk as possible from the people or circumstances around you of being caused to drop either camera or lens. Also make certain that the wind is not likely to raise dust or sand while you are changing lenses.

1) Ensure that the camera is switched to **OFF** and that the small red access lamp on the back of the camera next to the ▶ Quick Control Dial is not illuminated.

2) With the camera facing away from you, the memory card slot cover is on the right side of the camera body. To open it, slide the cover towards you with firm finger pressure and it will swing outwards on its hinges.

3) If removing a memory card, press firmly on the grey memory card eject button located at the bottom of the card slot and slide out the card.

4) To insert a memory card, slide the memory card into the camera's slot with its label side facing you, and with the two parallel rows of minute holes along the card edge to your left. When the card is almost fully inserted, slight resistance will be felt – push a little harder and the card will slide fully home and the eject button will spring back out.

5) Press the cover shut and slide it forwards until it snaps into position.

To prevent shooting without a CF card inserted, see 📷 Shooting Menu 1.

Warning!

Inserting the memory card incorrectly may damage the camera.

Common errors

When the red access lamp on the back of the camera (next to the ○ Quick Control Dial) is lit or blinking, it indicates that images are being processed – this may include being written, read, erased, or transferred to another device. Do not remove the battery or CF card when the lamp is illuminated or blinking. Either of these actions is likely to damage image data and may cause other camera malfunctions.

Tip

If the **Err CF** error message appears on the LCD, there may be a problem with your memory card. To save any images already on the card, transfer them to a computer and then attempt to reformat the card in the camera.

Inserting the battery

The EOS 50D is equipped with a BP-511A 7.4v 1389 mAh battery but can also use BP-511, BP-512, or BP-514 batteries.

Turn the camera upside down and locate the battery compartment on the right-hand side. Apply slight pressure to the lock and open the compartment. With the battery contacts downwards and to your left, insert the battery until it locks in position. Shut the battery compartment cover until there is an audible click. To remove the battery, ease the white plastic retaining clip to the side. Once removed, a battery should have its protective cover attached to prevent shorting.

Recharge level	Lamp blinks
0–50%	Once/second
50–75%	Twice/second
75–90%	Three times/second
91–100%	On continuously

Using mains electricity

By using the AC Adaptor Kit ACK-E2 (available separately) you can connect the EOS 50D to a mains power outlet instead of using battery power. Connect the DC coupler plug to the AC adaptor socket. Connect the power cord to the AC adaptor and then to the power outlet. Open the camera's battery compartment and, having removed the battery, insert the DC coupler. (Its cord should run through the notch which is normally hidden by a rectangular rubber cover.) Close the battery compartment.

Warning!
Never connect or disconnect the power cord while the camera is switched on.

Battery charging

The Battery Charger CB-5L (also CG-580) can be used to charge any of the batteries listed above. Remove the battery's protective cover and align the battery's front edge with the charger's index line. Slide the battery in the direction of the arrow while pressing down on the battery. Connect the power cord to the CB-5L charger and insert the plug into a mains outlet. Recharging is indicated by a blinking red lamp. A constantly illuminated red lamp indicates a fully charged battery. A fully discharged battery will take 90–100 minutes to recharge fully.

Battery life

The life of any battery will depend upon several factors: working temperature, past treatment of the battery, use of the image review facility, choice of lens, auto power-off setting, use of the built-in flash, long periods with the shutter button partially depressed (as when tracking a moving subject), and especially use of the Live View function. The table below is a rough guide to the number of exposures you can achieve with a single BP-511A battery.

Tips

Even when it is not in use, your camera battery will gradually lose its charge. Remove the battery if the camera is to remain unused for a long period. Storing the battery after it is fully recharged may have a negative effect on the battery's performance.

The camera's operating range is 0–40°C but in temperatures of 30–40°C or 0–10°C the battery may not perform optimally.

Dioptre adjustment

Using the EOS 50D without spectacles is facilitated by the dioptre adjustment. Turn the knob so that the AF points in the viewfinder are sharp. If this is insufficient, ten different versions of the Dioptric Adjustment Lens E are available separately.

Tips

The battery charger can be used abroad (100–240v AC 50/60 Hz) with a travel adaptor. Do not attach any form of voltage transformer.

If your battery runs out quickly, check the auto power-off (↑↑ˈ Set-up Menu 1) and image review time (◯ˈ Shooting Menu 1) settings to see if you can save power.

Temperature	No flash / no Live View	50% flash / no Live View	Live View / no flash
23°C (73°F)	800 exposures	640 exposures	180 exposures
0°C (32°F)	680 exposures	540 exposures	140 exposures

28

Basic camera functions

The following pages refer frequently to three of the EOS 50D's dials. They are key to the camera's operation and it is a good idea to memorize their symbols and location as soon as possible. They are the Mode Dial, the ◯ Quick Control Dial and the ☷ Main Dial. We shall come to the ❊ Multi-controller later. Let's start with the basics.

Switching the camera on

The power switch has three settings:

OFF The camera will not operate.
ON The camera operates but use of the ◯ Quick Control Dial is disabled. This will not restrict use of the Basic Zone modes.
⏷ The camera including the ◯ Quick Control Dial is fully operational.

Sensor cleaning takes place automatically each time you turn the camera on or off. A message to this effect is displayed briefly on the LCD monitor on the back of the camera. Automatic sensor cleaning can be disabled in ❙❚˙ Set-up Menu 2.

Tips
If the camera is set to power-off automatically after a set interval (❙❚˙ Set-up Menu 1), partially depressing the shutter button will fully reactivate the camera.

If the power switch is turned to **OFF** while an image file is being written, the camera will finish recording the image before turning itself off.

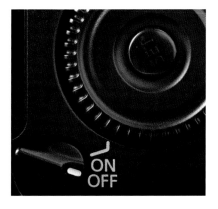

29

Drive mode

The EOS 50D provides three frame-advance modes plus two self-timer settings, all of which fall into the category of Drive mode.

Drive mode in each of the Basic Zone settings is selected automatically. In the Creative Zone, the Drive mode setting can be selected by depressing the **AF•DRIVE** button above the LCD panel on top of the camera and then rotating the ⭕ Quick Control Dial.

The maximum available burst of continuous images depends upon file quality, drive mode, memory card, and the buffer space available. The figure for the number of burst frames possible is shown in the viewfinder at bottom right. It represents the maximum possible burst and therefore assumes high-speed continuous shooting even if that mode is not selected. The display has a maximum of 99, which indicates 99 or higher.

Drive mode	
Single frame advance	☐
High-speed continuous 6.5 frames/sec	⊡H
Low-speed continuous 3 frames/sec	⊡
Self-timer 10-second delay	↻
Self-timer 2-second delay	↻₂

The Mode Dial provides 15 different shooting modes, each of which will be explained in detail later in this chapter. They are divided into the Basic Zone and the Creative Zone. To select the desired mode, turn the dial until its icon is lined up with the mark on the camera body.

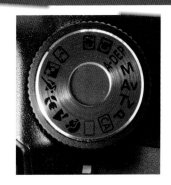

The Basic Zone provides eight fully automated modes. Six of these are for different types of subject, indicated on the Mode Dial by an icon. The remaining two are Full Auto ⃝ and Creative Auto **CA** modes. The Creative Zone has five advanced modes offering total control of all camera settings, plus two modes with user-defined settings.

FUNCTIONS

Mode dial

Basic Zone		Creative Zone	
Creative Auto	**CA**	Program	**P**
Full Auto	⃝	Shutter Priority	**Tv**
Portrait	🙎	Aperture Priority	**Av**
Landscape	🏔	Manual	**M**
Close-up	🌷	Auto depth-of-field	**A-DEP**
Sports	🏃	User-defined settings	**C1**
Night Portrait	🌃	User-defined settings	**C2**
Flash Off	🚫⚡		

The shutter-release button has two functions. Partially depressing it brings into play the autofocus and metering functions. Pressing it fully releases the shutter and takes the picture using the focus and exposure settings that were registered when you only partially depressed the shutter release. If the shutter-release button is fully depressed immediately, there will be a momentary delay before the picture is taken.

In the Creative Zone, the **AF•ON** button can be programmed using the Custom Functions menu to operate the focusing and metering functions instead of the shutter-release button.

If you have purchased the Battery Grip BG-E2N to go with your camera, then exactly the same applies to the additional shutter button provided on the battery grip for vertical shooting. This does, however, have a separate power switch which must be switched on for the additional shutter button to function.

Tip
Even while menus are displayed or an image is being reviewed or recorded, the Canon EOS 50D will immediately go to picture-taking readiness when you partially depress the shutter-release button (unless the buffer is full). This means you will very rarely miss an opportunity to take a picture.

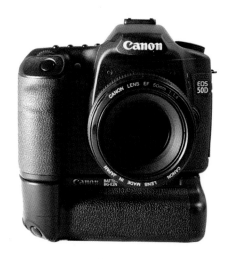

BATTERY GRIP
By adding the Battery Grip BG-E2N, you have two batteries and an additional shutter release for shooting in the vertical format.

32

The ⚙️ Main Dial next to the shutter release button is used for adjustments to the settings required for shooting. It is used sometimes on its own, and on other occasions after depressing a button to select the function you wish to adjust.

In **P** mode the Main Dial used on its own will adjust both aperture and shutter speed while retaining the equivalent exposure. In **Tv** and **M** modes it will adjust the shutter speed, and in **Av** it will adjust the aperture. All these functions are explained fully later in this chapter.

The ⚙️ Main Dial is also used to adjust metering mode, autofocus mode, and ISO in combination with the buttons located immediately above the LCD panel on top

of the camera. After pressing one of these buttons, each of which governs two different functions, the ability to adjust that function will remain active for six seconds. Having adjusted a setting, it is not necessary to wait for the six seconds to elapse: partially depressing the shutter-release button will immediately return the camera to shooting readiness.

In all of the above circumstances, any adjustments made will be visible in both the viewfinder and the LCD panel on top of the camera – with two exceptions. When adjusting metering mode or autofocus mode, the viewfinder display is turned off temporarily. As a result, these adjustments can only be seen in the LCD panel on top of the camera.

The EOS 50D accepts both EF and EF-S lenses, each of which are equipped with an AF/MF switch so you can change to manual focusing. This may be necessary in very low light or when focusing on something with insufficient contrast for an AF point to latch onto. It may also be useful when photographing landscapes to obtain maximum depth of field, or when taking extreme close-ups – especially if you are using the ×5 or ×10 magnification facility in Live View mode.

The camera is equipped with nine AF points which may function as a group or can be selected singly (see page 65). In the Creative Zone, the **AF•ON** button may also be used to achieve focus.

Three AF modes cover most eventualities:

One Shot mode
One Shot mode is suited to relatively still subjects. When you partially depress the shutter-release button, the camera will

focus just once on the subject. It will not refocus until you withdraw the pressure and partially depress the shutter-release button again. When focus is achieved, both the green ● focus confirmation light and the red AF point(s) that achieved focus will be visible in the viewfinder. There will also be a **beep** unless this has been switched off in Shooting Menu 1. If you continue to hold down the shutter-release button, focus will be locked and you can recompose your photograph.

AI Servo mode

AI Servo mode is suited to subjects with sustained movement. This facility is useful when the camera-to-subject distance keeps changing. While you partially depress the shutter-release button, the camera will continue to readjust focus automatically. The exposure settings (normally selected when you partially depress the shutter-release button) will be fixed at the moment the picture is taken.

When AF point selection is automatic and AI Servo is selected, the camera will first use the centre AF point to achieve focus, so it is necessary to place your subject centrally at the start, otherwise focus may track the wrong subject. During focus tracking, if the subject moves away from the centre AF point, tracking will continue as long as the subject is covered by an alternative AF point.

In AI Servo mode, the **beep** will not sound and the ● focus confirmation light will not be displayed in the viewfinder.

AI Focus

AI Focus is suited to a variety of still and moving subjects. In this mode the camera will switch between One Shot and AI Servo modes according to the movement of the subject. If focus is achieved using One Shot mode but the subject starts to move, the camera will automatically shift to AI Servo mode and track the subject, provided you keep the shutter-release button partially depressed.

Unlike with AI Servo mode fully selected, if focus is achieved while AI Servo is active in AI Focus mode, then the **beep** will sound, but more softly than normal. However, the ● focus confirmation light still does not light up in the viewfinder.

> **Tip**
> If focus cannot be achieved, the ● focus confirmation light will blink and you will not be able to take a picture even if you fully depress the shutter-release button. Under these circumstances, reposition the camera and try again, or switch the lens to manual focus.

34

Depth-of-field preview

The depth-of-field preview button is on the front of the camera, just below the lens-release button. Pressing it will stop the lens down to the currently selected aperture, providing a more accurate impression of the range of acceptable focus. A smaller aperture (higher f-number) will provide greater depth of field, but the viewfinder will appear darker as you stop

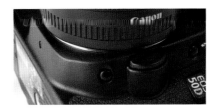

down. The exposure is locked while the depth-of-field preview button is depressed.

ISO setting

The ISO speed is the sensor's sensitivity to light and effectively governs the combined exposure values of aperture and shutter speed. A higher ISO speed enables a faster shutter speed and is therefore more useful in low light. However, higher ISO speeds bring more 'noise', producing a more grainy-looking image; so the slower the ISO speed, the crisper the final image.

In Basic Zone modes, the ISO is set automatically within the range ISO 100–1600 and cannot be overridden. Auto ISO is also possible in Creative Zone modes, but ISO can also be set manually in the range ISO 100–3200 using 1-stop or ½ stop increments.

To set the ISO speed, press the **ISO•⚡** button and rotate the ⛯ Main Dial to set the desired ISO speed or Auto ISO. The setting is shown in both the viewfinder and the LCD panel on top of the camera.

Expanded ISO

Use Custom Function I-3 (see page 121) to expand the ISO setting. Once enabled, the **H1** (6400) and **H2** (12800) settings are added to the list of possible settings selectable using the **ISO•⚡** button.

Tips
Doubling the ISO figure is equivalent to a 1-stop reduction in exposure.

Increasing the ISO speed also increases the effective range of a built-in or external flash.

If you are using the Quick Control Screen in conjunction with the **INFO** button, pressing the **ISO•⚡** button will bring up an ISO setting screen. Use the ⛯ Main Dial to amend the setting.

Built-in flash

The built-in flash operates automatically in Basic Zone modes. In Creative Zone modes, the built-in flash can be raised by pressing the small button on the front of the camera, just above the lens-release button. When the built-in flash is active and charged, the 💲 Flash symbol will appear in the viewfinder at bottom left.

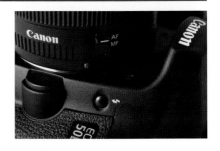

Metering mode

The EOS 50D provides four different metering modes to cover any eventuality:

Evaluative metering ⊡
This metering system is capable of coping with a wide range of lighting situations, including backlighting. It takes readings from 35 different zones.

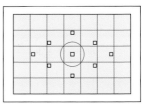

Centre-weighted Average metering ⊏⊐
This metering system gives added bias to readings taken from the centre of the frame, then averages readings from the whole area.

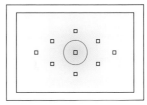

Partial metering ⊡
This mode takes readings from just 9% of the frame at the centre and is especially useful when the background is significantly brighter than the subject. It can also be used, in effect, as a spot meter with a larger than normal 'spot'.

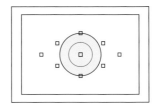

36

Spot metering [·]

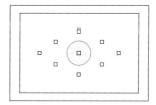

This makes use of a small area at the centre of the frame equalling just 3.8% of the viewfinder area. It can be used to take readings from small but important areas of the subject in order to ascertain an average tone, or any other tone if you know how its exposure will relate to the mid-tone.

To set the 50D's metering mode, press the [◉]•WB button and rotate the Main Dial to set the desired metering mode. The setting is shown on both the Quick Control Screen display and the LCD panel on top of the camera, using the symbols [◉] [◎] [·] or [].

If you're using the Quick Control Screen in conjunction with the **INFO** button, pressing the [◉]•WB metering mode button will bring up a metering mode settings screen. When the screen is active, you can use the Main Dial to amend the setting.

Image playback

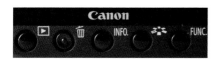

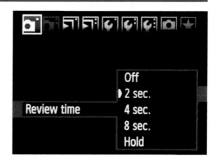

Immediate automatic playback of an image can be either disabled or enabled for a duration of 2, 4 or 8 seconds using Shooting Menu 1, or displayed indefinitely by selecting **Hold**.

If automatic image review is disabled, it is possible to manually review images by pressing the [▶] Playback button below the LCD monitor.

The first image to be shown will be the most recent or the last viewed. Use either the Main Dial or the ◯ Quick Control Dial to scroll through the images.

Press the **INFO** button to change the display style. The styles available are Single image, Single image with file quality setting, Histogram display, and Shooting information display.

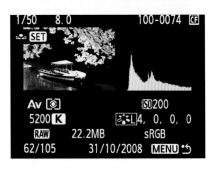

Magnify images

Zoom into the image to a maximum of 10× magnification by pressing the ⊞/🔍 button. Use the ✴ Multi-controller to move around the magnified image.

The ✱/🔳•🔍 button zooms out again; alternatively, you can return to the full-frame view after zooming in by pressing the ▶ Playback button once.

Rotating images

To rotate all portrait-format images automatically, enable Auto Rotate in ↑↑˙ Set-up Menu 1. To rotate a single image, press **MENU** and select Playback Menu 1. Highlight **Rotate** and press **SET**. The display will return to Playback mode. Select the image you wish to rotate and press **SET** again. The image will rotate. Pressing **SET** repeatedly will rotate the image through different orientations.

Index Display

If the ✱/🔳•🔍 Reduce button is pressed while a full-frame image is displayed, the LCD monitor will display four images at the same time. If it is pressed a second time, nine images will be displayed. The current image is highlighted in blue. To select a different image, rotate the ◯ Quick Control Dial. This multi-image display is referred to as the Index Display. To change from a nine-image display to a four-image display, or from a four-image display back to a single image, press the ⊞/🔍 Enlarge button. To exit from any of these options, press the ▶ Playback button. Next time the ▶ button is activated, the most recently viewed image will be displayed, using the Index Display style which was active when you last exited Playback. The most recently viewed image will be superseded by the most recently captured image if the camera has been used in the meantime.

38

Slide Show

In ▶' Playback Menu 2, select **Slide Show** to display a sequence of images on the memory card. The sequence can contain all the images on the memory card, a single folder, or images from a specific date. To pause, press the **SET** button; press it again to resume. In pause mode, you can move to a different image in the sequence by rotating either the 🔆 Main Dial or the ◯ Quick Control Dial; the slide show will resume from this point in the sequence. Press **MENU** to stop the slide show. The auto power-off function will not work during a slide show.

Note
Rotating the 🔆 Main Dial in pause mode will only change images one at a time, even if the **1 image** setting in **Image jump with** 🔆 has been altered in ▶' Playback menu 2 (see page 102).

Deleting images

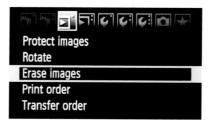

Method 1
To delete a single or highlighted image, press the 🗑 Erase button and confirm the deletion by highlighting **Erase** and pressing **SET**. Alternatively, select **Cancel** and press **SET** to return to Playback mode.

Method 2
To delete single, selected, or all images, press **MENU** and use the 🔆 Main Dial to select Playback Menu 1. Select **Erase images** by rotating the ◯ Quick Control Dial, then press **SET**. On the next screen,

choose **Select and erase images**, **All images on card**, or **All images in folder** and press **SET**. You can exit at any time by pressing **MENU**.

If you choose **Select and erase images** and press **SET**, you will see either a single image or a display of three images.

39

Toggle between the one-image or three-image displays using the ✳/⊞•◦ Reduce or ⊟/⊕ Enlarge buttons. The current image is highlighted in blue.

Select an image for deletion and press **SET**. A tick will be added in a box above the highlighted image. If that image is protected, the word **Protected** will appear instead. Scroll through consecutive images on the card and select all those you wish to erase by adding a tick. To remove a tick, highlight the image and press **SET**. The total number of images currently ticked is indicated at the top left of the monitor.

When your selection of images to delete is complete, press the 🗑 Erase button. You will get a **Cancel/OK** option to choose from. Select accordingly and press **SET**.

If you choose to delete an entire folder, the screen will display the first and last images in that folder as a reminder of its contents.

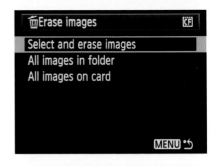

Tips

Select **Image jump with** 🔆 in ▶' Playback Menu 2 (see page 102) to enable the 🔆 Main Dial to jump 1, 10 or 100 images at a time, or jump by screen, date or folder during Playback functions. (On previous Canon models this was known as the **Jump** facility.)

Protecting your images will help prevent them from being deleted accidentally. To protect an image, press **MENU** and select ▶ Playback Menu 1. Next, select **Protect images** and use the ✳/⊡• ⊖ Reduce or ⊟/⊕ Enlarge buttons to toggle between a single image or the Index Display (see page 38). The current image is highlighted in blue.

Highlight the image to be protected and press **SET**. A key symbol ⊙‒ will be shown at the very top of the monitor display to indicate that the highlighted image is locked and cannot be deleted. To remove protection from the highlighted image,

press **SET** again. The key will disappear. This operation can be carried out in either single-image display or Index Display.

Notes
The ⊙‒ key symbol should not be confused with the larger key symbol accompanied by **SET**, which is an instruction, not a status indicator.

Protected images will still be erased when you format a memory card.

The LCD monitor provides three types of display when the camera is in shooting readiness. The first (shown right) appears when you press the **ISO•🔆**, **AF•DRIVE**, 🔲•**WB** or ⊟/⊕ buttons. The current setting is highlighted in green and can be adjusted by rotating either the 🗘 Main Dial or ○ Quick Control Dial.

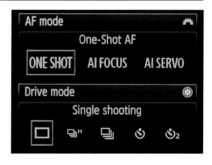

The second style (overleaf, top) shows a list of the camera settings. This appears when you press **INFO** – immediately if selected in ❢❢ Set up Menu 3, or by pressing **INFO** again to toggle between this and the Shooting Functions display.

FUNCTIONS

The third display style (right, centre) is referred to as the Shooting Functions setting screen. This will vary according to the shooting mode set. In the two examples shown here, the shooting mode is set to Creative Auto, displayed as **CA**. This screen can be accessed by pressing either **INFO** or the ❊ Multi-controller.

All the settings for the current shooting mode are displayed, including those that cannot be changed when you're using one of the Basic Zone modes – these will be 'greyed out'. The settings displayed in white are those that can be adjusted. When the Shooting Functions setting screen is accessed by pressing **INFO**, no functions are highlighted in green. To activate the adjustment procedure, press the ❊ Multi-controller (see below).

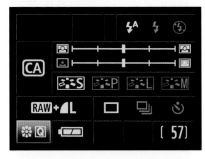

When the Shooting Functions display is accessed by pressing the ❊ Multi-controller, the first adjustable function will be highlighted in green (right, bottom). Functions are displayed on several different lines. To highlight a different function, push the ❊ Multi-controller up or down to change lines or left/right to select another function on the same line. Then rotate either the ✑ Main Dial or ◯ Quick Control Dial to change the setting. The currently selected setting is shown in a blue panel at the bottom of the screen.

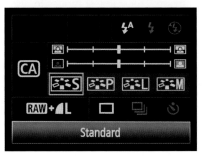

42

Exposure modes – the Basic Zone

The settings on the Mode Dial fall into two groups: the Basic Zone and the Creative Zone. The group of settings which makes use of icons on the dial, with the addition of ◯ Full Auto mode and **CA** Creative Auto mode, is known as the Basic Zone. The settings which are denoted by letters of the alphabet are known as the Creative Zone.

The Basic Zone is primarily intended for those who have yet to gain a deep understanding of the principles behind photography in general, and exposure in particular, and who have less experience to draw on. The simplest modes to use are ◯ Full Auto and **CA** Creative Auto. These modes are referred to collectively by Canon as the Image Zone, a new term introduced on the EOS 50D, though they still fall within the Basic Zone.

Each icon in the Image Zone represents a photographic style, for which automatic settings have been predetermined. The following styles are represented: Portrait, Landscape, Close-up, Sports, Night Portrait and No Flash. The settings for Full Auto mode are obviously a compromise,

and those for Creative Auto mirror the Full Auto settings but allow a little more flexibility.

In each of the Basic Zone modes, considerable thought has been given to the combination of aperture and shutter speed, the autofocus mode, and the various flash options provided by the built-in flash. The autofocus point is also selected automatically according to the position in the frame of what the camera deems to be the main subject. Full details for each Basic Zone mode can be found in the tables on the following pages.

> **Tip**
> If you are taking a lot of photos in a short time, on holiday for example, it can be difficult to remember where each batch of images was shot. It is well worth 'wasting' a shot on a sign or other object that indicates the location, either at the beginning or end of each group of images, or both.

Full Auto mode

Full Auto mode is a blessing for the less experienced photographer in situations where there is insufficient time to think carefully about camera settings and where lighting (and therefore exposure) is changeable; a children's party or family outing, for example. Basically, the camera does the thinking for you. This is often thought of as a basic mode but there is nothing basic about it at all, as it takes into account most of the settings over which you could have some control if you chose. The panel opposite indicates the various

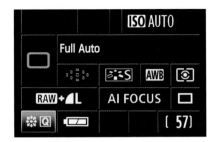

settings which the camera will select and which you cannot override. The built-in flash will automatically pop up into position if required and the AF-assist beam will be used to aid focusing in low light levels.

Using Full Auto mode

1) Turn the Mode Dial to ⬭.

2) Aim the camera at your subject. Focusing may be easier by placing the centre AF point over the main subject. You can recompose the picture later.

3) Lightly press the shutter button to achieve focus. The ● focus confirmation symbol and automatically selected AF points will be illuminated in the viewfinder. The exposure settings (aperture and speed) will appear at the bottom of the viewfinder.

4) In low light levels the built-in flash will pop up and the flash symbol ✚ will show

bottom left in the viewfinder when focus is achieved. (When you've finished taking the shots that are likely to require flash, push the flash unit back down manually.) The built-in flash may also operate in bright conditions to reduce shadows.

5) Retain light pressure on the shutter button to keep the focus locked and recompose the picture before depressing the button fully to take the photograph.

6) After a very brief delay, the captured image will display on the LED monitor for 2 seconds, unless the review function has been adjusted or switched off.

44

Full Auto mode

Quality setting	All settings are selectable using any one of RAW, sRAW 1, sRAW 2 or six levels of JPEG on their own, or in any combination of JPEG plus one RAW, sRAW 1 or sRAW 2.
Exposure Settings	Evaluative metering using 35 different zones; shutter speed and aperture are chosen to suit the light levels and subject; auto ISO; Standard Picture Style; Auto White Balance; Auto Lighting Optimizer
Focus settings	Automatic AF point selection in AI Focus mode (which will automatically switch to AI Servo mode if linear movement of the subject is detected, tracking the subject as long as you keep it covered by the AF points and continue to partially depress the shutter button)
Frame advance	Single frame advance; 10 sec self-timer
Flash and AF-assist settings	Flash and AF-assist settings; Automatic flash and automatic fill-in flash; red-eye reduction can be selected via **MENU □ ○**; AF-assist beam (effective up to 13ft/4m); first-curtain sync
Notes	Full Auto mode is easy to use and will give pleasing results in situations where the action and lighting are less challenging

Tip

To change the file quality or drive mode in the Quick Control Screen display, press **MENU** to display the Quick Control Screen. Press ✲ and rotate to highlight the desired function. Rotate either the ⌒ Main Dial or the ◯ Quick Control Dial to change the setting. Finally, press ✲ or **MENU** or partially depress the shutter release to return to the display screen.

WOODLAND FLOWERS
Full Auto mode is ideal for subjects like this with even tones, no bright highlights or deep shadows, and no depth-of-field requirements.

Creative Auto mode

Creative Auto mode is a new setting, introduced on the Canon EOS 50D as an additional Basic Zone mode. In essence, it adopts the default settings used by Full Auto mode but allows you to override certain settings. For the less experienced photographer, Creative Auto offers a useful intermediate step between Full Auto and Program mode.

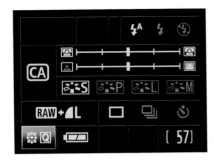

Full control over file-quality settings is provided, allowing you to choose between 27 different combinations of RAW, sRAW 1, sRAW 2 and JPEG formats. Four Picture Styles are incorporated: Standard, Portrait, Landscape and Monochrome – each using only the default parameter settings – along with the option of low-speed continuous shooting at about three frames per second.

There are two adjustable settings that mark a new approach from Canon: firstly, the degree of background blur; and secondly, the ability to adjust the overall brightness of the image. Each of these adjustments is achieved using a +/-2 incremental sliding scale in the Quick Control Screen. The background-blur scale adjusts the selected aperture in order to change the depth of field, with the corresponding shutter speed

changing accordingly – in effect, providing the same function as Program Shift in Program mode. However, the function is presented simply, with a desired result in mind (i.e. an increasingly or decreasingly blurred background) and without reference to the technical aspects of aperture and depth of field.

The brightness scale is a way of providing exposure compensation, once again concentrating on the photographer's desired end result while avoiding the need to explain the business of exposure and the relative properties of aperture and shutter speed.

While Full Auto mode provides 27 different file-quality settings with either One Shot drive or the self-timer, a total of 54 possible combinations, Creative Auto mode offers 24,300 different combinations of settings. That seems more than enough for any novice!

46

Creative Auto mode

Quality setting	All settings are selectable using any one of RAW, sRAW 1, sRAW 2 or 6 levels of JPEG on their own, or in any combination of JPEG plus one of RAW, sRAW 1 or sRAW 2.
Exposure settings	Evaluative metering using 35 different zones; shutter speed and aperture are chosen to suit the light levels and subject, but can be adjusted to increase/decrease background blur or to increase/decrease overall brightness; auto ISO; four Picture Styles are selectable: Standard, Portrait, Landscape or Monochrome; Auto White Balance; Auto Lighting Optimizer
Focus settings	Automatic AF point selection in AI Focus mode (which will automatically switch to AI Servo mode if linear movement of the subject is detected, tracking the subject as long as you keep it covered by the AF points and continue to partially depress the shutter button)
Frame advance	Single frame advance; continuous (low); 10 sec self-timer
Flash and AF-assist settings	Auto firing $\frac{1}{2}^A$; Flash on $\frac{1}{2}$; Flash off; automatic fill-in flash; red-eye reduction can be selected via **MENU □ 〇**; AF-assist beam (effective up to 13ft/4m); first-curtain sync
Notes	Creative Auto mode uses the same default settings as Full Auto mode but permits the ability to change some of the settings

Using Creative Auto mode

1) Turn the Mode Dial to **CA**. The Quick Control Screen is displayed.

2) Press the ✤ Multi-controller button into the camera body. The first of the selectable functions will be highlighted in green on the Quick Control Screen. You can then push ✤ up/down or left/right to select a different function, then rotate either the ✥ Main Dial or 〇 Quick Control Dial to change the setting.

3) Press the ✤ Multi-controller or **MENU** button, or partially depress the shutter release, to return to the display screen.

4) Aim the camera at your subject. Focusing may be easier by placing the centre AF point over the main subject. You can recompose the picture later.

5) Follow steps 3–6 under Using Full Auto mode (see page 44).

Portrait mode

Traditionally, portraits tend to be head-and-shoulders images with a vertical orientation (hence the term 'portrait format'). However, there are plenty of portrait situations that can benefit from landscape orientation, particularly when photographing someone in the context of their activity or profession.

Perspective and choice of lens or zoom setting are particularly important with portraits, as it is all too easy to distort the subject's features. Wide-angle lenses make

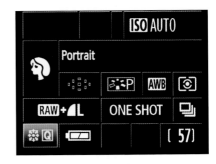

the features closest to the camera look disproportionately large, while longer telephotos have the opposite effect, tending to 'flatten' facial features. The traditional favourite for head-only portraits has always been a fast lens of around 85mm focal length (approx 50mm on the 50D due to its crop factor of 1.6), with a 50mm lens (approx 30mm on the 50D) being fine for upper-body portraits.

In portraits, the subject's eyes are critically important in terms of focus and clarity. If at all possible, try to include 'catchlights' – sharp points of light induced by flash, natural or reflected light.

MARILYN MONROE RECREATED
Portrait mode makes use of the Portrait Picture Style, which gives slightly warmer skin tones and a lower sharpness setting than the Standard or Landscape styles.

48

Portrait mode

Quality setting	All settings are selectable using any one of RAW, sRAW 1, sRAW 2 or 6 levels of JPEG on their own, or in any combination of JPEG plus one of RAW, sRAW 1 or sRAW 2
Exposure settings	Evaluative metering using 35 different zones; a wide aperture is selected in order to blur the background so that the subject is given greater prominence; auto ISO; Portrait Picture Style; Auto White Balance; Auto Lighting Optimizer
Focus settings	Automatic AF point selection in One Shot focus mode
Frame advance	Low-speed (max. 3 fps) continuous shooting; 10 sec self-timer
Flash and AF-assist settings	Automatic flash and automatic fill-in flash; red-eye reduction can be selected via MENU ☐ 📷 ; AF-assist beam (effective up to 13ft/4m); first-curtain sync
Notes	In Portrait mode the camera selects a colour setting to improve skin tones, plus a less sharp result than Full Auto to soften hair and blemishes

Using Portrait mode

1) Turn the Mode Dial to 🐾.

2) Aim the camera at your subject. Pay attention to framing and to distracting elements in the background. Focusing may be easier by placing the centre AF point over the main subject.

3) Lightly press the shutter button to achieve focus. The ● focus confirmation symbol and automatically selected AF points will be illuminated when focus is achieved. The exposure settings (aperture and speed), the selected ISO and the number of burst exposures possible also appear.

4) In low light levels the built-in flash will pop up and the flash symbol ⚡ will show bottom left in the viewfinder (push the flash back down manually when you have finished.) The flash may also operate in bright conditions to reduce shadows.

5) Retain light pressure on the shutter button to keep the focus locked and recompose the picture before depressing the button fully to take the photograph.

6) The captured image will display on the monitor for 2 seconds, unless the review function has been adjusted.

49

Landscape mode

While photos of family and friends tend to be the most popular subjects for amateur snappers, there's no doubt that those who aspire to be better photographers tend to favour scenic photography. The reasons are obvious: an unlimited supply of vistas which change according to the weather, light, season, and our own perceptions. I have never met a landscape photographer who feels he or she has run out of challenges.

The choice of wide-angle lenses has become more difficult since the advent of digital cameras offering less than full-frame coverage, because of the ×1.6 crop factor. Nevertheless, a high proportion of scenic photographs are still taken using wide-angle lenses (or wide zoom settings) to maximize depth

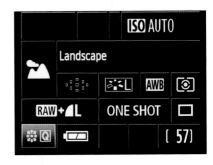

of field, capture a wider scene and accentuate foreground for a better sense of depth. However, just as portraits aren't always shot in portrait format, scenic photographs aren't always captured in landscape format. There are many subjects that might be better suited to a vertical format, such as waterfalls and trees. It is also useful for exaggerating the depth of an interesting foreground.

Common errors
Keep an eye on the shutter speed indicated in the viewfinder. If it blinks, this indicates the risk of camera shake, so use a tripod or find an alternative form of support for the camera.

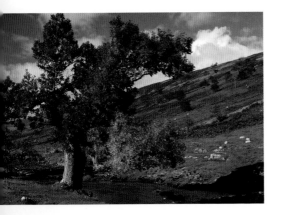

YORKSHIRE DALES
Evaluative metering coped perfectly with this scene, while the Landscape Picture Style brought out the vivid greens and the blue sky.

Landscape mode

Quality setting	All settings are selectable using any one of RAW, sRAW 1, sRAW 2 or 6 levels of JPEG on their own, or in any combination of JPEG plus one of RAW, sRAW 1 or sRAW 2
Exposure settings	Evaluative metering using 35 different zones; a narrow aperture is selected to maximize depth of field; auto ISO; Landscape Picture Style; Auto White Balance; Auto Lighting Optimizer
Focus settings	Automatic AF point selection in One Shot focus mode
Frame advance	Single frame advance; 10 sec self-timer
Flash and AF-assist settings	Flash and AF-assist beam are switched off
Notes	Landscape Picture Style provides vivid blues and greens. Slower shutter speeds may require the use of a tripod or other camera support

Using Landscape mode

1) Turn the Mode Dial to ▲ .

2) Aim the camera at your subject. Make sure you pay close attention to framing and to the foreground, which may contain distracting elements such as litter.

3) Lightly press the shutter button to achieve focus. The ● focus confirmation symbol and automatically selected AF points will be illuminated in the viewfinder. The exposure settings (aperture and speed) will appear at the bottom of the viewfinder, on the left. To the right is shown the ISO selected.

4) If you retain light pressure on the shutter button, the focus will be locked and you can recompose the picture before fully depressing the shutter button to take the photograph.

5) After a very brief delay, the captured image will display on the LCD monitor for 2 seconds unless the review function has been adjusted or switched off.

Close-up mode

The terms 'close-up' and 'macro' are used differently in this book. Macro, properly speaking, means a life-size image (i.e. at a magnification ratio of 1:1) and requires the use of either a special macro lens or extension tubes. A close-up, on the other hand, is considered as an image captured at the closest focusing distance of the (non-macro) lens being used.

There is a useful table on page 186 that shows the maximum magnification ratio of EF lenses. This tends to be somewhere between one-tenth and one-fifth life size, but varies enormously between lenses, even those of similar focal lengths.

In calculating exposure, good depth of field and a higher shutter speed are traded off against each other, so any auto settings selected by the camera will always be a compromise. This is true of all exposure modes, but the high magnification ratios involved here make it a particular concern, especially when working outdoors with ambient light.

Normally, obtaining both good depth of field and a higher shutter speed means selecting a higher ISO, but Close-up mode chooses your ISO setting for you and cannot be overridden. Therefore, you have to rely on plenty of light, preferably diffuse light rather than strong, direct lighting, when using Close-up mode. You must also avoid any movement of either camera or subject. The greater the magnification, the more critical this becomes, so a tripod and remote release are invaluable tools.

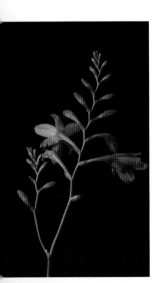

MONTBRETIA
To capture the elegant simplicity of this subject, I set it against a plain background and used diffused flash. To reduce the depth of field required, all the key elements were on a single plane.

Close-up mode

Quality setting	All settings are selectable using any one of RAW, sRAW 1, sRAW 2 or 6 levels of JPEG on their own, or in any combination of JPEG plus one of RAW, sRAW 1 or sRAW 2
Exposure settings	Evaluative metering using 35 different zones; shutter speed, aperture and ISO are chosen to suit the light levels and subject; Standard Picture Style; Auto White Balance; Auto Lighting Optimizer
Focus settings	Automatic AF point selection in One Shot focus mode
Frame advance	Single frame advance; 10 sec self-timer
Flash and AF-assist settings	Automatic fill-in flash; red-eye reduction can be selected via **MENU** ☐ **◯**; first-curtain sync; AF-assist beam
Notes	Autofocus will pick out the closest subject so, if you are photographing flowers, for example, make sure that there are no wisps of grass between the lens and the subject

Using Close-up mode

1) Turn the Mode Dial to 🌷.

2) Aim the camera at your subject.

3) If you are using a tripod, set the frame-advance mode to self-timer or use a remote release to minimize camera shake.

4) Lightly press the shutter button to achieve focus. If the lens cannot achieve focus, change the camera position (or adjust the AF/MF switch on the lens to MF and focus manually.)

5) In low light levels the built-in flash will pop up and the flash symbol ⚡ will

appear in the viewfinder. The built-in flash may also operate in bright conditions to reduce shadows.

6) Depress the shutter. When the red light by the ◌ Quick Control Dial is no longer lit or flashing, review the image, zooming in using the ⊟/⊕ Enlarge button to check for sharpness.

> **Tip**
> Live View mode (see pages 109–14) is ideal for close-up work but is only available in Creative Zone modes.

53

Sports mode

For sports, read any situation in which your subject matter is on the move: that might include festivals, children at play, your pet (unless it's a tortoise or goldfish!), school events and a host of other activities.

Like the other Basic Zone modes, Sports mode makes use of evaluative metering to select the exposure. The emphasis will be on a higher shutter speed, so unless it's very bright, you are likely to be working with a wider aperture and consequent loss of depth of field. In order to keep the moving subject in focus, the camera uses AI Servo to track your subject, provided you first focus using the centre AF point then keep the subject covered by the AF points as a whole, all the time keeping the shutter release partially depressed.

When a sequence of two or more shots is taken, this focus mode also attempts to predict (up to 26ft/8m) where the subject will be for the second or subsequent shot – a factor that is continually reassessed while focus-tracking takes place. This is known as Predictive Autofocus. Frame advance is set to continuous (high) at 6.3 fps so you are far less likely to miss that critical moment.

It is also helpful if you can predict the action too, and choose a suitable vantage point. The best sports photographers are invariably those who know in advance exactly where they will need to be positioned to obtain the best images.

TIGHT FRAMING
A fast-moving subject is easier to capture when it is smaller in the frame. You can always crop the image later to produce a more dramatic result.

Sports mode

Quality setting	All settings are selectable using any one of RAW, sRAW 1, sRAW 2 or 6 levels of JPEG on their own, or in any combination of JPEG plus one of RAW, sRAW 1 or sRAW 2.
Exposure settings	Evaluative metering using 35 different zones; shutter speed, aperture and ISO are chosen to suit the light levels and subject; Standard Picture Style; Auto White Balance; Auto Lighting Optimizer
Focus settings	Automatic AF point selection in AI Servo focus mode
Frame advance	Continuous (high) 6.3 fps; 10 sec self-timer
Flash and AF-assist settings	Flash and AF-assist beam are switched off
Notes	In this mode the camera uses the extra-sensitive centre AF point first to acquire focus. If the subject moves away from the centre AF point, focus tracking will be acquired by one or more of the other AF points.

Using Sports mode

1) Turn the Mode Dial to ✎.

2) Aim the camera with the centre AF point on the subject.

3) Lightly press the shutter button to achieve focus while panning to keep the subject covered by the AF points in the viewfinder. (The AF points will not light up in red as you are accustomed to.) Maintain light pressure on the shutter release.

4) Fully depress the shutter button at the desired moment, continuing to pan the camera as you do so.

5) Keep the shutter button depressed to take multiple photographs, continuing to pan and ensuring that the subject is covered by at least one of the AF points.

6) The number in the bottom right of the viewfinder indicates the number of continuous shots (known as a 'burst') that is possible depending on the file-quality setting you have selected.

7) Depending on how many burst frames have been exposed, there may be a short delay while files are written before they can be reviewed.

Night Portrait mode

The purpose of this mode is to achieve a well-lit subject and a well-lit background using a combination of two techniques. The exposure for the background is achieved by the camera setting a narrow aperture to create good depth of field, with a consequent low shutter speed, so that it is properly exposed for the ambient light. However, the main subject is lit by flash, which fires at a far higher speed than the shutter and freezes the subject while also providing a different quality of light. The flash itself would not reach the background and ordinarily this area of the picture

would be very dark. Night Portrait mode is especially effective when used with a dramatic sky at sunset and when your subject is standing in front of an illuminated building.

Backgrounds illuminated by floodlights will appear very yellow/orange in comparison to the subject. This is because the two forms of lighting – floodlights and flash – have different colour temperatures and, unless you set a different colour temperature, the flash will dominate.

Common errors
If you're using a sunset as background, keep the sun itself out of the frame to avoid flare and excessive contrast.

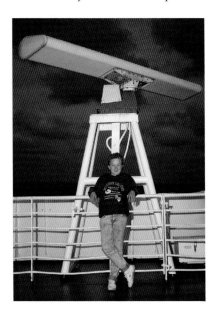

CRUISE SHIP, NORWEGIAN COAST
Position your subject about 15ft (4.5m) from the camera, or the built-in flash may not illuminate them properly. If they are still underexposed (too dark), ask them to step forward.

Night Portrait mode

Quality setting	All settings are selectable using any one of RAW, sRAW 1, sRAW 2 or 6 levels of JPEG on their own, or in any combination of JPEG plus one of RAW, sRAW 1 or sRAW 2.
Exposure settings	Evaluative metering using 35 different zones; aperture, shutter speed and ISO are selected to suit the subject; normal flash sync speed (1/250) is ignored in favour of the ambient lighting; Standard Picture Style; Auto White Balance; Auto Lighting Optimizer
Focus settings	Automatic AF point selection in One Shot focus mode
Frame advance	Single frame advance; 10 sec self-timer
Flash and AF-assist settings	Automatic flash; red-eye reduction can be selected via **MENU** □ **⊡**; first-curtain sync; AF-assist beam (effective up to 13ft/4m)
Notes	Shutter speeds are likely to be slow, but users of Image Stabilization lenses may still cope quite adequately without a tripod

Using Night Portrait mode

1) Turn the Mode Dial to 🌃 and turn on red-eye reduction via **MENU** □ **⊡**. For the best results, use a lens with three- or four-stop Image Stabilization, or a tripod and either the self-timer or remote release to minimize camera shake.

2) Aim the camera at your subject. Place the centre AF point over the main subject to aid focusing, as it is more sensitive.

3) Lightly press the shutter button to achieve focus. The ● focus confirmation symbol and automatically selected AF points will be illuminated in the viewfinder.

4) The built-in flash will pop up and the flash symbol ⚡ will show at the bottom of the viewfinder.

5) Retain light pressure on the shutter button to lock focus and recompose the picture before fully depressing the shutter button to take the photograph.

6) After a very brief delay, the captured image will display on the LCD monitor for 2 seconds unless the review function has been adjusted or switched off.

No Flash mode

This is essentially Full Auto mode with the flash function disabled, and is useful in situations where flash is not permitted or would be intrusive. With a fast maximum aperture lens such as the 50mm f/1.4, it is a very useful option for concerts, school plays and similar situations.

Reportage-style photography is making a comeback among camera enthusiasts (and noticeably so at weddings). If you are interested in street photography, No Flash

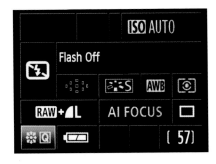

mode offers plenty of possibilities for shooting at night – especially if you want to experiment with monochrome images. Artificially lit scenes can take on some garish colours which sometimes detract from the subject matter, but black-and-white images allow you to focus much more on the content of the image. You will have to shoot in colour when using this mode, but can convert the image to monochrome in Digital Photo Professional (see page 229) as long as you have used one of the RAW or sRAW file-quality settings.

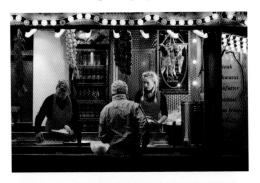

CANDID CAMERA
No Flash mode uses the Standard Picture Style and you cannot change it to the Monochrome Picture Style in this mode. However, if you choose one of the RAW or sRAW file-quality options, you can change the Picture Style to Monochrome later in Digital Photo Professional.

No Flash mode

Quality setting	All settings are selectable using any one of RAW, sRAW 1, sRAW 2 or 6 levels of JPEG on their own, or in any combination of JPEG plus one of RAW, sRAW 1 or sRAW 2.
Exposure settings	Evaluative metering using 35 different zones; shutter speed, aperture and ISO are chosen to suit the light levels and subject; Standard Picture Style; Auto White Balance; Auto Lighting Optimizer
Focus settings	Automatic AF point selection in AI Focus mode
Frame advance	Single frame advance; 10 sec self-timer
Flash and AF-assist settings	Flash and AF-assist beam are switched off
Notes	AI Focus mode uses One Shot mode for stationary subjects and AI Servo mode for moving subjects.

Using No Flash mode

1) Turn the Mode Dial to ⚡.

2) Aim the camera at your subject. Focusing may be easier by placing the centre AF point over the main subject. You can recompose the picture later.

3) Lightly press the shutter button to achieve focus. The ● focus confirmation symbol and automatically selected AF points will be illuminated in the viewfinder. The exposure settings (aperture and speed) will appear at the bottom of the viewfinder on the left.

4) In low light conditions it may be necessary to switch the lens to manual focusing, as the built-in flash will not function in this mode.

5) Retain light pressure on the shutter button to keep the focus locked and recompose the picture before depressing the button fully to take the photograph.

6) After a very brief delay, the captured image will display on the LCD monitor for 2 seconds, unless the review function has been adjusted or switched off.

Understanding exposure

Exposure is a product of two factors, time and aperture – the latter being the size of the opening through which light falls onto the digital camera's sensor. The time is the shutter speed, which is measured in fractions of a second: 1/60, 1/125, 1/250, 1/500, 1/1000 etc.

The aperture (opening) itself is measured in f-stops. The larger the number, the smaller the opening. Each stop represents a halving or doubling of the adjacent stop. Thus f/11 allows half as much light in as f/8 but twice as much as f/16. The sequence runs as follows: f/2.8, f/4, f/5.6, f/8, f/11, f/16, f/22. You use intermediate settings of either shutter speed or aperture to obtain a more accurate exposure, with the increment set to either 1/3 or 1/2-stop.

The photograph on this page was taken with a shutter speed of 1/250 sec and an aperture of f/8. From the table below you can see that any of the corresponding combinations of shutter speed and aperture would have resulted in the correct exposure.

Shutter speed/Aperture				
Shutter speed:				
1/60	1/125	1/250	1/500	1/1000
Aperture (f-stops):				
16	11	8	5.6	4

MAID OF THE LOCH
There is a third exposure factor – the ISO setting. ISO 200 is only half as sensitive to light as ISO 400 and therefore needs double the exposure. This photograph was taken at 1/250 at f/8 with a 100 ISO setting. Had that setting been 200 ISO, the necessary exposure would have been 1/500 at f/8 or 1/250 at f/11 (i.e. twice the shutter speed or one stop less exposure).

A light meter is simply a gadget that measures the quantity of light falling on it (known as an incident reading) or how much light is reflected by the subject (a reflected reading). Through-the-lens (TTL) metering makes use of reflected light readings, which means that they are more likely to be fooled by highly reflective surfaces in your shot.

How helpful a meter reading is depends upon how you, or your camera, interprets the result. Any light-meter reading – ranging from the 50D's 35-zone full-frame evaluative system to that of a simple 1° spot meter – averages the readings it has taken and gives a recommended shutter speed and aperture (for a given ISO setting) that would give the correct exposure for an 18% grey card. The metering process works as follows:

1) The extent of the area to be metered is determined by the selected metering mode.

2) The camera's light meter 'sees' this scene in black and white and takes the meter reading.

3) The meter suggests an exposure which would give an overall tone of 18% grey.

4) The camera user adjusts the suggested reading to account for highlight and shadow preferences.

OLDE ENGLAND
Your camera's light meter works by 'seeing' the selected scene in black and white (left) and then calculating the correct exposure for an overall tone of 18% grey. The result is a range of accurately represented colours (right).

FUNCTIONS

The AE Lock (Auto Exposure Lock) function is used when there is a difference between the area of the image that is to be metered and the area used to achieve focus, or when multiple frames will be taken using the same exposure in varied lighting, such as when the subject is backlit.

1) Focus on the subject by partially depressing the shutter release button.

2) Press the ✱/☷• Q button (☼⁴). The ✱ icon is displayed in the viewfinder, indicating exposure lock. The setting will be overridden by pressing the ✱/☷• Q button again.

3) Recompose the picture and depress the shutter-release button. To take multiple shots at the locked exposure, continue to depress the ✱/☷• Q button.

There are two techniques which can be employed to make life a little more certain: the first is to set exposure bracketing using Shooting Menu 2. The second is to be aware of constantly changing ambient light and to adjust your camera settings while you are walking around – so that when an opportunity presents itself, the camera is already set up to achieve the correct exposure. The latter method works best of all in Manual Exposure mode.

Tips
In Partial Metering, Spot Metering and Centre-weighted Metering modes, AE Lock is applied at the centre AF point.

When the lens is switched to MF (manual focus), AE Lock is also applied to the centre AF point.

In Evaluative Metering mode, AE Lock depends upon the AF point selection settings: with automatic AF point selection, AE Lock is applied to the AF point(s) which achieved focus; with manual AF point selection, AE Lock is applied to the selected AF point.

Common errors

One of the most frequent causes of badly exposed images is the tendency to shoot first and ask questions later. Often, you have a lot more time to get the shot than you think – enough to consider which metering mode is most likely to give the best result.

Exposure compensation

In most instances the exposure suggested by the camera will be quite adequate provided there are no bright highlights and deep shadows which contain detail that you want to retain. In these cases you can use exposure compensation to shift the overall exposure and pull in additional detail. This make all the tones darker or lighter, depending on which option you choose.

If your have essential detail in both the bright highlights and the deep shadows, it may be beyond the capacity of the sensor to retain the necessary detail. In this case you may wish to consider an average exposure or bracketing and some work on the computer afterwards using HDR (High Dynamic Range) software.

Exposure compensation of up to +/-2 stops in ⅓- or ½-stop increments can be set in any of the 50D's Creative Zone modes, regardless of which metering mode has been selected. You can set the exposure compensation increment using Custom Function I-1 (see page 120).

Setting exposure compensation

1) Turn the Mode Dial to any Creative Zone setting except **M** (Manual).

2) Turn the power switch to ⏻.

3) Frame your shot and partially depress the shutter-release button to obtain an exposure reading. Consider the balance between highlight and shadow and assess the likely level of compensation needed.

4) Check the exposure level indicator 2..1..0..1..2 at the bottom of the viewfinder or in the LCD top panel to make sure that it is at the centre of the exposure scale.

5) To set the level of compensation, turn the ◯ Quick Control Dial while partially depressing the shutter-release button.

One direction will increase the exposure and the opposite direction will decrease it, one increment at a time. The exposure level indicator 2..1..0..1..2 will show the extent of the compensation.

6) Take the photograph and review the result. You may wish to increase or decrease the compensation and take further exposures.

7) To cancel the exposure compensation, repeat step 5 and return the indicator 2..1..0..1..2 to the centre point of the scale.

8) You can set the power switch to **ON** to disable the ◯ Quick Control Dial and thus prevent accidentally changing the level of exposure compensation.

Highlight Tone Priority expands the dynamic range of the highlights only (it should not be confused with exposure compensation, which adjusts all the tones in an image by the same degree). This ensures the retention of highlight detail without sacrificing existing shadow detail. A classic example of the type of image this might assist with would be a typical bride-and-groom shot with the bride in white and the groom in a dark suit. This mode is only available in the ISO 200–1600 range.

To select Highlight Tone Priority:

1) Press the **MENU** button and select 📷 Custom Functions menu.

2) Highlight the **C.Fn. II Image** option and press **SET**.

3) Rotate the ◯ Quick Control Dial to show **3 Highlight Tone Priority**.

4) Press **SET** to highlight the existing setting.

5) Rotate the ◯ Quick Control Dial to change to the alternative setting.

6) Press **SET** again to save the setting, then press **MENU** to exit.

WHTE-CHEEKED PINTAIL
It is the importance of the highlight area that matters, not necessarily how extensive it is. Here, the eye is drawn to the bird's head and neck, but the white area is also important due to the name of this attractive migrant species.

64

Selecting the AF point

Automatic AF point selection will take place in the Basic Zone and in **A-DEP** mode and this cannot be overridden. In the two Camera User modes **C1** and **C2**, whether or not AF point selection is automatic will depend upon the settings you have saved. In the remaining Creative Zone modes, it is possible to select any one of the nine AF points or automatic AF point selection using all nine AF points.

Custom Function III-3 allows three different methods for selecting the AF point while shooting: Normal (default), Multi-controller, or Quick Control Dial. Each method is examined in detail below.

Normal
Press the ⊞/⊕ button (☾⁶). The currently selected AF point or points will be displayed in the viewfinder and in the LCD screen's top panel. If all nine AF points are indicated, automatic AF point selection is the current setting. To select an AF point, either scroll through the choices by turning the ◯ Quick Control Dial or the ⌂> Main Dial. Alternatively, tilt the ✳ Multi-controller in the appropriate direction.

Multi-controller direct
With this method there is no need to press the ⊞/⊕ button first. Simply press the ✳ Multi-controller in the desired direction. The AF point selected will change according to the direction in which you tilt the ✳ Multi-controller. Pressing ⊞/⊕ at any time will select automatic AF point selection. Pressing ✳ Multi-controller at any time will revert back to single AF point selection.

Quick Control Dial direct
Again, there is no need to press the ⊞/⊕ button first. When you rotate the ◯ Quick Control Dial, the AF point selected will change as you scroll through the choices. All nine AF points shown together indicate automatic AF point selection.

Common errors
Take care not to confuse the Normal and Quick Control Dial direct methods. Rotating the Main Dial in Quick Control Dial direct mode will alter the exposure settings. Experiment with each method to find the one that feels most intuitive, then stick with it.

AF lock

Maintaining light pressure on the shutter-release button will lock focus so that you can recompose the image, safe in the knowledge that your main subject will be sharply focused. However, this is not the only mechanism for locking focus.

By using **Custom Function Menu IV-1** it is possible to select a number of different permutations for the shutter-release button in conjunction with the **AF•ON** button. For example, if you select option 3, the shutter-release button will operate only the metering, with the **AF•ON** button used to initiate autofocus and also to lock focus if you maintain pressure on the button.

AF-assist beam

In low light, when the built-in flash is deployed, it fires a brief burst of flashes to illuminate the subject to aid focusing prior to taking the picture. The maximum effective distance for this feature is about 13ft (4m) with the built-in flash. (This should not be confused with the maximum effective distance for flash illumination using the built-in flash, which can extend up to 137ft (42m) at f/3.5 with an ISO setting of 12800 (H2).) If an external Speedlite is attached to the camera, the Speedlite will perform the AF-assist beam task instead and will function over a greater distance.

In **Custom Function III-5** (see page 128) it is possible to enable or disable the AF-assist beam. These settings apply to both the built-in flash and to an external Speedlite. It is also possible to make this function work only with an attached Speedlite. However, if the Speedlite's own AF-assist beam custom function is disabled, it will override the camera and the Speedlite will not fire.

SMUGGLERS' WALL PAINTING
This painting was found in Snargate church on Romney Marsh, UK. The church was very dark inside and I didn't want to use flash. With such a low-contrast subject, the AF system couldn't acquire focus and I couldn't focus manually with any accuracy. Using a tripod and a long exposure, AF-assist beam was used to solve the problem.

Exposure modes – the Creative Zone

Canon's Creative Zone modes allow the photographer absolute control over every single function on the camera, creating a seemingly infinite range of permutations. Many users may even find that there are some possibilities they never quite get to explore. What really matters, though, is that you can set the camera up for almost any situation – from shooting on a tripod using Live View and a laptop in a studio to candid street photography in an exotic location. Somewhere between the two extremes, the majority of users will work within their comfort zones while gradually expanding their horizons and trying new techniques.

(P) Program AE mode

Program mode automatically sets the shutter speed and aperture. The combination can be adjusted, but only as a combination and not individually. You could change 1/250 at f/8, for example, to 1/1000 at f/4 or another combination giving the same effective exposure. This is called Program Shift. However, full control is available over AF mode, drive mode, built-in flash and other functions, so it is still a quite flexible mode and the next step up the learning curve from Full Auto mode.

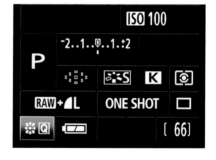

KEEP LEFT
Program mode is an ideal setting for walking around town, especially in conjunction with a wide-ranging zoom lens. Select a narrow aperture and a wide-angle setting for maximum depth of field, as in this image, or zoom into an interesting detail using a telephoto zoom setting, selecting a faster speed to combat possible camera shake by simply rotating the Main Dial.

Program AE mode

Quality settings	All settings are selectable using any one of RAW, sRAW 1, sRAW 2 or 6 levels of JPEG on their own, or in any combination of JPEG plus one of RAW, sRAW 1 or sRAW 2.
Exposure settings	Evaluative metering using 35 different zones; Partial metering; Centre-weighted metering; Spot metering; exposure compensation; auto-exposure bracketing; Auto Lighting Optimizer (JPEG only); Highlight Tone Priority; Long exposure noise reduction; High ISO noise reduction; ISO expansion
Focus settings	One Shot; AI Servo; AI Focus; automatic or manual AF point selection
Frame advance	Single frame; continuous (low); continuous (high); self-timer(10 or 2 sec)
Flash and AF-	Flash and fill-in flash; AF-assist beam; red-eye reduction; first-curtain sync; second-curtain sync; high-speed sync with selected Speedlites; flash exposure compensation; flash exposure lock; AF-assist beam (effective up to 13ft/4m); external flash function and Custom Function settings with compatible Speedlites
Notes	The least flexible of the Creative Zone modes

Using Program AE mode

1) Turn the Mode Dial to **P**.

2) Aim the camera at the subject and lightly press the shutter button to achieve focus. The focus confirmation symbol ● and selected AF points will be illuminated in the viewfinder.

3) The automatically selected shutter speed and aperture combination will be visible in the viewfinder. To change these settings using Program Shift, rotate the 🗲 Main Dial until the desired exposure combination shows in the viewfinder.

4) The built-in flash will not pop up automatically in Program mode. It can be raised manually if needed, and the flash symbol ⚡ will show in the viewfinder.

5) Retain light pressure on the shutter button to keep the focus locked and recompose the picture before depressing the button fully to take the photograph.

6) After a brief delay, the captured image will display on the LED monitor for 2 seconds, unless the review function has been adjusted or switched off.

68

(Tv) Shutter Priority AE mode

Shutter Priority mode gives the photographer the opportunity to decide on shutter speed as the single most important function. This may be in order to capture a fast-moving subject or to deliberately blur movement for pictorial effect. For the record, Tv stands for Time Value.

The key factor in determining a suitable shutter speed is not the absolute speed at which the subject is travelling. What is important is the speed at which the subject is moving across the frame, and its size in relation to the area of the frame.

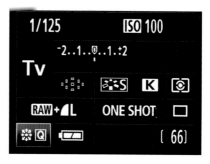

For example, a 1:1 magnification of a flower moving gently in the breeze is more likely to blur than an express train some distance away taken with a wide-angle lens.

A BRACE OF SPITFIRES
A shutter speed of 1/8000 second at f/3.5 has frozen these historic fighter planes mid-climb using a heavy 300mm f/2.8 lens handheld.

FUNCTIONS

Shutter priority mode

Quality settings	All settings are selectable using any one of RAW, sRAW 1, sRAW 2 or 6 levels of JPEG on their own, or in any combination of JPEG plus one of RAW, sRAW 1 or sRAW 2.
Exposure settings	Evaluative metering using 35 different zones; Partial metering; Centre-weighted metering; Spot metering; exposure compensation; auto-exposure bracketing; Auto Lighting Optimizer (JPEG only); Highlight Tone Priority; Long exposure noise reduction; High ISO noise reduction; ISO expansion; Safety Shift
Focus settings	One Shot; AI Servo; AI Focus; automatic or manual AF point selection
Frame advance	Single frame; continuous (low); continuous (high); self-timer (10 or 2 sec)
Flash and AF-	Flash and fill-in flash; AF-assist beam; red-eye reduction; first-curtain sync; second-curtain sync; high-speed sync with selected Speedlites; flash exposure compensation; flash exposure lock; AF-assist beam (effective up to 13ft/4m); external flash function and Custom Function settings with compatible Speedlites
Notes	User sets shutter speed and the camera automatically selects a suitable aperture. Useful in changing light conditions to avoid camera shake

Using Shutter Priority AE mode

1) Turn the Mode Dial to **Tv** and set the desired shutter speed.

2) Aim the camera at the subject and lightly press the shutter button to achieve focus. The focus confirmation symbol ● and selected AF points will be illuminated in the viewfinder.

3) The shutter speed and automatically selected aperture will be visible in the bottom left of the viewfinder.

4) The built-in flash will not pop up automatically in Tv mode. It can be raised manually if needed.

5) Retain light pressure on the shutter button to keep the focus locked and recompose the picture before depressing the button fully to take the photograph.

6) The captured image will display on the LCD monitor for 2 seconds, unless the review function has been adjusted.

70

(Av) Aperture Priority AE mode

This is the mode to use when you want to ensure that everything from the foreground to the background is in focus. Conversely, you can opt to use differential focus to make your subject stand out against an out-of-focus background. A wide aperture ensures narrower depth of field and a narrow aperture (larger number) will provide greater depth of field.

Many landscape photographers switch off autofocus on their lens when using this mode with a very narrow aperture. Instead, they focus manually on a point about a third of the way into the zone they want in focus. They may also use the depth-of-field scale on the lens, but these are less common on newer lenses.

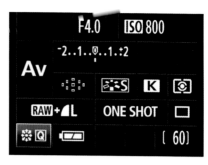

Common errors
If the shutter speed is flashing, the selected aperture is too low or too high for the current ISO rating and a correct exposure cannot be achieved unless it is adjusted. Nevertheless, the camera will still take the picture. Enable Safety Shift in **Custom Function I-6** and/or set Auto ISO to avoid this problem.

> **Tip**
> For very wide depth of field at slow ISO settings you will probably need a tripod. If you do not have a remote release, use the self-timer at its 10-second setting to minimize camera shake. The Mirror lock-up function in **Custom Function III-6** can also reduce camera vibration, though the viewfinder image will be lost until the shot has been taken.

DRYING NETS
Using a narrow aperture in Aperture Priority mode with a wide-angle lens, everything from a couple of feet away to infinity is in focus.

Aperture Priority mode

Quality settings	All settings are selectable using any one of RAW, sRAW 1, sRAW 2 or 6 levels of JPEG on their own, or in any combination of JPEG plus one of RAW, sRAW 1 or sRAW 2.
Exposure settings	Evaluative metering using 35 different zones; Partial metering; Centre-weighted metering; Spot metering; exposure compensation; auto-exposure bracketing; Auto Lighting Optimizer (JPEG only); Highlight Tone Priority; Long exposure noise reduction; High ISO noise reduction; ISO expansion; Safety Shift
Focus settings	One Shot; AI Servo; AI Focus; automatic or manual AF point selection
Frame advance	Single frame; continuous (low); continuous (high); self-timer (10 or 2 sec)
Flash and AF-assist settings	Flash and fill-in flash; AF-assist beam; red-eye reduction; first-curtain sync; second-curtain sync; high-speed sync with selected Speedlites; flash exposure compensation; flash exposure lock; AF-assist beam (effective up to 13ft/4m); external flash function and Custom Function settings with compatible Speedlites
Notes	User sets aperture and camera automatically selects a suitable shutter speed. Used to achieve maximum or deliberately reduced depth of field

Using Aperture Priority AE mode

1) Turn the Mode Dial to **Av** and set the desired aperture.

2) Aim the camera at the subject and lightly press the shutter button to achieve focus. The ● focus confirmation symbol and selected AF points will be illuminated in the viewfinder.

3) The aperture and automatically selected shutter speed will be visible in the bottom left of the viewfinder.

4) The built-in flash will not pop up automatically in Av mode. It can be raised manually if needed, when the flash symbol ⚡ will show bottom left in the viewfinder.

5) Retain light pressure on the shutter button to keep the focus locked and recompose the picture before depressing the button fully to take the photograph.

6) After a very brief delay, the captured image will display on the LCD monitor.

(M) Manual Exposure mode

This mode provides ultimate control over exposure as the shutter speed and aperture are set independently – the camera is not involved with choosing one to fit the other. This is particularly useful in awkward lighting situations; at times when the camera's light meter may be fooled by the luminosity or reflectivity of the subject matter; and when the desired effect is other than an averagely toned scene.

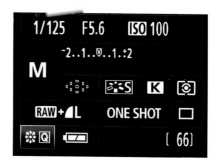

There are occasions when a particularly bright high-key image is required – for example, a soft-focus portrait of a bride in her wedding dress. Sometimes what might normally be deemed an underexposed result is needed, typically reportage images (*National Geographic* magazine, for example, nearly always uses 'heavy' images).

Another factor to bear in mind with the EOS 50D is that it offers a monochrome option, including the simulated use of black-and-white filters. Traditionally, metering for slide film has always been based on the highlights, while metering for black-and-white photography was based on the shadows. With the EOS 50D in Manual mode you can adopt different mid-tones to suit different styles of photography. You also have the benefits of the Highlight Tone Priority feature and Picture Styles to fine-tune your way of working.

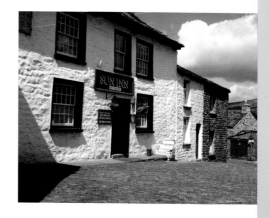

THE SUN INN, DENT, UK
Aptly named on a glorious day, the exposure for this shot was ⅓-stop less than that suggested by the meter in Evaluative metering mode.

Manual Exposure mode

Quality settings	All settings are selectable using any one of RAW, sRAW 1, sRAW 2 or 6 levels of JPEG on their own, or in any combination of JPEG plus one of RAW, sRAW 1 or sRAW 2.)
Exposure settings	Evaluative metering using 35 different zones; Partial metering; Centre-weighted metering; Spot metering; auto-exposure bracketing; Auto Lighting Optimizer (JPEG only); Highlight Tone P'riority; Long exposure noise reduction; High ISO noise reduction; ISO expansion
Focus settings	One Shot; AI Servo; AI Focus; automatic or manual AF point selection
Frame advance	Single frame; continuous (low); continuous (high); self-timer (10 or 2 sec)
Flash and AF-assist settings	Flash and fill-in flash; AF-assist beam; red-eye reduction; first-curtain sync; second-curtain sync; high-speed sync with selected Speedlites; flash exposure compensation; flash exposure lock; AF-assist beam (effective up to 13ft/4m); external flash function and Custom Function settings with compatible Speedlites
Notes	The user sets both the aperture and the shutter speed independently of one another. Used for ultimate control of all the camera's functions but requires the greatest understanding of photographic principles

Using Manual Exposure mode

1) Ensure that the camera power switch is set to ⌐. Turn the Mode Dial to **M** and set the desired metering mode.

2) Aim the camera at the subject and lightly press the shutter button to achieve focus. The ● focus confirmation symbol and selected AF points will be illuminated.

3) Rotate the 🔆 Main Dial to adjust the shutter speed and the ◯ Quick Control Dial to adjust the aperture until

the exposure level mark is centred. If you are metering from a selected area, take the reading and adjust as necessary to centre the exposure level mark again.

4) The built-in flash will not pop up automatically in Manual mode. It can be raised manually if needed.

5) Retain light pressure on the shutter button to keep the focus locked and depress the button fully to take the shot.

74

(A-DEP) Automatic Depth of Field AE mode

Using the data provided by the AF points, this mode automatically selects an aperture and shutter speed that will maximize depth of field. It will give you as fast a shutter speed as possible within the constraints of its objective, i.e. it won't give you f/11 when f/5.6 will do.

So what are the advantages of A-DEP mode? First, it removes the need to think about selecting a suitable aperture for each image. Second, it is extremely useful in situations demanding a very narrow aperture which would render the viewfinder image very dark when previewing the depth of field. Its main disadvantage is the complete loss of control over aperture and shutter speed settings.

A-DEP mode may suggest an aperture wider than experience leads you to expect. If you are uncertain that the recommended aperture is sufficient, use Aperture priority or Manual and either the depth-of-field preview function or hyperfocal focusing technique (see page 138).

(see page 138)

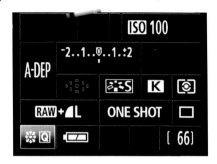

FUNCTIONS

Tips
If the selected aperture produces a shutter speed that is too slow, increase the ISO setting.

If shooting in RAW, you can use exposure compensation to gain a couple of stops by shooting at the wrong exposure and rescuing the image on the computer later.

PRESTON DOCKLANDS, UK
The camera suggested 1/800 sec at f/5.6 for this shot. I felt that f/5.6 was too wide and I didn't need 1/800 sec as I was using a wide zoom setting on an IS lens, so I shot the image again in Aperture Priority mode at f/11.

Automatic Depth of Field AE mode

Quality settings	All settings are selectable using any one of RAW, sRAW 1, sRAW 2 or 6 levels of JPEG on their own, or in any combination of JPEG plus one of RAW, sRAW 1 or sRAW 2.
Exposure settings	Evaluative metering using 35 different zones; Partial metering; Centre-weighted metering; Spot metering; exposure compensation; auto-exposure bracketing; Auto Lighting Optimizer (JPEG only); Highlight Tone Priority; Long exposure noise reduction; High ISO noise reduction; ISO expansion; Safety Shift
Focus settings	One Shot; automatic AF point selection. If AI Focus or AI Servo are selected the camera defaults to One Shot mode
Frame advance	Single frame; continuous (low); continuous (high); self-timer (10 or 2 sec)
Flash and AF-assist settings	Flash and fill-in flash; AF-assist beam; red-eye reduction; first-curtain sync; second-curtain sync; high-speed sync with selected Speedlites; flash exposure compensation; flash exposure lock; AF-assist beam (effective up to 13ft/4m); external flash function and Custom Function settings with compatible Speedlites
Notes	Useful to ensure that key elements of the image are in focus but control of the aperture and shutter speed selection is lost. Effectively acts like Program mode but without the option of Program Shift

Using A-DEP mode

1) Turn the Mode Dial to **A-DEP** and select the metering mode. Exposure compensation can be achieved by rotating the ◌ Quick Control Dial, provided the camera is switched to ◢ rather than **ON**.

2) Lightly press the shutter button to achieve focus. The ● focus confirmation symbol and selected AF points will be illuminated in the viewfinder.

3) The built-in flash will not pop up automatically in A-DEP mode. It can be raised manually if needed.

4) Retain light pressure on the shutter button to keep the focus locked. Note that if you recompose the image at this point, you may lose focus on critical elements of the subject. Depress the shutter button fully to take the photograph.

Custom exposure modes

One very useful function offered by the 50D's Mode Dial is the ability to define a set of parameters and settings and save them as one of the two Camera User settings, **C1** and **C2**, that are found on the Mode Dial. These settings are not affected by switching to any other mode, or by changing the settings when in one of the other modes and then switching back to **C1** or **C2**.

To make use of this facility, think carefully about the situations in which you take photographs and identify the key factors that affect each one. Two typical examples might be: a) shooting RAW images of landscapes using a tripod and remote shutter release, often using graduated neutral density filters and a polarizing filter with narrow apertures for maximum depth of field at ISO 100 in Manual mode. Landscape Picture Style and the use of Mirror lock-up is the norm; and b) shooting in fast-changing reportage situations where the subject is more

important than absolute image quality and there's little time for post-processing. RAW + large/fine JPEG at ISO 400 in Shutter Priority mode are selected. Monochrome Picture Style is selected, as most of the images to be used are black-and-white JPEGs, but the simultaneous RAW file means that colour is still a post-processing option for selected images by changing the Picture Style in Digital Photo Professional later.

You may find it useful to create a group of settings suitable for studio or close-up work using Live View, a group for wedding photography incorporating Highlight Tone Priority, or a group for use with multiple wireless flash, and so on.

Registering Custom exposure settings

1) Select either **C1** or **C2** and make all the setting changes that are required.

2) Select Set-up menu 3, then **Camera user setting**. Press **SET**.

3) Select **Register** then either **C1** or **C2** and press **SET**.

4) Select **OK** and press **SET**.

Menu options

The 50D's menu screens are shown on the monitor on the back of the camera. There are two Shooting menus, two Playback menus, three Set-up menus, a Custom Functions menu and the customizable My Menu for easy access to your most frequently changed options.

Each menu category is represented by a symbol and is colour-coded to make identification easier. The currently selected item on any menu is highlighted in the same colour as the type of menu. For example, the Playback menu symbol is blue, so its menu items are highlighted in blue.

Selecting menu options

This general procedure applies to all the menus which follow.

1) Select ⏻ on the camera power switch.

2) Press the **MENU** button and use the ⚙ Main Dial to scroll through the menus until you reach the one desired.

3) To highlight a different item on the menu, rotate the ⊙ Quick Control Dial.

4) When an item is highlighted, select it by pressing the **SET** button.

5) Many menus and dialogue boxes only offer a simple choice of On/Off or Enable/Disable. Use the ⊙ Quick Control Dial or ⚙ Main Dial followed by **SET** to confirm. Secondary menus may require the use of additional buttons; these are usually indicated at the bottom of the screen.

6) When a setting has been changed, press **SET** to save the new setting.

7) To exit at any stage, press the **MENU** button to go back one level, and repeat if necessary.

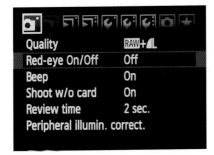

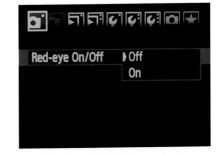

Menu summary

Menus or selected functions in grey are not accessible in Basic Zone modes.

◻ Shooting menu 1 (Red)	Options
Quality	RAW; sRAW 1; sRAW 2. JPEG: Large/fine; Large/normal; Medium/fine; Medium/normal; Small/fine; Small/normal. Any combination of RAW/sRAW and JPEG.
Red-eye On/Off	Off / On
Beep	On / Off
Shoot w/o card	On / Off
Review time	Off / 2 sec / 4 sec / 8 sec / Hold
Peripheral illumination correction	Enable / Disable

◻ Shooting menu 2 (Red)	Options
Exposure compensation/AEB	Compensation or bracketing in ⅓ or ½ stop increments, +/-2 stops
White balance	AWB / ☀ / 🏠 / ☁ / 🔆 / 🔅 / 💡 / 🔲 / K (2,500–10,000°K)
Custom WB	Manual setting of white balance
WB SHIFT/BKT	White-balance correction White-balance bracketing
Colour space	sRGB / Adobe RGB
Picture Style	Standard / Portrait / Landscape / Neutral / Faithful / Monochrome / User Def. 1,2,3
Dust Delete Data	Obtains data to be used to erase dust spots

▶ Playback menu 1 (Blue)	Options
Protect images	Prevent deletion of highlighted image(s)
Rotate	Rotate highlighted image(s)
Erase images	Erase highlighted image(s)
Print order	Specify images to be printed
Transfer order	Specify images to be transferred to computer

▶ Playback menu 2 (Blue)	Options
Highlight alert	Disable / Enable
AF point disp.	Disable / Enable
Histogram	Brightness / RGB
Auto play	Auto playback of image slide show
Slide show	Auto playback of all images on card / all images in folder / all images by date
Image jump with ⌂	Jump 1 / 10 / 100 images or by screen / date / folder

ᛉ Set-up menu 1 (Yellow)	Options
Auto power-off	1 min / 2 min / 4 min / 8 min / 15 min / 30 min / Off
Auto rotate	On ◻⬛ / On ⬛ / Off
Format	Initialize and erase data on memory card
File numbering	Continuous / Auto reset / Manual reset
Select folder	Choose folder on memory card

80

⌂Ť² Set-up menu 2 (Yellow) | Options

⌂Ť² Set-up menu 2 (Yellow)	Options
LCD brightness	Seven levels of brightness
Date / Time	Set date and time
Language	25 languages to select from
Video system	NTSC / PAL
Sensor cleaning	Auto cleaning / Clean now / Clean manually
Live View function settings	Live View shoot: Disable / Enable
	Exposure simulation: Disable / Enable Grid display: Off / On (2 styles) Silent shooting: Mode 1 / Mode 2 / Disable Metering timer: 4 sec / 16 sec / 30 sec / 1 min / 10 min / 30 min AF mode: Quick mode / Live mode (2 settings)

⌂Ť³ Set-up menu 3 (Yellow) | Options

⌂Ť³ Set-up menu 3 (Yellow)	Options
INFO button	Normal display / Camera settings / Shooting functions
Flash control	Flash firing / Built-in flash function settings / External flash function settings / External flash Custom Function settings / Clear external flash Custom Function settings
Camera user setting	Register current camera settings to C1 or C2
Clear all camera settings	Resets the camera to default settings / Delete copyright information
Firmware version	Updated firmware is downloaded from Canon website to memory card and installed in camera

Custom Functions menu (Orange) Options

C.Fn. I: Exposure C.Fn. II: Image C.Fn. III: Autofocus / Drive C.Fn. IV: Operation / other	Fully customize the camera settings within these groups
Clear all Custom Functions	Resets camera to default C.Fn. settings

✩ My Menu	Options
My Menu settings	Register frequently used menu items and Custom Functions

Tips

The camera is despatched from the factory with a set of default settings. These can be restored at any time by choosing ᵋⁱ Set-up Menu 3 and selecting **Clear all camera settings**.

You can resume shooting readiness even while a menu is displayed by simply pressing the shutter-release button halfway.

Frequently used menu items can be selected to appear in ✩ My Menu but this menu will not be displayed in Basic Zone modes.

Remember that ◘ⁱ Shooting Menu 2 and other menu options shown in grey in the above table cannot be used in Basic Zone modes.

My Menu

With My Menu, you can register up to six menus and Custom Functions that you use on a frequent basis.

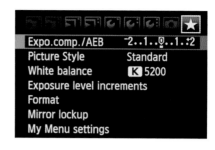

1) Press the **MENU** button and select ⭐ My Menu. Choose **My Menu settings** and press **SET**. Rotate the ◯ Quick Control Dial to select **Register**. Press **SET**.

2) Rotate the ◯ Quick Control Dial to select an item to include. Press **SET**, then **OK** when the dialogue box is displayed.

3) Repeat the process to include up to six menu items or Custom Functions and then press the **MENU** button to exit.

Shooting menu 1

There are two Shooting menus, which are both colour-coded red. Between them, these two menus control all the basic shooting-related functions, including the quality of the files recorded, auto exposure bracketing, white balance and colour options, and Picture Styles.

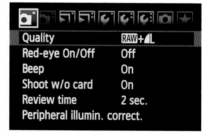

Setting file quality

There are 28 different settings for image quality, using various combinations of JPEG, RAW and sRAW files. The inclusion of two sRAW settings will be welcomed by many photographers, as they provide all the advantages of RAW quality and workflow but with much smaller file sizes than full RAW files.

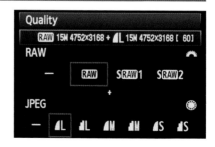

The EOS 50D's JPEG-only options include Large/fine, Large/normal, Medium/fine, Medium/normal, Small/fine and Small/ normal. Both RAW and sRAW can be chosen as stand-alone options. It is also possible to record images in both RAW and JPEG, or sRAW and JPEG, formats at the same time. The combination can make use of any of the six JPEG file sizes.

JPEG files take up much less space on your memory card, even at the Large/ fine setting. They also write faster, and the burst size is increased. JPEG files are also processed in-camera, so far less post-processing is required. The

disadvantage of JPEG is that you have far less control over the final image. It is also a compressed format – the smaller the file, the greater the compression and the greater the loss of picture quality.

RAW or sRAW files suit those who require the best-quality images and can use software to bring them to fruition. With the 50D's Picture Styles, however, some of the post-processing can be avoided, which makes RAW and sRAW more viable for those who are less skilled in post-processing. One final advantage of RAW or sRAW is that you can rescue images that are under- or over-exposed by at least a couple of stops.

File-quality settings

Quality		Pixels (approx)	File-size	Shots per 2Gb card (approx)	Max Burst (CF)	Max Burst (UDMA)
JPEG	▲L	15.1Mp	5Mb	370	60	90
	◢L		2.5Mb	740	150	740
	▲M	8Mp	3Mb	620	110	620
	◢M		1.6Mb	1190	390	1190
	▲S	3.7Mp	1.7Mb	1090	330	1090
	◢S		0.9Mb	2040	1050	2040
RAW	RAW	15.1Mp	20.2Mb	91	16	16
	sRAW1	7.1Mp	12.6Mb	140	16	16
	sRAW2	3.8Mp	9.2Mb	200	19	19
RAW +JPEG*	▲L + RAW	15.1Mp 15.1Mp	20.2Mb+ 5Mb	72	10	10
	▲L+ sRAW1	15.1Mp 7.1Mp	12.6Mb+ 5Mb	100	10	10
	▲L+ sRAW2	15.1Mp 3.8Mp	9.2Mb+ 5Mb	120	11	11

The above figures will vary depending on camera settings and brand of memory card.

*Both file types will be saved in the same folder with the same file name, but with different extensions (.JPG for the JPEG and .CR2 for the RAW file).

84

Red-eye On/Off

This feature can be used in any mode except ▲▲ Landscape, 🏃 Sports and ⚡ No Flash.

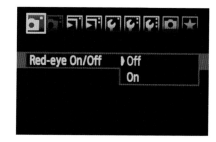

Beep

The beep is very useful to confirm focus, especially if you wear spectacles and have difficulty getting your eye right up to the viewfinder. However, it can also be an unwelcome distraction in situations like a church or museum, so it is possible to turn it off.

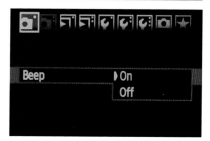

Shoot without card

With this function you can choose whether or not you want to allow the camera to function without a memory card installed. This facility might be used when capturing a large number of images direct to computer via USB or WFT.

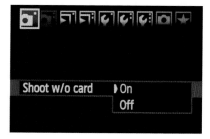

Review time

After shooting, the camera will display the image on the monitor for 2, 4 or 8 seconds, or for as long as you like if you have selected **Hold**. Alternatively, if want to conserve battery power and review images at a later time, you can turn the review function off.

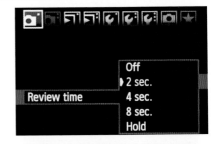

Peripheral illumination correction

In some circumstances, there may be slight loss of brightness in the corners of the image. This is more likely with EF-S lenses due to their smaller projected image circle. This menu option corrects this issue in-camera when shooting JPEG files; RAW shooters will need to make the correction later in Digital Photo Professional.

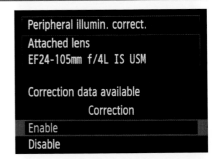

The EOS 50D comes programmed with correction data for 24 lenses, the list of which can be checked in EOS Utility (see page 230). This list also includes combinations of certain lenses and extenders. The correction data for lenses not already registered in the EOS 50D can be added to the camera.

Shooting menu 2

The EOS 50D's second Shooting menu gives you access to settings which control exposure, colour, contrast and sharpness. As with Shooting menu 1, selected items are highlighted in red. Exactly the same process is used to select a menu, highlight an item, and make further choices about your settings.

Expo.comp./AEB	⁻2..1..0..1.⁺2
White balance	K 5200
Custom WB	
WB SHIFT/BKT	0,0/±0
Color space	sRGB
Picture Style	Standard
Dust Delete Data	

Exposure compensation & Auto-exposure bracketing

The 50D's various metering modes cover most situations, but occasions will arise when you may wish to adjust exposure settings to compensate for unusual circumstances, such as backlighting or a highly reflective subject. This is the time to dial in some exposure compensation. The exposure scale in the settings screen will show either ½- or ⅓-stop increments according to the setting in C.Fn I-1.

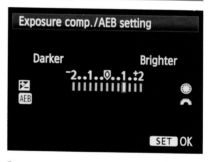

Exposure compensation of +1 stop.

Auto-exposure bracketing (AEB) is useful when you're not sure how the balance between highlights and shadows will work out. Three exposures are recorded, with one either side of the nominal setting, to a maximum of +/-2-stops. Auto-exposure bracketing can also be combined with Exposure compensation, as shown here.

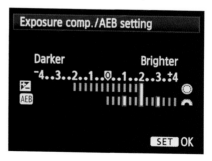

Exposure compensation of +2 stops with exposure bracketing of +/-1 stop.

Tips

Auto bracketing is not available in Basic Zone modes. Once selected in a Creative Zone mode, it will be retained when you change to any other Creative Zone mode (except the three Camera User settings). If **Bracketing auto cancel** is disabled in C.Fn I-4, the camera will retain the bracketing setting even when the camera is turned off.

The order in which the under-exposed, normal and over-exposed pictures are taken can be set to 0,-,+ (default) or -,0,+. This option is set using Custom Function I-5.

White balance

In order for other colours to be rendered accurately, white must be represented correctly. In most cases this means obtaining a pure white, without the colour cast that comes with different artificial light sources, and from natural lighting at different times of the day or in shade. These variations are measured according to what is known as colour temperature, which is measured in degrees Kelvin. The EOS 50D allows you to specify an exact colour temperature in the range 2500-10,000°K where this is known, or use the

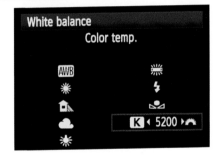

white-balance shortcuts programmed into the camera (see table below). A Custom white-balance setting can also be created.

AWB	Auto white balance: 3000–7000°K	☼	White fluorescent light: 4000°K
☀	Daylight: 5200°K	⚡	Flash: 6000°K
⌂	Shade: 7000°K	K	Colour temperature: 2500–10,000°K
☁	Cloudy, twilight, sunset: 6000°K	K	Custom: 2000–10,000°K
☀	Tungsten lighting: 3200°K		

Setting Custom White Balance

Using the same menu, it is possible to determine a Custom White Balance setting ◢ in the range 2000-10,000° K to suit a particular shooting situation.

1) Photograph a white object, ensuring that it fills the spot-metering circle. Any of the camera's white-balance settings can be used at this stage.

2) Using 📷ⁱ Shooting Menu 2, highlight **Custom White Balance** and press **SET**. A captured image will appear on the camera's monitor.

3) Turn either the ◯ Quick Control Dial or ⌒ Main Dial until the image you wish to use as a basis for your Custom WB setting appears, then press **SET**.

Expo.comp./AEB	¯2..1..0̲..1..+2
White balance	**K** 5200
Custom WB	
WB SHIFT/BKT	0,0/±0
Color space	sRGB
Picture Style	Standard
Dust Delete Data	

FUNCTIONS

4) You will be presented with a dialogue box reading 'Use WB data from this image for Custom WB'. Select **OK** and the data will be imported.

5) Exit the menu and press the 🔘•WB button. Rotate the ◯ Quick Control Dial to select ◢ Custom White Balance.

Common problems
If the exposure obtained in step 1 above is significantly underexposed or overexposed, a correct white balance may not be obtained.

If the image captured in step 1 is taken with the Picture Style set to Monochrome, it cannot be selected in step 3.

Tips
If you have registered a personal white-balance setting using the software provided with the camera, it will be replaced by any new Custom White Balance setting under ◢ Custom WB.

THE EXPANDED GUIDE

White-Balance Shift and Bracketing

These two functions are incorporated into the same menu screen, providing a simple graphic representation of a complex process. Adjusting the colour settings is not unlike using colour-correction filters, except that here, nine levels of correction are possible. Each increment is equivalent to a 5 mired shift. This facility can be applied to any white-balance setting including custom, °K and white-balance shortcut settings. It is only available in Creative Zone modes.

To set White-Balance Shift:

1) In ◻¡ Shooting Menu 2, highlight **WB SHIFT/BKT** and press **SET**.

2) Use the ✻ Multi-controller to move the white cursor from its central position to the new setting. The bias can be set towards Blue/Amber and/or Magenta/Green and the blue panel at the top right displays the new coordinates using the initial letter of the colour plus a number from 0–9.

3) Press **INFO** at any time to reset the bias to 0,0.

4) Press **SET** to finalize your setting.

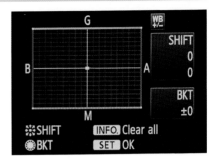

White-Balance Bracketing can be used in conjunction with White-Balance Shift to capture three versions of the same image, each with a different colour tone. The primary image will use the cursor location set in the previous section. Either side of this, two further images will be captured with a difference of up to three levels in single-level increments, each increment being 5 mireds. You can bracket with either a Blue/Amber bias or a Magenta/Green bias.

Tip
It is only necessary to press the shutter release once with White-Balance Bracketing selected in order to capture the three images. However, the total number of shots available on the CF card and the number of burst images available will be reduced by three.

To set White-Balance Bracketing:

1) Rotate the ◯ Quick Control Dial clockwise to set a Blue/Amber bias with one, two or three levels' difference. The increments will be shown in the blue panel (bottom right). Alternatively, rotate the ◯ Quick Control Dial anti-clockwise to set a Magenta/Green bias with one, two or three levels' difference.

2) Press **INFO** at any time to cancel bracketing (the cursor will be reset to 0,0).

3) When bracketing has been selected (without having pressed **SET**), it is still possible to use the ✷ Multi-controller to move the cursor around the screen to adjust the colour bias.

4) Press **SET** to finalize your settings and return to ◖ Shooting Menu 2.

Tip

White-Balance Bracketing can also be combined with Auto Exposure Bracketing, in which case pressing the shutter release three times will result in nine images being captured.

The bracketing sequence will be as follows: Standard white balance, Blue bias, Amber bias or Standard white balance, Magenta bias, Green bias.

Colour space

The term 'colour space' is used to describe the range of colours that can be reproduced within a given system. The Canon EOS 50D provides two such colour spaces: sRGB and Adobe RGB. The latter offers a more extensive range and is likely to be used by those for whom the final image is intended for conversion to the CMYK colour space for commercial printing in books, magazines or catalogues. Canon recommend sRGB for what they classify as 'normal use'.

Picture Style

In Basic Zone modes, Picture Styles are selected automatically. For example, in Portrait mode, Portrait Picture Style is adopted. It is in the Creative Zone, however, that the presets come into their own, because each style can be tweaked according to your personal preferences. They can be incorporated into the **C1** and **C2** Camera User modes, and the Picture Style menu can be accessed quickly and easily from ⚡ My Menu if so desired. In addition, three User Defined Picture Style settings can be created.

All the following options apply equally to JPEG and RAW files (including sharpness)

Picture Style	◐, ◑, ⚬, ◒			
⚡S Standard	3,	0,	0,	0
⚡P Portrait	2,	0,	0,	0
⚡L Landscape	4,	0,	0,	0
⚡N Neutral	0,	0,	0,	0
⚡F Faithful	0,	0,	0,	0
⚡M Monochrome	3,	0,	N,	N
⚡1 User Def. 1	Standard			
⚡2 User Def. 2	Standard			
⚡3 User Def. 3	Standard			
INFO. Detail set.	SET OK			

but RAW file users also have the option of resetting or changing the parameters afterwards on the computer.

Colour parameters

For each style there are four sets of parameters: ◐ Sharpness, ◑ Contrast, ⚬ Saturation and ◒ Colour Tone. With the exception of ◐ Sharpness, the settings for which range from 0 to +7, all the other settings range from -4 to +4.

Their effects are self-explanatory, apart from Colour Tone. With the Colour Tone parameter, a lower setting (-4, for example) produces a reddish skin tone, while a higher setting (such as +4) produces a yellower skin tone.

Tip
It is necessary to scroll down the camera menu to reveal the User Defined settings.

Monochrome parameters

In addition to ◐ Sharpness and ◑ Contrast, there are two monochrome-only settings: ⚘ Filter effect and ⊘ Toning effect. The symbols for these settings replace those for Saturation and Colour Tone as soon as Monochrome is selected.

To set a Picture Style (Method A)

1) Using 📷 Shooting Menu 2, rotate the ⊙ Quick Control Dial to highlight **Picture Style** and press **SET**.

2) Rotate the ⊙ Quick Control Dial to highlight the desired Picture Style.

3) To change the parameters of the highlighted Picture Style, press the **INFO** button to go to the **Detail set.** screen. (To accept the existing parameters, press **SET** or **MENU** to return to the Shooting Menu.)

4) Rotate the ⊙ Quick Control Dial to highlight the parameter you wish to change and press **SET**.

5) That parameter will now appear on a screen on its own. Rotate the ⊙ Quick Control Dial clockwise to increase the setting or anti-clockwise to decrease it. The white indicator will move along the scale accordingly, leaving a grey indicator showing the default setting.

6) Press **SET** to finalize the parameters. The **Default set.** screen appears. Press **MENU** once to return to the Picture Style screen, then press **SET** to finalize your choice of Picture Style and to return automatically to the Shooting Menu.

To set a Picture Style (Method B)

1) Press the ⁂ Picture Style selection button and rotate the ⊙ Quick Control Dial to highlight the desired Picture Style.

2) If you are happy with the existing parameters, press **SET**. The monitor will turn off or return to the Quick Display screen.

3) If you wish to change the parameters of the Picture Style, press the **INFO** button to change to the **Detail set.** screen.

4) Rotate the ⊙ Quick Control Dial to highlight the parameter you wish to change and press **SET**.

5) That parameter will now appear on a screen on its own. Rotate the ⊙ Quick Control Dial clockwise to increase the setting or anti-clockwise to decrease it. The white indicator will move along the scale accordingly, leaving a grey indicator showing the default setting.

6) Press **SET** again to finalize the Picture Style parameters. The **Default set.** screen appears. Press **MENU** once to return to the Picture Style screen, then press **SET** to finalize your choice of Picture Style and return automatically to the Shooting Menu.

Monochrome Picture Style settings

The procedure for setting or adjusting the parameters for Sharpness and Contrast are exactly as outlined on page 93. The procedure for setting Filter or Toning effects is the same up to the point where a single parameter is shown on screen.

Instead you are presented with a menu from which to choose. The Filter Effects menu offers a choice of yellow, orange, red or green filter effects or none at all. The Toning Effects menu offers a choice of sepia, blue, purple or green or none at all.

Monochrome Filter Effects

Yellow Blue sky will look less washed out and clouds will appear crisper.

Orange Blue sky will be darker and clouds more distinct. Good for stonework.

Red Blue sky will appear extremely dark, clouds very white, high contrast.

Green Good for lips and skin tones. Foliage will look crisper.

Registering User Defined Picture Styles

You can adjust the parameters of a Picture Style and register it as one of three User Defined styles, while keeping the default settings for the base style.

1) Press the ⚏ Picture Style selection button and rotate the ◯ Quick Control Dial to highlight User Defined 1/2/3, then press the **INFO** button to bring up the **Detail set.** screen.

2) Press **SET** and Picture Style will appear on its own with a scroll bar on the right. Use the ◯ Quick Control Dial to scroll through the base styles. (To exit without proceeding, press **MENU.**) Press **SET** to select your base Picture Style.

3) The **Detail set**. screen will appear with your desired base Picture Style indicated. Use the ◯ Quick Control Dial to highlight a parameter and press **SET**.

4) That parameter appears on a screen on its own. Rotate the ◯ Quick Control Dial clockwise to increase the setting or anti-clockwise to decrease it. The white indicator moves along the scale and a grey indicator shows the default setting.

5) Press **SET** to finalize the parameters. The **Detail set**. screen appears. Press **MENU** once to return to the Picture Style screen, then press **SET** to finalize your choice of Picture Style.

Under normal circumstances the 50D's Self-Cleaning Sensor Unit will eliminate most of the dust specks that show up on your images. When visible traces remain, however, you can append the Dust Delete Data to the images to erase the dust spots automatically at a later stage in the Digital Photo Professional software provided. Once obtained, the data is appended to all JPEG, RAW and sRAW images captured after this point, but has no significant impact on file size.

To obtain the Dust Delete Data:

1) Using a solid-white subject, set the lens focal length to 50mm or longer.

2) Set the lens to **MF** manual focus and rotate the focusing ring to the infinity setting.

3) In 📷 Shooting Menu 2, select **Dust Delete Data** and press **SET**.

> **Tip**
> Update the Dust Delete Data before an important shoot – especially if you will be working with narrow apertures, which show up dust spots more clearly.

4) Select **OK** and press **SET**.

5) After automatic sensor cleaning is completed, the following message will appear: 'Press the shutter button completely when ready for shooting'.

6) Photograph the solid-white subject at a distance of 8–12in (20–30cm). Ensure that the subject fills the viewfinder.

7) The resulting image will be captured automatically in **Av** Aperture Priority mode at an aperture of f/22. This image will not be saved, but the Dust Delete Data derived from it will be retained by the camera. A message screen appears that reads 'Data obtained'. Press **OK**.

8) If the data was not obtained, another message will advise you of this. Make sure you follow the preparatory steps carefully and try again.

FUNCTIONS

Playback menu 1

This is the first of two Playback menus, both identified by their blue highlighting. They cover the protection, deletion and rotation of selected images, together with your choice of images for the purpose of printing or transferring to computer.

Protect images

In order to avoid accidental deletion, you can protect selected images. These, once protected, will display the 🔒 key symbol.

1) Select ◢ on the camera power switch.

2) Press the **MENU** button and use the 🔆 Main Dial to scroll through the nine menus to ▶ Playback Menu 1.

3) Rotate the ⭕ Quick Control Dial to select **Protect images** and press **SET**.

4) Rotate either the ⭕ Quick Control Dial or 🔆 Main Dial to select the image to be protected and press **SET**. The 🔒 key icon appears above the protected image.

> **Note**
> To delete protected images, you must cancel the protection individually for each image.

5) To cancel protection for an image, highlight it and press **SET**. The 🔒 key icon will disappear.

6) To protect another image, repeat step 4.

7) To exit image protection, press the **MENU** button.

Warning!
Protected images will still be deleted when you format a memory card.

96

Rotate images

This facility enables you to rotate individual images, as opposed to the Auto Rotate function which will automatically rotate all portrait-format images to the correct orientation if selected.

1) Select ⏻ on the camera power switch.

2) Press the **MENU** button and then use the 🎛 Main Dial to scroll through the nine menus until you reach ▶ Playback Menu 1.

3) Rotate the ◯ Quick Control Dial to select **Rotate** and press **SET**.

Protect images
Rotate
Erase images
Print order
Transfer order

4) Rotate either the ◯ Quick Control Dial or the 🎛 Main Dial to select the image to be rotated, and press **SET**.

5) To rotate another image, repeat step 4.

6) To exit, press the **MENU** button.

Erase images

The Erase menu enables you to delete selected individual images, all images in a selected folder, or all images on the memory card – with the exception of any protected images in each case. There is a distinct advantage to erasing individual images via this menu as opposed to using the 🗑 button during review. This is that images are selected for deletion (marked with a tick) but not actually deleted until you finally press the 🗑 button to delete all selected images at once. Consequently, you can scroll backwards and forwards to compare similar images and uncheck an image if necessary.

🗑Erase images CF

Select and erase images
All images in folder
All images on card

To select and erase individual images:

1) Select ⏻ on the camera power switch.

2) Press **MENU** and use the 🎛 Main Dial to scroll through the menus until you reach ▶ Playback Menu 1.

3) Rotate the ⊙ Quick Control Dial to select **Erase images** and press **SET**.

4) Highlight **Select and erase images** and press **SET**.

5) Rotate the ⊙ Quick Control Dial or ⚙ Main Dial to select the image to be erased, and press **SET**. The ✓ check mark will appear above the image. If that image is protected, the word **Protected** will appear instead.

6) To cancel deletion, highlight the image and press **SET**. The ✓ icon will disappear.

7) To select another image, repeat Step 5. The total number of images currently ticked is indicated top left in the monitor.

8) To delete all images marked with ✓, press 🗑. A dialogue box will appear. Highlight **OK** and press **SET**. The selected images will be deleted and ▶ Playback Menu 1 will reappear on the monitor.

9) To exit at any stage, press the **MENU** button to go back one level.

> **Tip**
> Using the ✱/☷•⊖ and ⊡/⊕ buttons, you can toggle between a single image, four images or nine images displayed on the monitor.

To erase all images in a selected folder:

1) Follow steps 1–3 above. Highlight **All images in folder** and press **SET**.

2) Rotate the ⊙ Quick Control Dial to select **OK** and press **SET**.

3) Highlight the chosen folder and press **SET**, then **OK**.

4) All unprotected images will be erased from the selected folder and ▶ Playback Menu 1 will reappear on the monitor.

To erase all images:

1) Follow steps 1–3 above. Highlight **All images on card** and press **SET**.

2) Rotate the ⊙ Quick Control Dial to select **OK** and press **SET**.

3) All unprotected images will be erased and ▶ Playback Menu 1 will reappear on the monitor.

> **Tip**
> When a folder is selected for deletion, the first and last images in the folder are displayed as a reminder of the images it contains.

98

Print order

Using the Set up options in this menu, it is possible to specify the images to be printed, along with date and file-number information.

For a detailed guide to setting **Print order** options, see pages 239–40.

Transfer order

This menu works in much the same way as the **Print order** menu, but allows you to specify the images which are transferred to the computer.

For a detailed guide to setting **Transfer order** options under Playback Menu 1, see page 228.

Warning!
When transferring your images to the computer, do not switch off the camera or disconnect the USB cable while the blue lamp is blinking, as image data may be lost.

Playback menu 2

The second of the two Playback menus covers specific information relating to exposure and focus that can be included with the image being reviewed, together with the Slide show option.

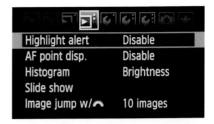

Highlight Alert

The Highlight Alert function is a valuable tool that warns you about overexposed highlight areas in an image you are about to capture.

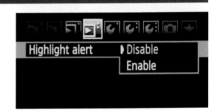

To enable the Highlight Alert function:

1) Select ⏻ on the power switch.

2) Press the **MENU** button and use the 🖒 Main Dial to scroll through the nine menus until you reach ▶' Playback Menu 2.

3) Rotate the ◯ Quick Control Dial to select **Highlight alert** and press **SET**.

4) Select **Enable** and press **SET**. ▶' Playback menu 2 will reappear. When you play an image back, any areas that contain highlight detail which the sensor cannot record accurately at the selected exposure will flash on and off.

5) To disable Highlight Alert, select **Disable** in step 4 and press **SET**.

AF point display

This function enables the superimposed display of AF points on the image being reviewed. If only one AF point was selected, this is all that will be displayed. If automatic AF point selection was in operation, all the focus points which were engaged when the image was captured will be displayed. The latter is a particularly useful aid when shooting in **A-DEP** mode. Selection is by the same process as described above for enabling Highlight Alert.

100

CANON EOS 50D

Histogram

When you're reviewing an image, pressing the **INFO** button brings up alternative screens that show useful shooting information, including a histogram. This menu function allows you to choose between an overall Brightness histogram or an RGB histogram, which shows the relative brightness of the Red, Blue and Green colour channels. The histogram is enabled in the same way as the Highlight Alert option (opposite page).

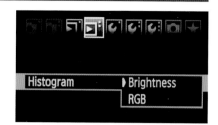

Using the Brightness histogram

The Brightness histogram is a graph that shows the overall exposure level, the distribution of brightness and the tonal gradation. It enables you to assess the exposure as a whole and also to judge the richness of the overall tonal range. With the ability to interpret these histograms comes the skill needed to fine-tune the exposure that is required.

The horizontal axis on the histogram shows the overall brightness level of the image. If the majority of the peaks appear on the left of the histogram, it indicates that the image may be too dark. Conversely, if the peaks are largely on the right, the image may be too bright. Why 'may be' as opposed to 'will be'? The reason I have qualified the wording is that

the answer all depends on the result you are seeking. You might actually want a very 'heavy' result, or perhaps a high-key, soft-focus image which is bright and ethereal in quality.

The vertical axis shows many pixels there are for each level of brightness. Too many pixels on the far left suggests that shadow detail will be lost. Too many on the right suggests that highlight detail will be lost. If you have enabled Highlight Alert the latter areas will quickly become apparent.

In particularly contrasty situations you may be in danger of losing both shadow and highlight detail from the image, in which case you will have to judge which to sacrifice in favour of the other.

Using the RGB histogram

The RGB histogram is a graph showing the distribution of brightness in terms of each of the primary colours – Red, Green and Blue. The horizontal axis shows each colour's brightness level (darker on the left and lighter on the right). The vertical axis shows how many pixels exist for each level of brightness in that particular colour. The greater the number of pixels on the left, the darker that colour will appear in the image. The greater the number of pixels on the right, the brighter that colour will be, possibly to the extent that the colour is too saturated and won't hold detail.

Note
When you're reviewing images, pressing the **INFO** button twice brings up a third screen showing both histograms.

Slide show

Slide show initiates continuous playback of your images, with or without the shooting information and histograms described above. You can press **INFO** during the slide show to change the display to include shooting information and histograms. By selecting **All images** and pressing **SET**, a scroll menu offers the choice of displaying all images on the card, images shot on a specific date, or images in a specific folder.

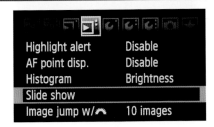

By selecting **Set up** you can display each image for 1, 2, 3, 4 or 5 seconds.

Image jump with Main Dial

When you need to locate a group of images among many on a memory card, this facility can speed up the process enormously, especially when combined with use of the 4- or 9-image display (see page 98).

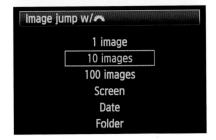

Set-up menu 1

This is the first of three menus that cover settings which, in most cases, you will determine once and need not return to often, except in special circumstances. Highlighting for all Set-up menus is in yellow.

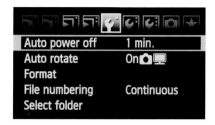

To set options in ⚙ Set-up menu 1:

1) Select ⤶ on the power switch.

2) Press the **MENU** button and then use the ⚙ Main Dial to scroll through the nine menus until you reach ⚙ Set-up Menu 1.

3) To highlight a different item on the menu, rotate the ◯ Quick Control Dial in either direction.

4) To select an item once it is highlighted, press the **SET** button.

5) When secondary menus or confirmation dialogue boxes are displayed, use the ◯ Quick Control Dial to highlight your selection and press the **SET** button to save.

6) To exit at any stage, press the **MENU** button to go back one level and repeat if necessary.

Auto power-off

With this setting, you can save battery power while keeping the camera ready for action. You can instruct the camera to turn itself off after a set interval ranging from 1–30 minutes of non-operation, but power will be restored immediately as soon as you depress the shutter-release button (or any other button). If you wish the camera to remain switched on at all times, you should select the **Off** option from the menu. The LCD monitor will always turn itself off after 30 minutes, whatever the setting.

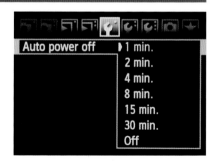

FUNCTIONS

File numbering

Each time you record an image, the camera allocates a file number to it and places it in a folder. The file numbers and folder names can be changed when they are on your computer, but not in-camera.

Images are assigned a sequential file number from 0001 to 9999 – for example, IMG_0001.JPG – and are saved in one folder. The prefix IMG_ is used regardless of file type but the suffix will be either .JPG or .CR2 (.CR2 is used for both RAW and sRAW files). When a folder is full and contains 9999 images, the camera automatically creates a new folder.

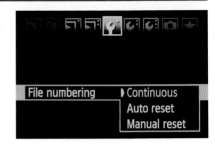

The first image in the new folder will revert to 0001, even if **Continuous** is selected in the File numbering menu. The camera can create up to 999 folders. A new folder is also created for each new shooting date.

Continuous

If you select this option, when you change a memory card, the file number of the first image recorded on the new card will continue from the last image on the card you removed. So, if the last shot taken on a card was IMG_0673.JPG, the first shot on the new card will be IMG_0674.JPG. As soon as the file number reaches 9999, a new folder will still be created and the file number will revert to 0001.

Auto reset

Each time you replace a memory card, the file numbering will start from 0001.

Common problems

The terminology here can be confusing. Continuous file numbering is sometimes assumed to be a mechanism for counting the number of shutter actuations. In fact, it relates only to the continuation of the file-numbering sequence when you replace the memory card.

Even if Auto reset is selected, if you insert a memory card that contains previously captured images, the camera is likely to continue the sequential file numbering from the last image shot on that card. To avoid this, format the card to delete all previous images – provided, of course, that you have already backed them up.

104

Manual reset

When you reset the file numbering manually, the camera creates a new folder immediately and starts the file numbering in that folder from 0001. This is convenient if you are shooting similar images in a variety of different locations or at different times and want to keep each set of images separate. This can be extremely helpful when renaming files or adding captions at a later date. After a manual reset, the file-numbering sequence will return to Continuous or Auto reset.

Auto rotate

If Auto rotate is enabled, all vertical images will be rotated automatically so that they are displayed with the correct orientation. This can be applied to either the camera monitor and computer , or just the computer , or it can be disabled altogether.

Format

If the memory card is new or has been in use in a different camera, the Format function will initialize the card ready for use in the current camera. Formatting a card removes all images and data stored on that card.

Select folder

A folder will be created automatically for downloaded images, but you can also create a new one or select one from a list of previously created folders. When it is full, or when file-numbering is manually reset, a new folder is created. The first and last images in the selected folder are displayed on the menu screen.

105

Set-up menu 2

As with Set-up menu 1, you will visit most of the settings in Set-up menu 2 when you first acquire the camera, but rarely afterwards – with the possible exceptions of the Live View functions (see page 109–114).

To set options in ᵀᵀ˙ Set-up menu 2:

1) Select ⏻ on the power switch.

2) Press the **MENU** button and use the 𝄃🗘 Main Dial to scroll through the nine menus until you reach ᵀᵀ˙ Set-up Menu 2.

3) To change the highlighting to a different item on the menu, rotate the ◯ Quick Control Dial.

4) To select an item once it is highlighted, press the **SET** button.

LCD brightness	☀ ├─┼─┼─┼─┤ ☀
Date/Time	27/11/'08 14:32
Language	English
Video system	PAL
Sensor cleaning	
Live View function settings	

5) When secondary menus or dialogue boxes are displayed, use the ◯ Quick Control Dial to highlight your selection and press the **SET** button to save the setting.

6) To exit at any stage, press the **MENU** button to go back one level and repeat if necessary.

LCD brightness

When this function is selected, three items are displayed on the monitor: the last image recorded, a grey scale on the right of the monitor and a slider control at the bottom. Rotate the ◯ Quick Control Dial in either direction to change the setting. When a change is made, the arrow on the slider will move along the scale and all the bands of the grey scale graphic will become darker or lighter, as will the displayed image.

To set or amend the Date/Time:

1) Rotate the ⊙ Quick Control Dial to scroll through the different settings.

2) To change a setting, highlight it and press **SET**.

3) Rotate the ⊙ Quick Control Dial again in either direction to change to the desired setting, then save it by pressing **SET**.

4) Repeat the process for each setting you wish to change.

5) To save all changes, highlight **OK** and press **SET**.

Common problems

Changes may appear to have been made on the selected menu screen, but make sure you highlight **OK** and press **SET** after making any changes. If you don't, the changes will not be registered, even if you pressed **SET** after each individual change.

Twenty-five different languages are programmed into the EOS 50D. If, just for fun, you select a language which does not use the roman alphabet, you may find it difficult to restore your own language. Whichever language is selected, the LCD top panel continues to use English.

You can connect the camera to a TV set using the cable provided, making it easy to share your images with family or friends. This topic is covered in detail in Chapter 8, Connection (see page 241). However, you must first use the Video System menu to establish the correct video format. The choice of settings is between NTSC (more common in North America) and PAL (more common in Europe).

FUNCTIONS

Dust specks on the sensor are one of digital photography's major irritations, and they are virtually impossible to avoid. They show up particularly in areas of plain colour, such as expanses of blue sky, and when using narrow apertures – assuming the image is magnified sufficiently for them to be noticeable. To minimize the problem, try to avoid changing lenses frequently if possible, especially in a dusty or windy environment, and don't use f/22 when f/8 will do!

While it may occasionally be necessary to have your camera's sensor professionally cleaned by an authorized Canon service centre, the 50D's Integrated Cleaning System is designed to shake off particles of dust during routine use.

Tips
Consecutive cleaning operations will not necessarily be more effective than a single cycle.

For best results, stand the camera on its base on a firm surface.

The **Clean manually** setting is for use by service technicians and is only displayed in the menu when a Creative Zone is selected.

If you enable **Auto Cleaning**, the Self Cleaning Sensor Unit will operate for approximately one second each time you set the power switch to **ON**, ⏻ or **OFF**. The LCD monitor displays a message indicating that this is taking place.

It is also possible to instruct the camera to operate the sensor cleaning operation immediately by selecting the **Clean now** option in the Sensor Cleaning menu.

To select the Clean now function:

1) Rotate the ◌ Quick Control Dial to select **Clean now** and press **SET**.

2) Select **OK** and press **SET**.

3) The LCD monitor displays the sensor-cleaning message. You hear the sound of the shutter but no picture is taken.

4) Remember that the manually selected sensor-cleaning operation takes slightly longer than the automatic cleaning operation (approximately 2.5 sec).

108

Live View allows you to view the subject on the camera's LCD monitor rather than through the viewfinder, but it will only function in Creative Zone modes. Live View on the EOS 50D is really only suitable for static subjects, ideally using a tripod. Live View shooting can be also carried out with the image displayed on the computer screen, with camera functions operated remotely (see the manual provided on CD-ROM with the camera for details). You can also display the Live View image on a TV with the cable provided, or with an HDMI cable (available separately).

FUNCTIONS

Tip
During Live View it is still possible to change camera settings while in any Creative Zone mode. With the **AF•DRIVE** and **ISO•⚡** buttons, the setting screen will still appear on the LCD monitor. The same is true for the ⊙•**WB** button and White-Balance settings, but Evaluative metering is automatically selected for all Live View modes. The **MENU** button functions normally during Live View, allowing access to all menus; however, if **Dust Delete Data**, **Sensor cleaning**, **Clear settings** or **Firmware Ver.** are selected, Live View will terminate.

Note
All Live View settings are accessed via **Live View function settings** in ⚙ Set-up menu 2.

Warning!
When using Live View shooting, a hard-disk type memory card is not recommended.

Warning!
High camera temperature may degrade image quality. Prolonged Live View shooting will increase the camera's internal temperature.

Live View: Simulated exposure

This function, when enabled, displays the image at a brightness level that simulates the outcome of the current exposure settings. This is a 'live' setting and will change as you adjust the exposure settings. When disabled, a standard brightness setting is adopted, regardless of how inappropriate the exposure settings may be.

Live View: Grid display

The grid display can be turned off (default) or can use the **Grid 1** overlay which divides each side of the frame into thirds. **Grid 2** divides the longer side of the frame by six and the shorter side by four. Neither grid is displayed when the captured image is played back.

Live View: Silent shooting

The default setting is **Mode 1**, which is quieter than normal shooting and permits continuous shooting to be selected, though **High-speed continuous shooting** will be slightly slower than its normal maximum, providing up to 5.8 fps. No image will be displayed on the monitor during continuous shooting. If continuous shooting is selected, all images will be recorded using the same exposure as the first shot in the sequence.

With **Mode 2** selected, only one frame can be exposed at a time, regardless of whether continuous shooting is selected or not. Having fully depressed the shutter release to take the photo, maintain full pressure on the shutter release to suspend all other camera activity. When you release pressure sufficiently for the shutter release to return to its halfway position, camera activity will resume and the sound of the reflex mirror will be heard. This allows you to take a single picture with the minimum

of intrusion, before moving to a less intrusive position to allow the reflex mirror to return to its previous position.

When **Disable** is selected, Live View works normally and sounds as if two shots are being taken, though it is in fact only one.

Warning!
If you use any extension tube(s) or vertical shift on a TS-E lens in Live View, you should disable **Silent shooting** as exposure is likely to be inaccurate.

110

Live View: Metering timer

This function determines how long the current AE lock setting will be retained in the camera's memory. The options range from 4 seconds to 30 minutes.

Tip

The **Auto power-off** setting in 🏠 Set-up Menu 1 will apply when Live View is in operation. However, if the **Auto power-off** setting is **Off**, the Live View facility will switch itself off, though the camera will remain switched on. This is to prevent heat build-up affecting the sensor during Live View operation.

Live View: AF modes

Three AF modes are provided in Live View: Quick mode, Live mode and Live ⓛ Face Detection mode. Although AF is functional, Canon still advise manual focusing using a magnified image display for absolute accuracy.

Tips

With a Live View image displayed, you can press the **AF•DRIVE** button and select the AF mode using the ⛭ Main Dial.

The Remote Switch RS-80N3 and Timer Remote Controller TC-80N3 (both sold separately) will not activate AF during Live View but can be used to release the shutter.

Quick mode

The AF system will focus in One Shot mode, just as if you were shooting using the viewfinder in the normal way. The Live View image display is briefly interrupted during the AF operation. Live View's Quick mode makes use of the camera's normal AF points.

1) Select ⏻ on the camera power switch. Choose a Creative Zone shooting mode.

2) Select Ỷ Set-up menu 2 and highlight **Live View function settings**. Press **SET**.

3) Rotate the ◌ Quick Control Dial to highlight **Enable** and press **SET**.

4) Rotate the ◌ Quick Control Dial to highlight **AF mode** and press **SET**. Select **Quick mode** and press **SET** again.

5) Press the 🄯/ᗺᵥ button. The Live View image will be displayed. The tiny rectangle indicates the currently selected AF point and the larger white one shows the magnifying frame.

6) Press **AF•DRIVE** and use the ✺ Multi-controller to select the desired AF point.

7) Position the AF point over the subject and hold down the **AF•ON** button. The Live View image will turn off while the AF operation takes place. You will hear the reflex mirror but this is not the shutter being activated.

8) When focus is achieved, the beep will sound and the Live View image will be displayed on the monitor again (with the active AF point shown in red, provided pressure is retained on the **AF•ON** button).

9) Fully depress the shutter release to take the picture.

Live mode

This mode may be a little slower than Quick mode but it has the distinct advantage of allowing the focusing frame to be moved anywhere in the image, except right at the edge of the frame.

1) Select ⏻ on the camera power switch. Choose a Creative Zone shooting mode.

2) Select Ỷ Set-up menu 2 and highlight **Live View function settings**. Press **SET**.

3) Rotate the ◌ Quick Control Dial to highlight **Enable** and press **SET**.

4) Rotate the ◌ Quick Control Dial to highlight **AF mode** and press **SET**. Then select **Live mode** and press **SET** again.

5) Press the 🄯/ᗺᵥ button. The Live View image will be displayed. A single white rectangle indicates the AF point/focusing frame. (This is a much larger rectangle than is used for the AF point in Quick Mode. It is also portrait-orientated to distinguish it from the magnifying frame in Quick Mode.)

112

6) To move the AF point, use the ✳ Multi-controller. Pressing it in will return the AF point to the centre of the frame.

7) Position the AF point over the subject and hold down the **AF•ON** button. When focus is achieved, the beep will sound and the AF point will turn green. If AF proves impossible, the AF point will turn red.

8) Fully depress the shutter release to take the picture.

Live ☺ Face Detection mode
This is the same as Live mode except that the camera is programmed to recognize the human face and to focus on this instead of the nearest part of the subject.

1) Select ⌡ on the camera power switch. Choose a Creative Zone shooting mode.

2) Select ⌕ Set-up menu 2 and highlight **Live View function settings**. Press **SET**.

3) Rotate the ◯ Quick Control Dial to highlight **Enable** and press **SET**.

4) Rotate the ◯ Quick Control Dial to highlight **AF mode** and press **SET**. Then select **Live ☺ mode** and press **SET** again.

HALLOWEEN
Face Detection AF mode works by recognizing the shapes of faces and their pattern of contrast. It does not allow for good looks or otherwise!

5) Press the ☐/⎙⌁ button. The Live View image will be displayed without any AF point or magnifying frame.

6) Point the camera at the subject. When a single face is detected, the ⸢ ⸤ focusing frame will appear, centred on the subject's face. The appearance of the ⸢ ⸤ focusing frame does not indicate that focus is achieved. The size of the ⸢ ⸤ focusing frame will vary according to the area occupied by the subject.

7) If more than one face is detected, the ⸢ ⸤ focusing frame will be displayed instead. Use the ✳ Multi-controller to move the ⸢ ⸤ focusing frame over the face of the desired subject.

8) Hold down the **AF•ON** button.

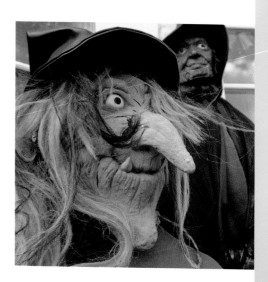

9) When focus is achieved, the beep will sound and the focusing frame will turn green. If AF proves impossible, it will turn red. If no face can be detected, the focusing frame will remain centred.

10) Fully depress the shutter release to take the picture.

Tips

When using Live ⊡ Face Detection mode, the EOS 50D may interpret another subject as a 'face' if certain characteristics are present.

Face detection may be adversely affected by the face being either very large or very small within the frame as a whole, by excessive or poor light levels, or by tilting the camera.

If the detected face is too near the edge of the image, the ⊏⊐ focusing frame will be 'greyed out' and pressing the **AF•ON** button to focus will activate another focusing frame in the centre of the image.

You can toggle between Live Mode and Live ⊡ modes by pressing the ❋ Multi-controller.

Pressing the ⊞/⊕ button in Live ⊡ mode will not magnify the image.

Manual focus in Live View

1) Select ⌐ on the camera power switch. Choose a Creative Zone shooting mode.

2) Select ῖῙˑ Set-up menu 2 and highlight **Live View function settings**. Press **SET**.

3) Rotate the ◯ Quick Control Dial to highlight **Enable** and press **SET**. It does not matter which setting is activated under **AF mode**.

4) Set the lens focus mode switch to **MF**.

5) Press the ◧/⎙~ button. The Live View image will be displayed with a white rectangular focusing frame.

6) Position the focusing frame over the key part of the subject using the ❋ Multi-controller. Manually focus the lens.

7) Use the ⊞/⊕ button to magnify the image and check focus.

8) Fully depress the shutter release to take the picture.

Set-up menu 3

This menu is used for registering the settings for the Camera User modes **C1** and **C2**. It is also used to clear all camera settings back to their default values, so care needs to be taken not to use this function accidentally. This menu also identifies the current firmware installed on the camera.

INFO button

The **INFO** button can be used to display a summary of information in addition to that provided by the LCD top panel. This menu determines which display will be shown when the **INFO** button is first pressed: Camera Settings or Shooting Functions. Whichever option is selected, you can toggle between the two screens and Off by pressing the **INFO** button a second or third time.

> **Tip**
> The Shooting Functions display in this menu is also referred to as the Quick Control Screen.

Flash control

This menu permits changes to a variety of settings for both the built-in flash and an external flash, provided the latter is a Canon EX Speedlite that permits the setting of functions on the camera.

Flash firing

The first option is simply to enable or disable flash firing. If disabled, then neither the built-in flash nor an external flash will fire, but they will continue to provide an AF-assist beam, provided this is not disabled in Custom Function III-5.

Built-in flash functions

On this screen you can adjust the settings for shutter synchronization, flash exposure compensation and flash metering mode within E-TTL II. The top line, shown in pale grey to indicate that it cannot be changed, indicates the Flash mode.

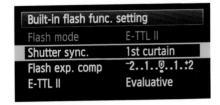

Synchronization

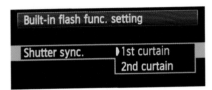

Shutter synchronization can be set to **1st curtain** or **2nd curtain** (see page 170). The default setting, considered to be 'normal' flash exposure, is 1st curtain. See also C.Fn.I-7 (page 123).

Flash exposure compensation

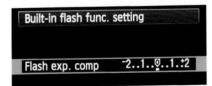

Flash exposure compensation works just like exposure compensation for the camera. When it is highlighted, rotate the ◯ Quick Control Dial to select the level of compensation and press **SET**. Exposure increments can be set in C.Fn.I-1.

E-TTL II metering mode

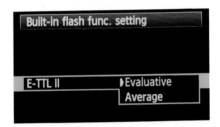

The E-TTL II metering mode can be set to either **Evaluative** or **Average**. Evaluative metering compares the data obtained by the metering burst with the exposure levels under ambient lighting to extrapolate the best flash exposure. Readings are taken from the entire frame and distance information, provided by compatible lenses, is also factored in. Average metering simply calculates the flash exposure based on readings across the frame, without taking into account the ambient lighting, and may require some flash exposure compensation. Note that built-in flash settings will be retained when you switch to an EX Speedlite, and built-in flash functions cannot be adjusted once an external flash is fitted.

External flash function settings

The External flash functions screen allows you to make changes to the settings for an external flash unit. Depending on the unit, these include Flash exposure bracketing, Flash exposure compensation and Flash metering mode. Functions displayed in pale grey have to be set on the flash itself.

To clear all Speedlite settings, press **INFO**. Any new changes to these settings will still need to be set on the Speedlite rather than the camera.

Warning!

Clearing the Speedlite settings using the INFO button will also return all built-in flash settings to their default values.

External flash Custom Functions & Clear external flash C.Functions

These functions operate in much the same way as the External flash function settings (above), except that you have direct access to the Speedlite's custom functions, as long as the model is compatible (models later than the 550EX).

Common problems

Lenses equipped to transmit distance data to the camera will provide the most accurate exposure. However, distance data does not account for using the Speedlite in bounce mode or when multiple Speedlites are used. With EX Speedlites that are set to TTL, or EZ/E/EG/ML/TL Speedlites which are set to TTL or A-TTL, the flash will fire at full output only.

These are the two custom modes – **C1** and **C2** – found on the Mode Dial. They can be set up to incorporate two groups of camera settings that you use frequently.

To register Camera user settings:

1) Turn the power switch to the ⌐ position and choose the desired settings.

2) Go to 𝝮ᵢ Set-up menu 3 and highlight **Camera User setting**. Press **SET**.

3) On the next menu, highlight **Register** and press **SET** again.

4) On the third menu, rotate the ◌ Quick Control Dial to select **C1** or **C2** and press **SET** again.

Tips
When the Mode Dial is set to **C1** or **C2**, the **Clear all camera settings** option in 𝝮ᵢ Set-up menu 3 and the **Clear all Custom Functions** option in ◙ Custom Functions Menu will not operate.

When settings have been saved as a group in **C1** or **C2**, you can still change the drive mode and menu settings manually when in one of these two modes.

5) When the confirmation box appears, select **OK** and press **SET** for the last time. Your settings will now be registered.

To clear Camera user settings:

1) Go to 𝝮ᵢ Set-up Menu 3 and highlight **Camera User setting**. Press **SET**.

2) Rotate the ◌ Quick Control Dial to select **Clear Settings** and press **SET**.

3) Select the group of settings you wish to clear (**C1** or **C2**). Press **SET**.

4) Select **OK** in the confirmation box and press **SET** for the last time. Your settings for the Camera User mode dial setting selected will now be deregistered. Follow the same procedure to cancel the settings for the other Camera User mode.

118

This function should not be confused with the **Clear settings** option encountered in **Camera user settings**. It is a separate function that refers to all camera settings that have been changed from the default factory settings.

INFO. button Normal disp.
Flash control
Camera user setting
Clear settings
Firmware Ver. 1.0.3

1) To clear all the camera settings, switch the camera on using the ⏻ setting.

2) Select ⚙️ Set-up menu 3. Highlight **Clear settings** and press **SET**.

3) When the confirmation dialogue box appears, select **OK** and press **SET**. All camera settings will now be restored to their default values.

Canon periodically update the camera's firmware; check their website to see when a new version is available and for full installation instructions. Alternatively, you can have the firmware installed for you at a Canon Service Centre.

INFO. button Normal disp.
Flash control
Camera user setting
Clear settings
Firmware Ver. 1.0.3

Tip
When you update your camera's firmware, check to see whether the software supplied with the camera also has updates to download. Software updates will usually be found in the same place as the firmware on Canon's website.

FUNCTIONS

Custom Functions menu

This menu alone provides 25 options for fine-tuning your camera usage and it is well worth familiarizing yourself with the choices available.

Custom Functions are divided into four groups primarily concerned with Exposure, Image, Autofocus and Drive, with a final group, called Operation/Others, for additional options that don't fall into any of the above categories. These groups are abbreviated to C.Fn I, C.Fn II, and so on, using Roman numerals. Choices within each group are referred to by

their position in the respective menu, eg. C.Fn IV-3. There are many different menus, but the procedure for accessing each menu item is the same, and is shown below.

1) Select ⏻ on the camera power switch.

2) Press the **MENU** button and use the 🎛 Main Dial to scroll through the menus until you reach the 📷 Custom Functions menu.

3) To change the highlighting to one of C.Fn I, C.Fn II, C.Fn III or C.Fn IV, rotate the ⭕ Quick Control Dial.

4) To select one of the Custom Functions categories once it is highlighted, press the **SET** button.

5) When a Custom Functions category has been selected, it does not display a

secondary menu of its own. Instead, the last-viewed sub-menu from within that category is displayed. Rotate the ⭕ Quick Control Dial to scroll through the sub-menus for that category. The number for each sub-menu is displayed in the top right corner of the screen.

6) Press **SET** to make this menu active and the current selection will be highlighted.

7) Rotate the ⭕ Quick Control Dial to highlight the desired function setting and press **SET**.

8) Press **MENU** to exit to the main Custom Functions menu.

C.Fn I-1 Exposure level increments

FUNCTIONS

This provides a choice between ⅓- or ½-stop increments for both normal and flash exposure settings

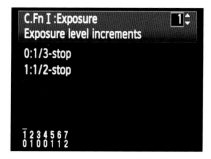

C.Fn I-2 ISO speed setting increments

This provides a choice between ⅓- or 1-stop increments for ISO speed settings. At the time of writing, no analysis was available comparing noise at different ISO settings on the EOS 50D. On previous models, however, it has been suggested that using the next highest 1-stop increment is favourable to using ⅓-stop increments; ISO 200 might be preferable to ISO 160, for example.

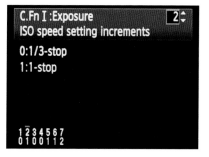

C.Fn I-3 ISO expansion

The normal ISO range is from 100–3200 (100–1600 in Auto ISO and 200–3200 in Highlight Tone Priority) but can be set to 6400 (H1) or 12,800 (H2) if you enable ISO expansion using this menu. Remember that a high ISO will significantly increase noise in your images. High ISO noise reduction can be adjusted or disabled in C.Fn II-2 (see page 124).

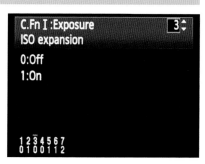

C.Fn I-4 Bracketing auto cancel

With this feature set to **On**, both Auto exposure bracketing and White-balance bracketing will be cancelled if the camera's power switch is turned to **OFF** (this does not apply to Auto power-off, which can be interpreted as a standby setting). Auto exposure bracketing will also be cancelled before a flash is fired.

Tip

In each Custom Function category's sub-menu, the current settings for all the sub-menus in that Custom Function category are displayed numerically at the bottom of the display. Default settings are represented by a zero.

With this function switched off, both AEB and WB-BKT settings will be retained even when the power switch is set to **OFF**, though AEB will still be cancelled before a flash is fired.

C.Fn I-5 Bracketing sequence

This function applies to both Auto exposure bracketing and White-balance bracketing. It offers a choice between having the bracketing sequence with the nominally correct exposure first, followed by the under- and over-exposed images, or having them in order of exposure value. With White-balance bracketing, **0** represents standard white balance, + more Amber/green and - more Blue/magenta.

122

C.Fn I-6 Safety shift

This function applies solely to Aperture Priority (Av) and Shutter Priority (Tv) modes and enables an automatic adjustment to the exposure if there is a last-moment shift in lighting conditions.

C.Fn I-7 Flash sync. speed in Av mode

This function applies solely to Aperture Priority (Av) mode and the use of flash. The flash sync speed can be set to a fixed 1/250 sec or one of two **Auto** settings, providing either a fully automated setting or a restricted automatic setting between 1/60 and 1/250 sec. Either of the **Auto** settings will set a suitable speed to match the ambient light, up to a maximum of 1/250 sec. You must also select the full **Auto** setting if you intend to use high-speed flash sync.

C.Fn II-1 Long exposure noise reduction

The default setting for this function is **OFF**. When changed to **Auto**, the camera will automatically apply noise reduction to exposures of 1 sec or longer provided it detects noise in the image just captured. When switched to **On**, this function will apply noise reduction to all exposures of 1 sec or longer.

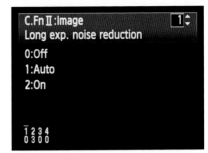

C.Fn II-2 High ISO speed noise reduction

This function will reduce noise at all ISO settings, not just high ISO speeds as it seems to suggest. The **Standard** default setting can be reduced, increased or disabled. The size of the maximum burst for continuous shooting will be significantly reduced if **Strong** is selected.

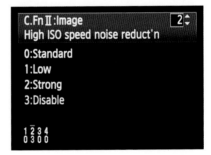

Tips

The noise-reduction process is applied after the image is captured and will effectively double the time it takes to record the image.

If set to **On** and shooting with Live View, the LCD monitor display will be disabled while the noise-reduction process is applied.

The size of the maximum burst for continuous shooting will be drastically reduced when noise reduction is applied.

124

C.Fn II-3 Highlight Tone Priority

This function expands the dynamic range of the highlights to ensure the retention of highlight detail without sacrificing existing shadow detail (though noise may increase

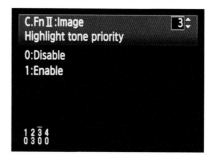

Tip
To show that this function has been enabled, the symbol **D+** (standing for Dynamic range) is displayed with the ISO setting in the LCD top panel, in the viewfinder and on the Quick Control Screen.

in the shadows). It only operates in the ISO 200–3200 range. Highlight Tone Priority can be combined with exposure compensation in any Creative Zone mode.

C.Fn II-4 Auto Lighting Optimizer

This new function is applied to all Basic Zone modes at its **Standard** setting, and is enabled by default in all Creative Zone

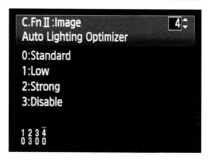

Tips
Use of Auto Lighting Optimizer may increase noise in certain shooting situations.

If shooting RAW or sRAW files, this function can be disabled or adjusted later in Digital Photo Professional. However, a much greater variation can be achieved using the Shadow/Highlights tool in Photoshop (CS3 and above).

modes except Manual, also at the Standard setting. Its role is to automatically adjust both brightness and contrast and it is useful when an image contains both dark shadows and highlights. Four settings are available, including **Disable**.

C.Fn III: Auto focus/Drive

C.Fn III-1 Lens drive when AF impossible

Although the new '+' type AF sensors – and the especially sensitive centre AF point on the EOS 50D – improve focus acquisition, there are still circumstances under which AF will struggle to achieve focus. In these conditions the lens will continue to 'hunt' for focus and it can be quicker to focus manually. (Many EF lenses provide full-time manual focus, which can be safely employed even when the lens is switched to **AF**.) This function allows the camera to disengage AF when the lens is unable to achieve focus using AF so that

it will not continue to 'hunt'. It is most useful with 'true' macro lenses and extreme telephotos.

C.Fn III-2 Lens AF stop button function

The AF stop button is only provided on super-telephoto IS lenses. This function allows you to designate different functions for the AF stop button. For a detailed explanation of any of these settings, refer to Canon's instruction manual.

CANON EOS 50D

The ability to change a specific AF point quickly is a feature which many find invaluable. There are three options available. The **Normal** setting makes use of the 🔲/🔍 AF point selection button which is pressed once to light up the current AF point in the viewfinder, then either the 🔘 Main Dial or the 🔘 Quick Control Dial is rotated to scroll through the different AF points and the Auto setting.

C.FnⅢ:Autofocus/Drive 3
AF point selection method
0:Normal
1:Multi-controller direct
2:Quick Control Dial direct

1234567
1000200

Alternatively, the 🔆 Multi-controller can be used on its own, without pressing the 🔲/🔍 AF point selection button first. However, this is a purely directional control (you press the Multi-controller in for the centre AF point) rather than a scrolling control. Consequently, you cannot select the Auto setting and must press the 🔲/🔍 AF point selection button as a shortcut to implement Auto AF point selection.

The third option is to use just the 🔘 Quick Control Dial without pressing the 🔲/🔍 AF point selection button first. With this selection there is an added feature: you can hold down the 🔲/🔍 AF point selection button while rotating the 🔘 Main Dial in order to set exposure compensation.

C.Fn III-4 Superimposed display

This function deals with the AF points in the viewfinder. The **Off** setting stops AF points from lighting up in red in the viewfinder when focusing, though they will continue to light up when being selected. The **Off** setting still permits the beep (unless disabled) and the ● focus confirmation lamp.

C.FnⅢ:Autofocus/Drive 4
Superimposed display
0:On
1:Off

1234567
1000200

FUNCTIONS

C.Fn III-5 AF-assist beam firing

If **Enable** is selected, either the built-in flash or an EX Speedlite can use the AF-assist beam to assist with focusing. If **Disable** is selected, neither will be able to use it. You can also enable only an external flash's AF-assist beam, provided it is not disabled on the Speedlite itself.

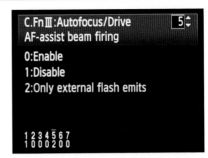

C.Fn III-6 Mirror lock-up

To prevent the slight vibration that can be caused by the reflex mirror operation, the mirror can be locked up as soon as your focusing, framing and exposure-setting procedures have been completed. When the Mirror lock-up function is enabled, fully depressing the shutter-release button once swings the mirror up and locks it in place. This operation sounds like shutter actuation but is not. The shutter-release button is then pressed a second time to take the exposure and release the mirror afterwards. The remote release RS-80N3 can be used to further reduce the risk of vibration.

128

C.Fn III-7 AF Microadjustment

Lenses contain many components which are engineered to microscopic tolerances, but minute differences may still occur. In addition, those lenses which make use of alternative lightweight materials may also react to higher temperatures, for instance. Some of these differences may cancel one another out; others may have a cumulative effect. This is only likely to affect those involved with extreme close-ups, studio work, or fine-art photography demanding the utmost precision.

It has always been possible to have a lens calibrated at a Canon Service Centre, but the EOS 50D now has AF Microadjustment settings in-camera (a facility first seen on the EOS 1D Mk III and 1Ds Mk III). These

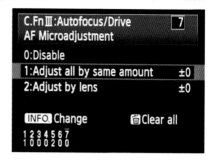

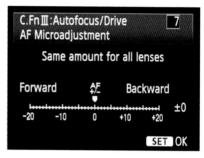

Notes
Any adjustments made are applied only within the camera. The lens is not affected in any way, other than responding to the AF commands issued by the camera.

Any adjustments made can later be reset to zero, or adjusted further by repeating the AF Microadjustment operation. If adjustments have been made for a particular lens, that lens must be fitted for later adjustments to be made.

adjustments effectively move the focal plane forwards or back to ensure absolute precision when focusing.

Adjustment may be necessary if the sharpest plane of focus in your images tends to be beyond, or in front of, the subject plane you believe should be sharpest. This may happen with all lenses, or it may suggest one particular lens that requires compensation. Settings can be applied individually to a maximum of 20 lenses. If a lens is combined with either the EF 1.4× or 2× extender, it will be treated as a separate camera/lens combination.

FUNCTIONS

To perform AF Microadjustment:

1) Review your suspect images at 100% (actual pixel level), looking for a tendency for the sharpest plane of focus to be either in front of or behind where it should be.

2) Set the camera on a tripod, aimed at a target subject at a distance typical of the way you normally use that specific lens. Camera-to-subject distance should be at least 50× focal length. Subject lighting should be even and bright enough for the AF system to acquire focus easily (use the centre AF point). Be sure the subject has some depth, i.e. discernible detail both in front of and behind the point you focus on.

3) If using a zoom lens, start your tests with the lens set at its longest focal length. Evaluate the results before testing the lens at wider settings.

4) Take test shots with the lens set at maximum aperture in Manual or Aperture Priority mode, with One Shot AF and a low ISO. Any Image Stabilizer on the lens should be switched off. It is recommended that you enable Mirror lock-up and use the self-timer or a remote release.

5) Select C.Fn III-7. Highlight either **Adjust all by same amount** or **Adjust by lens** and press **SET**. Press **INFO** to display the adjustment screen. Take a series of test shots at different AF Microadjustment settings (see step 6).

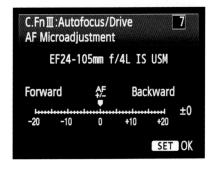

6) For each shot, move the pointer forward on the AF Microadjustment scale if you perceive back-focusing, or backward if your sharpest plane of focus is too close to the camera. Canon suggest starting with +/-20 and reducing the setting until you feel it is correct.

7) Observe your test images at 100% view on your computer monitor, not the camera's LCD screen. When you deem the adjustment to be correct, shoot a variety of subjects at that setting and assess the results. Adjust further if necessary.

Warning!

Carry out this adjustment only if it is absolutely necessary. If carried out improperly, it may prevent correct focusing from being achieved. AF Microadjustment cannot be performed during Live View shooting in Live and Live 'L' modes. If camera settings are cleared, the microadjustment setting will be retained, though the AF Microadjustment menu will be reset to the default 0:Disable setting.

130

Warning!

The first four functions in this category change the roles performed by different buttons or dials. This is a powerful opportunity to redesign the way in which you use the EOS 50D, but there are handling implications for each combination and any reprogramming should be thought through carefully.

C.Fn IV-1 Shutter button / AF-ON button

This menu offers several combinations for the shutter release button and **AF•ON** button, all involving the metering, auto exposure lock and autofocus functions. The default setting uses partial pressure on the shutter release to initiate both autofocus and metering, with the same function also being performed by the **AF•ON** button, but only in Creative Zone modes. The other options should be considered alongside other settings and your preferred ways of working.

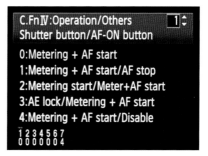

C.Fn IV:Operation/Others 1
Shutter button/AF-ON button

0:Metering + AF start
1:Metering + AF start/AF stop
2:Metering start/Meter+AF start
3:AE lock/Metering + AF start
4:Metering + AF start/Disable

1 2 3 4 5 6 7
0 0 0 0 0 0 4

C.Fn IV-2 AF-ON / AE lock button switch

This menu seems to suggest the disabling of these buttons, but, if **Enable** is selected, it actually swaps ('switches') their respective functions.

C.Fn IV:Operation/Others 2
AF-ON/AE lock button switch

0:Disable
1:Enable

1 2 3 4 5 6 7
0 0 0 0 0 0 4

FUNCTIONS

C.Fn IV-3 Assign SET button

The **SET** button can be programmed to perform various functions, any of which you may like to access quickly. It can be used to bring up either the Image quality selection screen or the Picture Style menu, to access the Menu system or to replay the last image captured.

C.Fn IV-4 Dial direction during Tv/Av

This menu appears to relate only to Tv and Av modes, but actually applies to Manual mode as well. In Tv and Av modes, the effect of rotating the Main Dial is reversed. In M mode, the effects of rotating each of the Main Dial and the Quick Control Dial are reversed. In all cases, with **Normal** selected, clockwise rotation decreases the exposure.

C.Fn IV-5 Focusing screen

If you change the type of focusing screen, you should identify the new one being used via this menu.

132

C.Fn IV-6 Add original decision data

When this function is enabled, data is added to each new image you capture to confirm its originality. For anyone to verify originality they must purchase the Original Data Security Kit OSK-E3.

C.Fn IV-7 Assign FUNC. Button

The **FUNC** button can be programmed to serve a variety of purposes. Used in conjunction with **My Menu** and the two **Camera User** modes, you can exercise a great deal of choice over the camera's handling characteristics.

Clear all Custom Functions

This function is different from **Clear settings** in Set-up menu 3 (see page 119) in that only the Custom Function settings will be returned to their default settings.

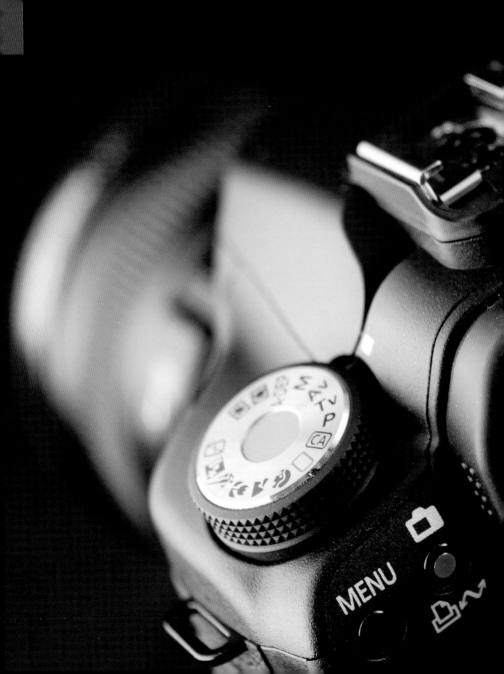

Chapter **3**

In the field

Every photograph is a snapshot in so far as it records a moment in time, usually measured in hundredths, if not thousandths, of a second. But not every photograph is worth a thousand words, as the old adage goes. So what makes the difference?

In this age of automation, almost anyone can take a reasonably exposed and in-focus photograph most of the time. But there are four other factors to consider: firstly, the intentions of the photographer, and finally, the impact the image has on the viewer. In between those two factors lie the content of the image and its treatment, both of which have to be considered in the light of what doesn't take place within the frame as much as what does.

The simplest approach for the aspiring photographer is to visualize the end result before even picking up the camera. Once the end product is envisaged, the other considerations can fall into place quite quickly when one has a degree of experience. But this is an equally valid approach for the novice: how can you judge your degree of success if you don't know what you were setting out to achieve?

What doesn't appear in the frame is an aspect of photography that professionals deal with instinctively, but beginners rarely consider. It's important to step back and look for distracting elements, whether it's a piece of litter in the foreground or someone with a bright red or yellow jacket in the background.

THE QUEEN
Photography can demand a much wider range of skills than just handling a camera. To capture this image and get it published, it was necessary to contact Buckingham Palace's Press Office, compete with other sharp-elbowed photojournalists and negotiate terms with a magazine editor. These have nothing to do with handling a camera, but everything to do with this being a successful photograph.

CANON EOS 50D

Depth of field

No lens has two clearly defined zones – in focus and out of focus. What it does have is a single plane of sharp focus with a gradual transition, both in front of and behind that plane, towards being out of focus. There comes a point in that transition where relative sharpness ceases to be acceptable. This point will occur twice: both in front of and behind the plane of sharp focus – unless the far point is deemed to be so far away that it reaches infinity. The term 'depth of field' is used to identify this zone within the image which is deemed to be in acceptable apparent focus.

Circle of confusion

The term 'acceptable apparent focus' sounds subjective, rather than absolute, and that is indeed true. While a lens on a test bench can have all sorts of tests performed to determine absolute measurements, depth of field is not one of them. Depth of field depends in particular on the intended magnification of the image and on the chosen size of the circle of confusion, the latter being the size of an area of the image at which a point ceases to be a point and becomes a small circle. For 35mm cameras and their full-frame digital counterparts, this is generally in the order of 0.001in (0.035mm) in size and assumes an average magnification of ×5, resulting in a 5 × 7in (13 × 18cm) print.

However, both professional and keen amateur photographers are likely to want enlargements greater than 5 × 7in. Many professionals choose to use an aperture at least one stop smaller than the depth-of-field scale on the lens indicates for the distances required (i.e. the closest and furthest points in focus).

Lens manufacturers always used to mark their lenses with a useful depth-of-field scale which gave an indication of this zone of acceptable sharpness. Now, the depth-of-field scale is often so cramped or lacking in aperture markings that it is almost meaningless (or is omitted entirely). The reason for this appears to be the reduced arc through which the lens travels in order to achieve focus, so that autofocus speeds can be faster and faster. Check out an old design

> **Tip**
> With any lens, narrow depth of field is achieved by using wide apertures, and wider depth of field by using narrower apertures.

like the EF 28mm f/2.8 to see just how much longer the travel is and therefore how much easier its depth-of-field scale is to use.

Serious landscape photographers will always see depth of field as a matter of prime importance, and it is they who plead for the retention of decent depth-of-field scales most of all, owing to their frequent use of the hyperfocal distance focusing technique (see below).

Using hyperfocal distance

The hyperfocal distance at a given aperture is the closest point of focus at which infinity falls within the depth of field. The hyperfocal distance varies according to aperture.

For landscape photographers, learning to use hyperfocal distance is one of the first skills to be acquired. This is the point on which you would focus the lens to ensure that everything from that point to infinity is in focus, along with a significant zone in front of it. You do not even need to look through the viewfinder to do it: simply switch the lens to manual focus and manually turn the focus ring so that the infinity mark is just inside the mark for the selected aperture on the depth-of-field scale. The equivalent mark at the other end of the scale shows the closest point that will be in focus.

Sensor confusion

There is a need to comment here on cameras which use a less than full-frame sensor – like the EOS 50D, which has a 1.6× crop factor. What this means in effect is that if you placed a 50D side by side with a full-frame camera and fitted them both with identical lenses, the field of view of the full-frame camera would be 1.6× greater than that of the 50D.

Few camera users realize that the image projected by the lens onto the film or sensor is circular rather than rectangular. A full-frame sensor (left on the first illustration opposite) is large enough to accommodate the maximum amount of the projected image circle. However, the smaller

COASTAL ARCHITECTURE
Scenes like this Mediterranean coastline demand a sharp foreground as well as main subject, so mastery of depth of field is essential. Everything from 3ft (0.9m) to infinity is in focus in this handheld shot using a 24mm zoom setting.

138

APS-C sensor (centre) covers a smaller proportion of the image circle projected by a lens designed for 35mm or a full-frame sensor. This is very useful in terms of quality as it crops away the parts of the image circle where deterioration of the image is most likely. Finally, an EF-S lens, designed solely for use with an APS-C sensor, has a smaller image circle, once again maximizing the sensor area (right).

In the second illustration below, the black triangles represent a main subject within the image as a whole, assuming identical camera-to-subject distance and the same focal-length lens. Note that the main subject as projected onto the sensor is identical in terms of absolute size in both cases, but the smaller sensor has cropped away a lot of the area around the main subject.

There is a great deal of confusion about the implications of this as regards lenses. This is largely because people insist on making comparisons such as saying that a 50mm lens on a camera equipped with the smaller APS-C sensor is equivalent to an 80mm lens (i.e. 50mm × 1.6) with a full-frame sensor. Not true. A 50mm lens behaves like a 50mm lens no matter what camera it is on, and the size of the projected image will always be the same, assuming identical camera-to-subject distance. The only thing that changes is the field of view.

In summary, assuming that the four key factors of focal length, circle of confusion size, aperture, and camera-to-subject distance are identical, there is no difference in depth of field between full-frame and less than full-frame sensor cameras. Any claim to the contrary is not comparing like with like. It is no use comparing identical camera views because one of the determining factors must be changed in order to achieve the same view.

Capturing action

Few techniques test your reflexes, and your understanding of basic photographic principles, more than capturing moving subjects, especially when high speeds are involved. You will also need to develop the ability to predict the best vantage point to capture the action.

To freeze or not to freeze

In order to capture a pin-sharp image of a fast-moving subject, three factors must be considered: a fast shutter speed, a firmly held or supported camera position, and an understanding of the nature of what I call 'apparent speed'. Remember that completely freezing the subject isn't always the best approach, because a degree of blur often helps to increase the impression of speed.

With a top speed of 1/8000 sec, the EOS 50D can easily freeze the action, but you may need to adopt a higher ISO setting in low light. Camera support is a matter of personal choice, but the single most useful tool for action shots is the monopod, which provides support while allowing mobility.

Now to 'apparent speed'. Ignore the actual speed of travel: what matters is the speed of movement across the frame. A moving subject that passes at right angles to the camera position has the highest apparent speed. A subject that is approaching head-on seems to move much more slowly. Very often the best compromise is a vantage point which has the subject moving towards you at an angle of around 45 degrees. Compared with a subject crossing at right angles, you will probably need less than half the shutter speed and can more easily control just the right amount of blur.

SHARP CAR, BLURRED WHEELS
A shutter speed of 1/500 sec was enough to capture a clear image of this racing car while still allowing some blur in the spoked wheels (inset).

Panning

If you stand perfectly still and photograph a fast-moving subject, the likely result is that the subject will be blurred and all the stationary elements of the image will be sharp. Panning the camera (moving the camera through one plane, usually horizontal, while keeping the subject in the viewfinder) can produce the opposite result: the moving object is sharp and the stationary elements are blurred.

The result depends largely on the selected shutter speed. An extremely fast shutter speed may even freeze the background if panning slowly. Conversely, a slow shutter speed may create a blurred background and a blurred subject – this can be quite effective if the degree of blur differs between the subject and the background. The use of flash, especially with second-curtain flash, in conjunction with the latter technique can be very effective.

Blurring for effect

The most popular subject for this technique is undoubtedly water. As with fast-moving subjects, the scale and speed of travel across the frame are the key issues. It is helpful if the water's direction of travel is across the frame – the opposite of fast-moving subjects. To obtain a slow shutter speed in bright conditions, a slow ISO and small aperture will be required. In very bright conditions a neutral density filter or polarizing filter can also be useful in reducing shutter speed by two stops or more. Precise shutter speeds needed to blur water will vary according to the situation, but half a second is a good rule of thumb.

Tip

Filling the frame with a well-exposed moving subject is one of the hardest aspects of recording motion. To begin with, choose a focal length and camera-to-subject distance that leave the subject a little smaller in the frame, and crop the result later on your computer.

Common errors

It is often assumed, wrongly, that the use of high-speed continuous drive will always guarantee a result. Relied upon solely, it may not. The EOS 50D can shoot at a maximum of 6.3 frames per second. If those frames are shot at, say, 1/2000 second, the shutter will have been open for a total of just 0.00325 of a second, so it is still possible to miss the critical moment.

Composition

The term 'composition' refers to the relative placement of objects within the frame. Personal preferences and intuition are all-important, but it is always worth learning from other photographers. It is also worthwhile learning from your own mistakes, rather than trying to follow a set of rules without knowing how or why those so-called rules work.

Balance

Every photograph includes a number of different elements and each one contributes to its impact. Balance needs to be considered in terms of not just shape but colour, density, activity, mood, light and perspective.

Again, this is a matter of personal preference, but it also has a great deal to do with the dimensions of the final photo as well as the subject matter and its treatment.

In order to achieve balance, you must think in terms of the essence of the image. If the picture is highly dynamic then you will want it to have a 'busy' feel, which can be achieved with striking angles, vivid colour, blurred motion and lots of detail. Conversely, if you want to produce a restful image, then keep it as simple as possible and avoid hard shapes, straight lines and bold colours. A landscape format is usually selected for tranquil scenes.

WATER MILL, NORFOLK
I had some degree of control over where I could stand, without deviating from a public footpath, and was able to wait for the lone canoeist to arrive at a suitable position.

142

When it comes down to simple composition, one might say that a symmetrical photo is one which has absolute balance, but symmetry can make a composition seem far too anchored, so use it sparingly. Trust your instincts, don't try to follow set 'rules', and shoot from a variety of viewpoints. The great thing about digital photography is that it will cost you nothing to experiment.

The rule of thirds and the Golden Ratio

The so-called 'rule of thirds' is often referred to in photography as one of the essential guides to composition. The rule suggests that the frame should be divided by horizontal and vertical lines, a third of the way along each side. Key components of the composition should be placed either along the lines or at the points where these lines intersect.

The rule of thirds is a simplistic tool that serves a useful purpose when we have little or no control over elements in the composition. However, it doesn't even begin to compete with the centuries-old system that makes use of the Golden Ratio and the Golden Rectangle.

The Golden Ratio is claimed to provide the most aesthetically pleasing frame dimensions, known as the Golden Rectangle. This rectangle has a ratio of 1:1.618, when shortened to three decimal places, compared with the 1:1.497 provided by the EOS 50D's sensor. By taking a square off each Golden Rectangle, a new one is created and rotated through 90°. The Golden Rectangle can then be further subdivided by following the same process, providing many more opportunities for placing the main and subsidiary components of the composition.

GOLDEN RATIO vs. RULE OF THIRDS
The dotted lines represent the rule of thirds. The continuous lines represent just a few of the Golden Rectangles constructed using the Golden Ratio. You can see how many more possibilities this system offers in terms of composition.

Artists, of course, are often starting from scratch, while photographers usually work with the scene in front of them. Nevertheless, it is worth being aware of the Golden Ratio principles, if only to better appreciate the work of some of the world's greatest studio photographers, who are most able to construct images in the same way an artist does.

Directing the eye

It is generally accepted that an image will first have an immediate impact as a whole on the viewer, perhaps at an emotional level. After that, there are a number of natural processes that can be harnessed to direct the viewer's eye to specific points in the image and also to lead the viewer through the image in the way you would like.

For instance, the eye will naturally be drawn towards colours which stand out, especially reds and yellows, and along strong lines.

Of particular importance are converging lines in an image. These tend to create triangles which act as arrows, creating a degree of dynamism from diagonal lines in the composition. These points of convergence can also act as 'stoppers' that temporarily arrest the viewer's eye movement while they linger on a specific area of the image.

The viewing process also depends upon cultural background. There is a school of thought that a person's first written language dictates their default reading direction and that this also determines whether we 'read' a photograph or painting from left to right or vice versa.

TURNTABLE
Straight lines and bold use of colour dominate, but there is also a lot of information packed into this shot. The yellow lines demonstrate how the eye is directed through the image.

144

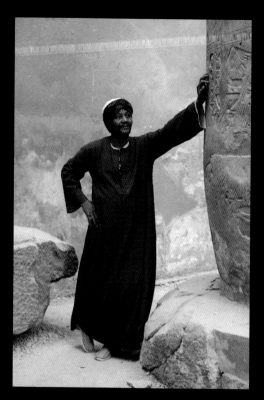

EGYPT
The main subject in this image, shot at Luxor Temple in Egypt, is obviously the man, but the column with its hieroglyphs is also of secondary importance. The first inset image shows how this subject occupies the frame when it is divided into thirds. Of more importance, in terms of dynamics, are the lines shown in the second inset image. Note how the blocks of stone at the bottom of the image act as 'stoppers' which help to concentrate the eye on the central figure. (The one on the left also lies on a 'third'.) The diagonal lines also help to keep the eye centred on the main subject, with a strong diagonal formed by the arms travelling almost through the face to meet his line of sight where his hand rests on the pillar and its strongest hieroglyph.

Settings
Aperture priority
ISO 200
1/30 sec at f/4
Evaluative metering
White balance: Daylight
Picture Style: Landscape
One Shot AF

Lighting

Light has qualities above and beyond its mere presence and it is the manipulation of these qualities that sets a good photograph apart from a mediocre one. True, there are occasions when the subject is powerful enough to stand alone, as with reportage photography, but even then a dramatic picture can be further enhanced by the use of colour, light direction or contrast.

Colour

Photography makes use of three types of colour. There is the colour which a subject appears to have in its own right, but which is actually just a function of reflected light. Then there is the colour of the light falling on the subject, and finally the colours used for printing or displaying the image. The last two, in particular, are ones which we can exercise a lot of control over, even removing colour from an image to render it as a set of grey tones. One might argue that there is also a fourth category of colour, taking into account the way that specialist films such as infra-red record colour. The EOS 50D has the ability to select white-balance options in order to correct the colour temperature of the light emanating from various sources in different circumstances.

Light sources

Light always comes from a specific source. Photography commonly makes use of two types of light source: direct and reflected. The most-used direct source is the sun: even on a dull winter's day thick with cloud, any available light is still coming from that orb in the sky. The second source commonly used is flash, with artificial light sources such as domestic lighting, street lighting and studio lighting following behind. Each of these has particular qualities that can be harnessed to good effect, notably its inherent colour, which is known as its colour temperature.

> **Tip**
> You can bracket exposures using three different white-balance settings, just like normal exposure bracketing. You can also combine the two, creating nine subtly different versions of the same shot. The over- and under-exposed versions will give slightly different colour rendition compared with the nominally correct version, so all nine will be different to some degree.

Direction of light

This plays a much more important role than most people realize and it affects far more than just the direction in which the shadows fall. It affects the overall appearance of the subject: frontal lighting produces little shadow and a more colourful appearance; side lighting can increase shadow, which can mean less colour but more interesting shapes; back-lit subjects may appear as silhouettes or possess an ethereal, translucent quality.

There is always a temptation to shoot with the sun behind us on a sunny day, but it is worth exploring a subject for different possibilities and from different angles. If you have control over the direction of light – when using flash, for example – try out different set-ups with direct, diffused and reflected light. Similarly, if you can't control the light direction but have the option

Tip
If shooting JPEGs, bracket your exposures in non-standard lighting situations as even $1/3$-stop can make a significant difference to highlight detail. RAW images can always be fine-tuned during post-processing.

of moving the subject in relation to it, you can change the position of the subject to achieve varying results.

Contrast

Contrast is the term given to the difference between light and dark areas in an image. Ideally, we manage to render some detail in both of these, but strong lighting such as sunshine can often pose problems for photographers as it not only illuminates the subject but creates dense shadows as well.

EARLY MORNING LIGHT
Sunrise and sunset are the two most familiar examples of changes in the colour of light.

Image properties

Sometimes, digital photographs can seem to take on a life of their own, exhibiting some rather strange effects which the photographer definitely hadn't intended.

ADJUSTING IN PHOTOSHOP
Clipping shadow detail results in a more noticeable loss of colour than clipped highlights. Note the much darker foliage in the image on the left. The image was processed in Photoshop CS3 using the Shadow/Highlight adjustment to reduce clipping at both ends of the scale (right). This has retained the foliage colour and more detail in the roof of the boat in the foreground.

Dynamic range and clipping
The dynamic range is the spread of possible tones from the darkest to the lightest that can be recorded in an image. While digital images can record a far wider range than, say, transparency (slide) film, they still fall a little short of the range that the human eye can distinguish. If the tones exceed this range, detail will be lost, whether it's in the highlights or in the shadows or both. This loss of detail is referred to as clipping. The top of the dynamic range is reached when a pixel records the

brightest tone possible without being pure white. At the opposite end of the scale the reverse is true, with a pixel recording detail just short of being black. The extent of this range is determined by the ISO setting, with lower ISO settings providing the greatest range. Lower ISO settings will also give a smoother transition between tones.

As a result, the photographer is usually faced with three options: favouring the highlights and allowing the deepest shadow tones to merge; favouring the shadows and allowing the highlights to burn out; or aiming between the two and allowing some clipping at both ends of the range. Clipping is the term used to describe the merging of tones at either end of the brightness scale.

The choice of what part of the tonal range to favour is usually determined by the intended end product. For instance, when producing images for magazine or book use, the quality of the paper to be used by the intended publisher can play a major part. Photos solely for screen display, on the other hand, present fewer problems as they don't depend on reflected light and can usually harness a full range of tones.

Flare

Flare will be familiar to most former film users. It occurs due to the scattering of light waves within the lens and manifests itself in the form of diffuse rays emanating from a pronounced highlight, with odd coloured shapes along their path. While photographic software can remedy many problems, flare isn't generally one of them, though if the effect is minor it may be possible to copy sections of the image and paste them over the offending signs of flare. The best solution is to avoid the problem in the first place by using an appropriate lens hood and trying to avoid shooting directly into a light source.

FOREST FLARE
Flare is often used for creative effect but is actually a product of the shortcomings of lens technology. It is hard to remove after shooting but can be avoided by changing the camera position.

Noise

Noise occurs in digital images due to missing information at pixel level. Images are composed of millions of pixels, some of which may function poorly or even fail to function at all, in which case they may appear white or lacking the correct colour. These pixels blend into the image creating undesirable flecks of random colour, especially noticeable in darker areas of smooth colour such as shadows.

The appearance of noise can be exacerbated by a number of factors such as temperature, long exposures and a high ISO setting. When two or more factors are present, noise is more likely. A white speck in a constant position in images may indicate a 'hot' pixel due to failure of one of the pixels on the sensor, in which case the camera will need to be serviced to remedy the problem.

Aliasing

This is the term used to describe the process by which individual pixels start to become visible in the image at normal levels of magnification. It tends to be more apparent in low-resolution images, especially those with diagonal or curved lines – telephone lines running diagonally across your image are a common example. The answer is prevention rather than cure: as often as possible, shoot in RAW, sRAW or Large/Fine

Tips

The EOS 50D's features include long exposure noise reduction, enabled via Custom Function II-1, and high ISO speed noise reduction, enabled via Custom Function II-2 (see page 124). If the latter function is enabled, the maximum burst available in continuous shooting mode will be significantly reduced.

It has been suggested that Canon's $\frac{1}{3}$-stop ISO settings are achieved by a different process, one that is not as effective at controlling noise, than that used for full-stop ISO settings. A whole-stop setting (eg ISO 200) may actually produce less noise than a lower intermediate ISO.

JPEG. It is far easier to create a quality small image from a larger one than the other way round.

A common cause of aliasing is the overzealous use of sharpening, especially in images with smaller file sizes. If you are shooting JPEGs and know that your images are only going to be used as thumbnails or low-resolution images for use on screen, you can use the Picture Style options to reduce the setting for the

150

sharpening parameter. You will only be able to do this if you work in one of the Creative Zone modes. If you use a Basic Zone exposure mode, you lose control over sharpening and other parameters.

Sharpening images

Many casual photographers remain blissfully unaware of the need for digital images to be sharpened. This is because they shoot JPEGs, which are sharpened in-camera long before the results are printed or displayed on screen. However, anyone who shoots RAW files will quickly realize that most of their images require some degree of sharpening, certainly if they are to be enlarged or used commercially.

In general, sharpening images works fine as long as the image is to be used at its original size or larger. However, sharpening images and then reducing them in size significantly can result in an over-sharpened appearance, which is true relative to the image size. If you want to produce thumbnails or other small images for any reason, it is better to do this before sharpening takes place. Sharpening JPEGs can always be carried out later on the computer. However, once it has been carried out, either in-camera or on the computer, it cannot be undone, except with RAW images.

RIGGING
This is the sort of shot where over-zealous sharpening will become all too apparent, with the rigging acquiring a noticeable case of 'the jaggies'.

Reflections

RIPPLES
This image has been inverted so that the subject appears the right way up. In this instance the strong colours and blue sky are essential components in conjunction with the reflection.

Settings
Manual (M) mode
ISO 100
1/400 sec at f/5.6
Evaluative metering
White balance: 5200°K
Focus mode One Shot AF

Reflective surfaces surround us in our everyday lives and can provide excellent opportunities for interesting images, even when other factors such as the weather seem to be working against us. Curved reflective surfaces can give a 'fish-eye' effect but demand good control of depth of field when working at close distances. Water probably provides the most frequently used reflective surface, but care should be taken to introduce strong reflected colours whenever possible.

Using exposure compensation

All light meters work in the same way: they average what they see and give a reading based on the assumption that you are looking at an 18% grey card.

Scenes like this will fool a meter into giving a reading that won't actually give you the best result. The large area of near-white occupying the centre of the frame, and the lack of shadow due to direct sunlight, suggested a reading half a stop lower than was necessary. Exactly how much exposure compensation is needed can be a matter of experience, trial and error, educated guesswork, or bracketing. Using either ½- or ⅓-stop increments, a set of three exposures can be taken with or without additional exposure compensation. The EOS 50D's high-resolution 3in (7.6cm) LCD monitor is ideal for reviewing the results.

Highlight Tone Priority can also be selected in Creative Zone modes to improve the end result.

CRUCIFORM COLUMNS
These decorative white columns dominate the centre of the image and will have a significant effect on all meter readings, though less so with evaluative metering mode, used here with just ½-stop exposure compensation being sufficient to hold detail yet retain colour in the trees behind.

Settings
Canon EF 24–105mm f/4 L
Aperture priority (Av) mode
ISO 100
1/250 sec at f/8
Exposure compensation: +½
Evaluative metering
White balance: Daylight
Focus mode: One Shot AF
Picture Style: Landscape

In one sense, capturing a silhouette is simple because it only has two elements: the silhouette itself and the background. The first has line and shape, but no tonal detail, and the latter is simply a matter of colour. So why do so many holiday snaps of sunsets not work?

The answer is a lack of planning. Before I visit a location I print off compass directions and times of sunrises and sunsets. If a good sunset looks likely I set out early to locate a scene which will give me a strong silhouette. A meter reading should be taken from the sky area but without including the sun itself; this will determine the mid-tone, turning the darker foreground into a silhouette. Readings will change rapidly as the sun sinks below the horizon.

But it isn't only sunsets which make effective silhouette images. In this example, there is almost no colour at all, except for a range of steely greys which add to the mood.

Settings
Canon EF 24–105mm f/4 L
Zoom setting: 24mm
A-DEP mode
ISO 100
f/4 at 1/500 sec
Evaluative metering
White balance: Daylight
One Shot AF

LAKE OF MENTEITH, SCOTLAND
The silhouette elements in the foreground are provided by both the tree branches and the reeds, with the distant shore and mountains beyond still silhouetted but adding a sense of depth to the image.

CANON EOS 50D

A sense of depth

A popular technique in landscape photography is to use a physical feature such as a river, road, or other strong line that winds its way from the foreground into the distance, to lead the eye into the picture. This creates a feeling of depth. Another, more subtle, way to do this is to make use of foreground and middle-distance features which are on different planes.

The photograph below is of National Park scenery in Scotland. As I was driving into an area known as The Trossachs, I had to travel over a mountain pass connecting two valleys. I reached the highest point of the pass and was presented with a whole series of views, including this dramatic scene. What struck me most were the differences in the three bands of scenery, making this an ideal image to demonstrate the use of features on different planes.

THE TROSSACHS, SCOTLAND
The three parallel bands of mountain scenery recede into the distance, giving the image a sense of depth.

Settings
EF 24–105mm f/4 L
Aperture Priority (Av) mode
1SO 100
Evaluative metering
1/400 sec at f/5.6
White balance: 5200 °K
Landscape Picture Style

Photo essays

With digital photography you can fire off as many shots as you like at no extra cost. This makes it ideal for what I call 'stalking the subject', or compiling a group of images on a single theme – as with these images of Glasgow's Science Park.

When I come across a favourable photographic situation I want to make the most of it and have a variety of usable images at the end. I also find that stalking the subject gradually hones my ideas and the shots obtained get better as I go along. However, it is usually still necessary to obtain a simple 'establishing shot', which is often little more than a technically competent record of the subject, in context if possible.

PORTRAIT FORMAT
I usually shoot as many portrait-format frames as I do landscape-format. After all, how many landscape-format magazines can you name?

ESTABLISHING SHOT
It is useful if an establishing shot can also be readily converted to monochrome. This can be done in Digital Photo Professional by adjusting the Picture Style of the RAW image.

DETAIL

In any photographic situation, It is always worth recording some of the detail in its own right.

General settings

EF 24–105mm f/4 L
Aperture Priority (Av) mode
Evaluative metering
ISO 100
f/8 at 1/125–1/500 sec

ABSTRACT

Occasionally, a fine abstract can be created by cropping one of the other images, such as this crop from the establishing shot.

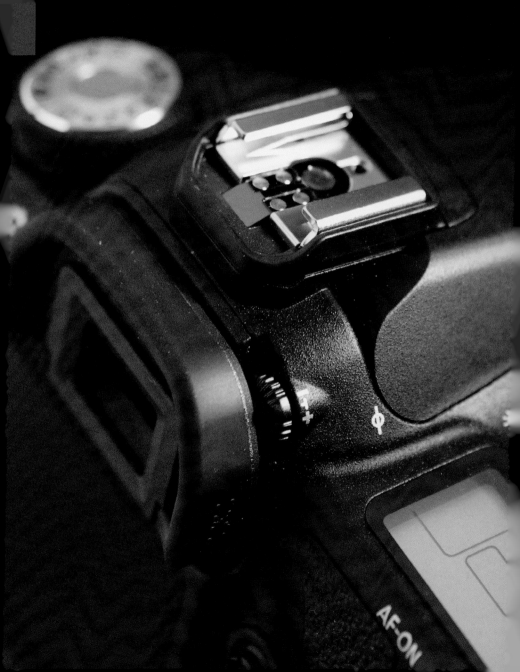

Chapter **4**

Flash

Flash photography has developed to such an extent that it is often imbued with almost magical properties. Magic, say some, is simply the science that other people know but we don't: the following pages should help to dispel some of the mystery.

There are a great many camera users who have little or no idea of the principles of flash photography. They can be seen on aircraft flying over the Alps as they use flash to photograph the dramatic scenery below. You don't need a scientific explanation of Guide Numbers to realize that these people are being more than a little optimistic.

The EOS 50D comes equipped with a built-in flash that provides a wide enough beam to be used with a 17mm (full-frame) lens and sufficient power to provide adequate lighting of a subject 10ft (3m) away, assuming ISO 100 at f/4.0. At settings of ISO 12,800 and f/4, Canon claim coverage of up to 120ft (36m).

In other words, it is a very useful tool in compact situations. The coverage is very even, not as harsh as earlier models such as the EOS 10D, and blends well with ambient light. It can be used as the main source of lighting or simply as fill-in to relieve some of the dark shadows on a sunny day. In Basic Zone modes built-in flash is automatic.

SIR JACKIE STEWART OBE
The built-in flash does a fine job of filling in shadows in the contrasty light of a sunny day.

160

The advantages of the built-in flash compared with using an EX Speedlite come down to weight and convenience. None of the Speedlites is exceptionally heavy, but it still means extra weight plus an extra set of batteries or a power pack, and possibly extra recharging at the end of the day. Both make use of E-TTL II metering, AF-assist beam, red-eye reduction, flash exposure bracketing, flash exposure lock and first- or second-curtain synchronization. The advantages of using a Speedlite are its added power, high-speed synchronization, adjustable power output, off-camera capability and variable output.

E-TTL II flash exposure system
The third generation of Canon's auto flash exposure system provides almost seamless integration of flash and camera in most situations where flash would be either helpful or essential. The E-TTL designation stands for 'evaluative through-the-lens' metering, as opposed to measuring the flash exposure from a sensor housed within the flash gun. The fact that the exposure is based on what is seen through the lens means that you can safely position the flash off-camera, at a totally different angle to the subject compared with that of the camera, and still achieve accurate exposure.

When the shutter-release button is fully depressed, it signals the Speedlite, assuming it is a recent E-TTL II model, to fire a pre-exposure metering burst in order to ascertain the correct exposure. The data gathered on the brightness levels of the subject during this initial burst of flash is compared with the data for the same areas of the image under ambient light. From these two sets of data the correct flash output and exposure are calculated. With many EF lenses, this burst will also assess the distance to the subject. The shutter activation and the main flash burst (assuming first-curtain sync is set) will follow so quickly on the back of the metering burst that the two will be inseparable to the naked eye.

FLASH

Note
While all current EF and EF-S lenses are E-TTL II compatible, not all are capable of delivering distance information to help calculate flash exposure more accurately. See page 162 for a list of these lenses.

The following lenses provide the distance information that is necessary for full compatibility with E-TTL II metering:

EF 14mm f/2.8L II USM	EF 17–40mm f/4L USM
EF 20mm f/2.8 USM	EF-S 17–55mm f/2.8 IS USM
EF 24mm f/1.4L II USM	EF-S 17–85mm f/4–5.6 IS USM
EF 28mm f/1.8 USM	EF-S 18–55mm f/3.5–5.6
EF 35mm f/1.4L USM	EF 20–35mm f/3.5–4.5 USM
EF 50mm f/1.2L USM	EF 24–70mm f/2.8L USM
EF-S 60mm f/3.5 USM Macroa	EF 24–85mm f/3.5–4.5 USM
MP-E 65mm f/2.8 1–5x Macro Photo	EF 24–105mm f/4 IS USM
EF 85mm f/1.2L II USM	EF 28–90mm f/4–5.6 III
EF 85mm f/1.8 USM	EF 28–105mm f/4–5.6
EF 100mm f/2 USM	EF 28–105mm f/3.5–5.6 II USM
EF 100mm f/2.8 Macro USM	EF 28–105mm f/4–5.6 USM
EF 135mm f/2L USM	EF 28–135mm f/3.5–5.6 IS USM
EF 180mm f/3.5L Macro USM	EF 28–200mm f/3.5–4.5 II USM
EF 200mm f/2L IS USM	EF 28–300mm f/3.5–5.6L IS USM
EF 200mm f/2.8L II USM	EF 55–200mm f/4.5–5.6 II USM
EF 300mm f/2.8L IS USM	EF-S 55–250mm f/4-5.6 IS
EF 300mm f/4L IS USM	EF 70–200mm f/2.8L IS USM
EF 400mm f/2.8L IS USM	EF 70–200mm f/2.8L USM
EF 400mm f/4L DO IS USM	EF 70–200mm f/4L IS USM
EF 400mm f/5.6L USM	EF 70–200mm f/4L USM
EF 500mm f/4L IS USM	EF 70–300mm f/4.5–5.6 DO IS USM
EF 600mm f/4L IS USM	EF 100–300mm f/4.5–5.6 IS USM
EF 800mm f/5.6L IS USM	EF 100–300mm f/4.5–5.6 USM
EF-S 10–22mm f/3.5–4.5 USM	EF 100–400mm f/4.5–5.6L IS USM
EF 16–35mm f/2.8L II USM	

162

Guide numbers

There is an easy way to compare the performance of different models of flashgun and that is to look at their Guide Numbers. This is a measurement of power that can be applied equally to any flash unit, and measures the maximum distance over which the flash will provide effective coverage. As this distance is dependent upon the sensitivity of the film or sensor, the measurement is qualified by the addition of an ISO setting. The Guide Number for Canon's 580EX Speedlite is 190/58 (ft/m) at ISO 100.

Calculating flash exposure

Aperture also affects flash coverage, but the equations involved in calculating flash exposure are simple enough for us to calculate the third factor involved as long as we have the other two. (In the following examples, the term 'flash-to-subject distance' is used because the flash could be used off-camera.)

The basic equation is as follows: *Guide Number / Flash-to-subject distance = Aperture.* This could also be written as *Guide Number / Aperture = Flash-to-subject distance* or *Flash-to-subject distance × Aperture = Guide Number.*

Take the 580EX as an example using the maximum flash to subject distance: *190 (GN) / 190ft = Aperture.* We would therefore need an aperture of f/1 to achieve flash coverage. As this is unrealistic, let's take another example using a flash-to-subject distance of 50ft: *190 (GN) / 50ft = f/3.8* (f/4 for practical purposes).

If we know the Guide Number and the aperture we want to use, f/16 for example, but aren't sure of the flash-to-subject distance limitations, we can still calculate this easily: *190 (GN) / f/16 = Flash-to-subject distance.* This would give us an answer of 11.9ft (3.6m) as the maximum distance over which the flash would perform adequately with f/16 as our working aperture.

To make our lives easier, Canon provide zoom heads on some of their flashguns. These sense the focal length in use and harness the power of the flash more effectively by narrowing (or widening) the flash beam to suit the lens. For this reason the full Guide Number also refers to the maximum focal length that the zoom head will accommodate automatically. Consequently, the full Guide Number for our example of the 580EX Speedlite is 190/58 (ft/m) ISO 100 at 105mm. EX Speedlites also display a useful graphic indicating the distance over which flash can be used at current settings.

FLASH

Flash exposure lock

When part of the subject is critical in terms of exposure, you can take a flash exposure reading of that area of the image using the same metering circle as the Partial metering mode, and lock it into the camera/flash combination.

1) Having adjusted all appropriate settings and switched on the external flash or raised the built-in flash, aim the camera at the critical part of the subject.

2) Focus with the centre of the viewfinder over the important part of the subject and press the ✱/◱• ⊖ FE lock button.

3) The flash head will emit a metering pre-flash and the camera will calculate the correct exposure.

4) In the viewfinder, **FEL** Flash Exposure Lock is displayed momentarily, then replaced with the ⚡* symbol.

5) Recompose the shot and press the shutter-release button.

6) The flash will fire, the picture will be taken, and the ⚡* symbol will disappear, indicating that no exposure settings have been retained.

Flash exposure bracketing

This function is not built into the EOS 50D but can be found on EX Speedlites from the 550EX upwards. It will enable three exposures to be made, just as with the normal exposure-bracketing procedure. A slightly less convenient but equally effective alternative is available via the camera's functions in that you can adjust the flash exposure compensation settings for each of three shots, thereby matching the bracketing process.

Tips
Flash exposure compensation can be set at any time. The built-in flash does not need to be in its active position, nor does an external flash need to be switched on.

When the flash-to-subject distance is too great and correct exposure cannot be achieved, the ⚡ Flash ready symbol blinks in the viewfinder.

As you double the flash-to-subject distance, 4× illumination is required. This is known as the Inverse Square Law.

Flash exposure compensation

It is possible to select Flash exposure compensation when using either the built-in flash or a compatible external flash, providing you are using one of the Creative Zone modes. This works in exactly the same way as normal exposure compensation, taking three different pictures up to +/-2 stops, and permits you to control the end result so that the subject has a more natural appearance.

1) Turn the camera's power switch to ◢ .

2) Press the ⚡± button.

3) Rotate the ◯ Quick Control Dial to set flash exposure compensation in either ⅓- or ½- stop increments. (The increment can be set in Custom Function I-1.)

4) The ⚡± Flash Exposure Compensation symbol will appear in the viewfinder at bottom left.

5) Take the picture and review the result, adjusting compensation and repeating the shot if necessary.

Common errors

Flash exposure compensation shares the same graphic ▨▨▨▨▨ on the top panel as Exposure compensation/ Auto exposure bracketing. The Flash exposure compensation setting is only visible while the ⚡± button is depressed. As soon as you release the ⚡± button, the display graphic reverts to its normal display. However, Flash exposure compensation settings are retained after switching the camera off. Because the Flash exposure compensation setting isn't normally visible in the top panel, pay attention to the viewfinder symbol as a reminder that an adjustment has been made before you enter a different shooting situation.

> **Note**
> If the Quick Control Screen is displayed when you press **ISO•⚡±** in step 2, the ISO speed/Flash exposure compensation menus will be displayed on the LCD monitor as well as in the top panel.

FLASH

Bounce and direct flash

The two most popular techniques for reducing the impact of direct flash are the use of a diffuser and bouncing the flash off a reflective surface. While there is a small diffuser on the market which will fit the built-in flash, bounce flash remains the sole preserve of those using EX Speedlites and other compatible flashguns mounted on the hotshoe or used off-camera with the off-camera shoe cord.

Depending on the model, if the flashgun is mounted on the camera's hotshoe, bounce flash can be achieved by rotating and tilting the flash head to point at the reflecting surface, which should normally be a little above and to one side of the subject. Bounce flash, especially when used with the flash gun off-camera, is a good way of both softening shadows and controlling where they fall.

A portable collapsible reflector such those produced by Lastolite is worth carrying in the field. They are available as white, gold or silver for neutral, warm or cold tones.

Bounce flash

The concept of bounce flash is that the surface(s) being used to reflect the flash will provide, in effect, a larger and therefore more diffuse light source. This also assumes that it is light enough in tone to perform this purpose and that it won't

imbue the subject with a colour cast. If the reflecting surface has a matt finish or is darker in tone, it will be less effective because it will absorb some of the light and will require a much wider aperture or shorter flash-to-subject distance to work.

With this technique, the flash-to-subject distance includes the distance to the reflecting surface and from that surface to the subject. Also, about two stops of light may be lost when using this technique, so the flash-to-subject distance will be much shorter than would normally be the case for any given aperture.

FLOWER SHOW
An external flash was bounced off the white marquee ceiling for this colourful shot.

166

Direct flash

One of the most common problems with direct flash (i.e. not diffused or bounced) is red-eye, a phenomenon which occurs when light from the flash is picked up by the blood vessels at the back of the eye. It is particularly noticeable when the flash gun is mounted on top of the camera. At one time, the only technique for dealing with this was to use diffused lighting or to move the flash gun away from the lens axis, or both.

The red-eye reduction function on the EOS 50D, enabled in ◻️ Shooting Menu 1, works by using the flash to direct a beam of light at the subject prior to the actual exposure and the flash firing as normal. This causes the pupils in the eyes to narrow, so that red-eye is reduced. When red-eye reduction is enabled and either the built-in or external flash is on, the exposure compensation scale 2..1..●..1..2 at the bottom of the viewfinder is replaced by the ||||| symbol when focus is confirmed. This shows in all modes except Landscape, Sports and Flash Off.

Direct flash must always be considered carefully, particularly the harshness of its impact when used on close or highly reflective subjects. It is worth noting that many professional press photographers keep a Sto-fen Omnibounce diffuser on their camera-mounted flashguns at all times to soften direct flash.

STILL LIFE
This subject was in an isolated position with no possibility of bouncing the flash off a nearby surface. There was no option but to use direct flash, but it has worked well because of the interesting mixture of shapes and textures.

FLASH

In order to ensure that the focal-plane shutter opens in conjunction with the flash exposure, a camera has a specific flash synchronization speed. Historically it was much slower than today, commonly 1/60 sec, but it has crept up over the years and today 1/200 or 1/250 sec is not uncommon. When taking photographs in the dark, the flash sync speed isn't a problem, but when using flash to fill in shadows on a bright day, a higher flash sync speed is crucial. One of great advantages of medium-format cameras has always been the predominance of leaf-shutter lenses, rather than having a focal-plane shutter within the camera body, which allow higher flash sync speeds than could be achieved with 35mm cameras with their focal-plane shutters.

Current technology means that users of EX Speedlites can dial in high-speed flash sync speeds – right up to 1/8000 sec in the case of the EOS 50D. This can be applied to Manual (**M**), Shutter Priority (**Tv**) and Aperture Priority (**Av**) modes.

To use high-speed sync in Aperture Priority (**Av**) mode, you must first set Custom Function I-7 to **Auto** (see page 123) or the maximum sync speed (in this exposure mode only) will be set to 1/250 sec. When high-speed sync is enabled, the ⚡H symbol will show on the Speedlite's display. However, its display in the EOS 50D's viewfinder is dependent upon circumstances according to the exposure mode you have selected.

Attaching the EX Speedlite (all modes)

1) With camera and Speedlite switched off, mount the Speedlite on the camera's hotshoe and tighten the locking mechanism.

2) Turn the camera's power switch to ⏻ if using the Creative Zone or either **ON** or ⏻ if using the Basic Zone.

3) Turn on the Speedlite.

4) On the camera, adjust the white-balance setting as appropriate. All white-balance settings are available in the Creative Zone but the options are limited in the Basic Zone.

High-speed sync in Manual (M) mode

5) Select high-speed sync on the EX Speedlite. The ⚡H symbol will be displayed on the Speedlite's display.

6) Select Manual (M) exposure mode on the camera.

7) The ⚡H symbol will be displayed in the viewfinder at all times, regardless of shutter speed and aperture selected.

8) On the camera, select the combination of shutter speed, aperture and ISO speed appropriate to the shooting situation. You can do this using the camera's LCD top panel or by pressing the **INFO** button and using the Quick Display Screen.

9) Flash exposure compensation can be set on either the camera or the Speedlite in ⅓ stop increments up to +/-2 stops. However, if settings have been adjusted from zero on both camera and Speedlite, the Speedlite's settings will override those on the camera.

10) Flash exposure bracketing and other Custom Functions may be available to you depending on the EX Speedlite being used.

11) Take the picture and review the result.

High-speed sync in Shutter Priority (Tv) mode

5) Select high-speed sync on the EX Speedlite. The ⚡H symbol will be displayed on the Speedlite's display.

6) Select Shutter Priority (Tv) exposure mode on the camera.

7) The ⚡H symbol is only displayed in the viewfinder when a shutter speed higher than 1/250 sec is selected. At 1/250 sec or lower, the ⚡ symbol will be displayed.

8) Follow steps 8–11 as above.

High-speed sync in Aperture Priority (Av) mode

5) Select high-speed sync on the EX Speedlite. The ⚡H symbol will be shown on the Speedlite's display.

6) On the camera, set Custom Function I-7 to **Auto** to disable the Auto setting (1/60–1/250 sec) and the fixed sync speed of 1/250 sec in Aperture Priority (Av) mode.

7) Select Aperture Priority (Av) mode.

8) The ⚡H symbol is only displayed in the viewfinder when a shutter speed higher than 1/250 sec is selected. At 1/250 sec or lower, the ⚡ symbol will be displayed.

9) Follow steps 8–11 as above.

FLASH

A focal-plane shutter works by two shutter curtains moving across the frame. Both of these curtains move across the focal plane at the same speed, but there is a small gap between them which is how the film or sensor is exposed to the image projected by the lens. With a higher shutter speed, the curtains don't move any faster but the gap between the curtains gets narrower. With an extremely slow shutter speed, the entire frame may be completely exposed before the second curtain begins to follow the first. This system makes it possible to control shutter speeds precisely and to reach speeds of up to 1/8000 second.

With the E-TTL flash system, the flash actually fires twice. The first burst is a pre-flash in the sense that it fires just before the shutter opens in order to determine exposure. The second burst is the one which illuminates the subject.

When first-curtain synchronization is selected, the illuminating burst occurs as soon as the travel of the first curtain opens the gap between it and the second curtain. This second burst is normally so soon after the metering burst that, to the naked eye, the two are indistinguishable.

When second-curtain synchronization is selected, the illuminating burst is fired at the end of the exposure, just before the second curtain catches up with the first.

Because there is a longer time lag between metering and illumination, it may be more obvious that the flash has fired twice.

So how do these settings affect the image? The duration of the flash is very short and has the effect of freezing movement. However, if the exposure is long enough for the ambient light to record subject detail, the image will be illuminated by of a mixture of flash and ambient light. The subject will be frozen and sharp but there will also be a ghost image which is not, and there may also be light trails from moving highlights. It is these light trails that are affected most significantly by switching from first- to second-curtain synchronization.

Imagine a subject moving across the frame from left to right. With first-curtain sync, the flash will fire immediately and will freeze the image towards the left of the frame. Any ambient light will continue to expose the subject as it continues to move across the frame. The end result is a sharp subject with light trails extending into the area into which it is moving, making it appear as if it is moving backwards.

With second-curtain sync, the subject is lit by the ambient light first and then frozen by the flash at the end of the exposure. This adds to the impression of forward movement and looks much more natural.

170

When a single flash head is no longer sufficient, either in terms of power or to control highlights and shadows, Canon make it easy to use multiple flash units with either wired or wireless connectivity. Wired connection can be achieved using the accessories listed at the end of this chapter, but it is important to note that, with the exception of the off-camera shoe cord, the benefits of E-TTL II metering will be lost. A wireless system, however, will retain full E-TTL II compatibility and can be established using either the Wireless Transmitter ST-E2 as the camera-mounted control unit or an EX Speedlite (550EX upwards) as the master unit. All other flash units will be deemed 'slave' units. The ST-E2 is purely a control unit and transmitter and does not incorporate a flash head.

DANCING WITH ROBOTS
Captured at a theme park in France, the robotic arm and its riders were moving unpredictably in and out of focus, so AI Focus and first-curtain sync were selected.

FLASH

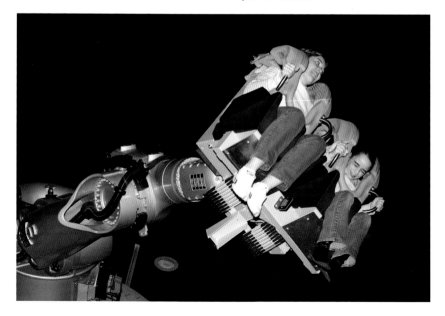

EX Speedlites

Canon's EX range of Speedlites is fully compatible with E-TTL II metering. The range runs from the inexpensive 220EX to the high-powered 580EX II, and barely used discontinued models can readily be found on eBay. The model number is a quick and easy indication of the power of each unit, with the 580EX having a Guide Number of 58 (metres at ISO 100) and the 430EX having a Guide Number of 43 (metres at ISO 100), for example. If you are interested in wireless flash photography, you should always check whether any particular model is capable of acting as a master unit or only as a slave unit (see page 171).

220EX Speedlite

The 220EX Speedlite is the smallest and least expensive of Canon's range. It includes flash exposure lock compatibility and high-speed (FP) synchronization. However, this model is not compatible with use as a wireless slave unit, and it can't take Canon's external power pack.

Max. guide number 72/22 (ISO 100 ft/m)
Zoom range 28mm fixed
Tilt/swivel No
Recycling time 0.1–4.5 sec
AF-assist beam Yes
Weight (w/o batteries) 160g

172

430EX II Speedlite

The 430EX II Speedlite provides flash exposure lock compatibility, high-speed (FP) synchronization and can be used as a wireless slave unit with the 550EX, 580EX, 580EX II, Speedlite Transmitter ST-E2, and Macro Twin Lite MT-24EX and Macro Ring Lite MR-14EX. The bottom end of its zoom range has been extended from 24mm on the 420EX down to a very useful 14mm.

Max. guide number 141/43 (ISO 100 ft/m) at 105mm
Zoom range 24–105mm (14mm with wide panel)
Tilt/swivel Yes
Recycling time 0.1–3.7 sec
AF-assist beam Yes
Custom functions/settings 9/20
Wireless channels 4
Weight (w/o batteries) 320g

580EX II Speedlite

The 580EX II Speedlite provides flash exposure lock, high-speed (FP) synchronization, 14 custom functions, flash exposure bracketing, automatic or manual zoom head and strobe facility. It can be used as either a master or slave unit for wireless flash photography. It even provides colour temperature control for optimal white balance and manual settings down to 1/128 power in ⅓-stop increments. The Mk II version has added weathersealing, 20% faster recycling, a PC socket and external metering sensor for non-TTL flash.

Max. guide number 190/58 (ISO 100 ft/m) at 105mm
Zoom range 24–105mm (14mm with wide panel)
Tilt/swivel Yes
Recycling time 0.1–6 sec
AF-assist beam Yes
Custom functions/settings 14/32
Wireless channels 4
Catchlight reflector panel
Weight (w/o batteries) 375g

FLASH

MR-14EX Macro Ring Lite

This unit consists of a control unit which is mounted on the hotshoe and a ring-flash unit which is mounted on the lens. The ring-flash unit has two flash tubes on opposite sides of the lens and the lighting ratio between these can be adjusted to provide better shadow control. It also has built-in focusing lamps and modelling flash and is capable of acting as master unit for wireless flash photography. The Ring Lite is designed for close-up photography where a hotshoe-mounted flash would be ineffective due to the short camera-to-subject distance.

Max. guide number 46/14 (ISO 100 ft/m)
Designed for use with EF macro lenses
Tilt/swivel No
Modelling flash Yes
Recycling time 0.1–7 sec
Weight (w/o batteries) 404g

MT-24EX Macro Twin Lite

The Twin Lite consists of a control unit which is mounted on the camera's hotshoe plus two small flash heads which are mounted on either side of the lens and can be adjusted independently. This model offers far more flexibility than the Ring Flash. It has the same wireless capabilities as the Ring Flash and is designed for use with the same EF Macro lenses.

Max. guide number 72/22 (ISO 100 ft/m)
(with both heads firing)
Zoom range N/A
Tilt/swivel Yes
Recycling time 4–7 sec
Weight (w/o batteries) 404g

174

Flash accessories

One of the great advantages of using a system camera like the 50D is the range of accessories available, and Canon produces an extremely wide range of useful additions for its flash units. These increase both the range of situations in which you can work and the flexibility of use, giving you maximum control of the end result. In particular, they will help you to use the flash off-camera to reduce red-eye when shooting people and animals and for improved shadow placement, giving a more natural appearance to your photographs.

Speedlite Transmitter ST-E2

This unit acts as an on-camera wireless transmitter for all current EX Speedlites except the 220EX. It can control two groups of slave flash heads with flash ratio variable between the two groups. The ST-E2 is not entirely necessary for wireless flash as some EX models can also act as master units, with or without the master unit firing.

Off-camera Shoe Adaptor 2

This is a simple hotshoe socket for a Speedlite and incorporates a ¼in tripod socket, to be used with either of the connecting cords (see page 176).

TTL Hotshoe Adaptor 3

This can be used with either the connecting cords and the TTL distributor, or the off-camera shoe cord to connect up to four separate Speedlites.

TTL Distributor

This accessory provides four connection sockets: one to connect to the TTL Hotshoe Adaptor 3 and three more for connecting to off-camera shoe adapters via Connecting cords 60 and 300.

Off-camera Shoe Cord OC-E3

This is one of the first accessories many people buy, enabling an EX Speedlite to be used up to 2ft (0.6m) away from the camera while retaining all normal functions. It is ideal for close-ups with a small light cube such as the Lastolite ePhotomaker, as well as improving bounce flash capability and helping to avoid red-eye.

Compact Battery Pack CP-E4

The CP-E4 improves recycling times and the number of flashes available. It also permits the fast changeover of CPM-E4 battery magazines.

Speedlite L bracket SB-E2

This bracket allows a Speedlite to be positioned to the side of the camera rather than on the hotshoe, helping to reduce red-eye by taking the flash head off the camera-lens axis. It requires an off-camera shoe cord.

Connecting Cords 60 and 300

A 2ft (0.6m) coiled lead or a 10ft (3m) straight lead to connect the TTL Distributor and TTL Hotshoe Adaptor 3.

Tips

Wired flash accessories are not compatible with E-TTL II metering, irrespective of the capabilities of the flash unit you are using. For full E-TTL II compatibility, use a wireless system with the 550EX/580EX/580EX II or ST-E2 transmitter as the master unit.

To ensure maximum compatibility, new accessories are often released at the same time as new Speedlites. Sometimes, but not always, these are compatible with discontinued flash units. To check compatibility, consult the Canon website or, even better, obtain a copy of EOS Magazine's annual products supplement, which lists all current and discontinued Canon products, in some cases as far back as the late 1980s.

Expo Imaging have recently released a ring-flash accessory with adaptors to fit both the 580EX II and the original 580EX. It fits directly onto the flash head and, because of the flash unit's much higher guide number compared with dedicated ring-flash units, it provides a much greater flash-to-subject distance. This means that it can be used for portraits and other subjects in addition to close-up work. Called the Ray Flash Adaptor, it is considerably less expensive than either the Canon or Sigma ring flash units.

DON'T BE AFRAID TO EXPERIMENT

This still life was arranged within a specially made all-black version of Lastolite's ePhotomaker which the author, having suggested the concept, was testing for the company. It makes use of a special crush-proof black velvet which does not wrinkle when packed away. The lighting was provided by off-camera wireless flash using 550EX and 580EX Speedlites.

Settings

Aperture Priority (Av) mode
Evaluative metering
Live View
ISO 100
1/250 sec at f/16
Manual focusing
550EX and 580EX wireless flash

Chapter **5**

Close-up

The revealing world of close-up photography is both fascinating and rewarding, and is available to all photographers with the minimum of additional equipment. What it does require, however, is great attention to technique and rock-solid camera support. The high magnifications involved mean that a slight error in focusing or the smallest camera movement will be immediately noticeable.

The other factors which are of greatest importance in close-up photography are lighting and depth of field. The latter is easily dealt with by choosing a very narrow aperture, though newcomers to close-up photography will still be surprised by how little depth of field is available – often no more than a few millimetres, even at the narrowest aperture. For this reason, purpose-built macro lenses often have a narrower aperture than usual, perhaps f/32 rather than f/16 or f/22. As well as making the use of depth-of-field preview more difficult, apertures like these require even slower shutter speeds, making lack of camera movement even more important, and this is one reason why much extreme close-up photography requires flash.

NATURAL GRAPHICS
A simple walk in the countryside will often yield an unexpected photographic opportunity, so a macro lens is a good choice if you're only taking one lens. This larch had been felled by a forester only a couple of days before and was still fresh, the shadow providing a striking graphic element to the composition.

SHEET MUSIC
Depth of field is a major issue when shooting close-ups, especially when the image is to be enlarged. Detailed examination of the sheet music in this still-life shows just how limited depth of field can be at moderate apertures.

Settings
Aperture Priority (Av)
ISO 100
1/200 sec at f/8
Evaluative metering
One Shot AF
550EX Speedlite

Lighting for close-ups

Lighting is one of the most difficult aspects of extreme close-up work. The very narrow apertures and slow shutter speeds necessary cannot be overcome by using a high ISO speed unless quality is to be sacrificed, so diffuse ambient lighting is often not sufficient unless working outdoors, when the additional problem of wind has to be borne in mind.

Flash might seem the obvious solution, but it has its own problems. To start with, a flashgun mounted on the camera's hotshoe cannot be tilted down sufficiently to illuminate the subject at close proximity.

The starting point, then, for lighting close-ups is off-camera flash. This requires the Canon off-camera shoe cord OC-E3 that will retain all E-TTL II features. However, direct flash will produce a rather harsh light at such short distances so it is best to diffuse it. The two simplest ways of doing this are to either bounce the light off a white or near-white surface such as a sheet of white card or a Lastolite reflector, or to put translucent material between the flash and the subject. The oldest trick in the book is to drape a white handkerchief over the flash head.

One reason why bounce flash works so well is that the effective size of the light source has been increased. If you bounce the light off a standard Lastolite reflector, you have a much larger light source of approximately 3ft (0.9m) in diameter.

The best inexpensive solution for photographing small objects with just one off-camera flash is some form of light tent or light cube. Lastolite's ePhotomaker, originally designed to help people photograph items for sale on eBay, is a small light tent with one internal side consisting of reflective material, the rest being translucent fabric that acts as both diffuser and reflector. By mounting the off-camera flash outside the ePhotomaker on the opposite side to the reflective material, a good balance of light and shadow can be achieved quickly and easily.

PRODUCT SHOTS
All the product shots in this book were taken using a single 550EX II Speedlite with an off-camera shoe cord and a Lastolite ePhotomaker.

182

For maximum control of shadows, two or more flash heads are even better. One solution is to use a ring-flash unit. This has two small flash heads within a circular reflector that fits on the front of the lens with the flash heads on opposite sides of the lens. However, this brings us back to the harsher effects of direct flash and can also produce small doughnut-shaped reflections in shiny surfaces. Ring flash is best reserved for matt subjects and for shooting flowers and similar subjects outdoors.

Canon also manufacture a (very expensive) lens-mounted two-head unit. This consists of a control unit that mounts on the hotshoe and has two independently adjustable heads. There are also lots of proprietary products enabling the user to use two flash heads in a similar configuration using either wired or wireless flash. Remember that a wireless set-up is necessary for full E-TTL II compatibility.

Because depth of field is so limited in close-up photography, it is often impossible to get the whole of the subject, from front to back, in acceptably sharp focus. Subjective

decisions may need to be made about which parts of the subject need to be in sharp focus and which can be sacrificed. This means that there are great advantages to be had from adopting manual focus for the task. This is where the EOS 50D's Live View feature comes into its own, as it is designed with manual focusing very much in mind.

With Live View you have the advantage of a large image on the monitor that can be used to check depth of field. By making use of the 5× or 10× magnification function, which can be used in conjunction with depth-of-field preview and the ✹ Multi-controller button to roam around the image to check focus in detail, you have an ideal tool for close-up photography.

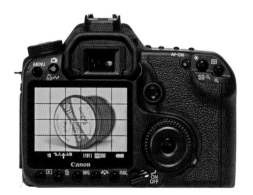

LIVE VIEW GRID
Two different grids can be selected in Live View, making composition and alignment much easier when composing extreme close-ups.

Working distance

The nature of the subjects you plan to photograph will play a large part in determining the working distance between the camera and subject, which in itself will help to determine the focal length(s) of the lens you use. Inanimate objects can be photographed from mere inches away, whereas live subjects will require a greater distance. If you plan to photograph live subjects that are camera-shy or dangerous, you should opt for a longer focal length to increase the working distance.

Because the EOS 50D's sensor is only 22.3 × 14.9mm in size, any lens which is designed for use on a full-frame camera will have its field of view cropped by a factor of 1.6. This means that you can fill the frame from slightly further away than would be the case with a 35mm or full-frame camera body. This is useful if you plan to use extension tubes on a conventional lens. Extension tubes bring the front element of the lens closer to the subject (see page 187).

HUMMINGBIRD HAWKMOTH
Your working distance needs to be great enough not to frighten away your subject.

Close-up attachment lenses

These are one of the easiest routes into close-up photography and screw onto the lens thread just like filters. If you are not planning significant enlargements of your photos, close-up attachment lenses are good value and can produce great results.

They are best used with prime lenses such as a 50mm standard lens or a moderate wide-angle with close focusing capability, and work by reducing the minimum focusing distance even further. Magnification is measured in dioptres, generally +1, +2, +3 or +4, and their great advantage for the novice is that all the camera functions are retained.

Close-up attachments can be used two or more at a time, for example combining a +2 with a +3 attachment to obtain +5 dioptres. However, the optical quality will not be of the same standard as your lens and using two or more will reduce image quality more noticeably. This is another reason to use prime (fixed focal length) lenses – their image quality, despite many advances in zoom lens quality, still tends to be better.

There are some very inexpensive close-up attachment lenses on the market, but as with filters, you will have to pay more for better quality. Canon produce both 2 dioptre (Type 500D) and 4 dioptre (Type 250D)

ISOLATED SUBJECT
A small Lastolite reflector is a useful and versatile aid to take into the field with you for close-up work. It folds up very small, can be stuffed in a pocket and can be used to keep the wind off a subject as well as to reduce shadows. Perhaps best of all, it can be placed behind a subject to isolate it from its background, as shown in this image.

lenses in both 52mm and 55mm fittings, plus a 2 dioptre (Type 500D) lens in both 72mm and 77mm fittings. All are double-element construction for higher quality. The Type number indicates the greatest possible lens-subject distance in millimetres. The 250D is optimized for use with lenses between 50mm and 135mm; the 500D is designed for lenses between 75mm and 300mm.

Lens magnification tables

The table below shows the level of magnification you can achieve by attaching either the 250D or 500D close-up attachment lenses (see page 185) to a selection of prime (fixed focal length) lenses.

Lens	Size (mm)	Magnification 250D	500D
EF 20mm f/2.8 USM	72	N/A	0.17–0.04
EF 24mm f/2.8	58	0.25–0.10	0.20–0.05
EF 28mm f/2.8	52	0.24–0.12	0.19–0.06
EF 35mm f/2	52	0.36–0.14	0.30–0.07
EF 50mm f/1.0L	72	N/A	0.24–0.10
EF 50mm f/1.4 USM	58	0.35–0.21	0.25–0.10
EF 50mm f/1.8 II	52	0.36–0.20	0.25–0.10
EF 50mm f/2.5 Macro	52	0.68–0.20	0.59–0.10
EF-S 60mm f/2.8 Macro	52	1.41	1.21
EF 85mm f/1.2L USM	72	N/A	0.28–0.17
EF 85mm f/1.8 USM	58	0.50–0.34	0.31–0.17
EF 100mm f/2 USM	58	0.57–0.40	0.35–0.20
EF 100mm f/2.8 Macro	52	1.41–0.41	1.21–0.20
EF 135mm f/2.8 SF	52	0.70–0.55	0.41–0.27
EF 200mm f/2.8L USM	72	N/A	0.57–0.39
EF 300mm f/4L USM	77	N/A	0.70–0.59
EF 400mm f/5.6L USM	77	N/A	0.91–0.78

Extension tubes

Extension tubes fit between the lens and the camera body and can be used singly or in combination. Canon produce two: Extension Tube EF 12 II and Extension Tube EF 25 II. The former provides 12mm of extension and the latter 25mm. By increasing the distance from the lens to the lens mount and thus the focal plane, the minimum focusing distance and the magnification of the image are both increased. Both of Canon's extension tubes retain autofocus capability. They are compatible with most EF and EF-S lenses.

Bellows

Bellows work on the same principles as extension tubes, but are a much more flexible tool. The basic concept is simplicity itself – a concertina-shaped light-proof tube with a male lens mount at one end and a female lens mount at the other, the whole affair being mounted on a base that allows minute adjustment. This facilitates better control over the magnification ratio and focusing. But the greatest benefit is that bellows do not employ any glass elements at all and consequently can be used to deliver maximum image quality.

TUBES AND BELLOWS
(Right) Extension tubes EF 12 II and EF 25 II. (Below) This Balpro Novoflex bellows features tilt and shift adjustments for maximum control of perspective and depth of field. Metering is still possible with the appropriate adaptor.

The downside is that there is a significant loss of light involved, and exposure must be adjusted to correct this. At one time it was necessary to employ complex calculations to work out the correct exposure, but today's digital cameras are so easy to use that you may as well work on a trial-and-error basis. Canon do not produce this particular accessory, but alternatives are available from independent manufacturers, notably Novoflex.

Macro lenses

There are three types of lens that tend to be sold as macro lenses. The first is a specialist lens designed for extremely high magnifications, such as Canon's MP-E65 f/2.8 Macro lens which has a maximum magnification of an astonishing 5× life-size. The second is a purpose-built conventional macro lens with a maximum reproduction ratio of 1:1, though half life-size is now commonly accepted in this category. These are excellent lenses for everyday use too, often giving crisp and contrasty results in everyday situations. Finally, there are those lenses that boast what they refer to as a 'macro setting', which may offer a magnification ratio of up to perhaps 1:4, or one quarter life-size.

For close-up photography in general, a dedicated fixed focal-length macro lens is the ideal choice and provides excellent image quality at close focusing distances. Canon manufacture several.

There are two with shorter focal lengths – the full-frame but only half life-size EF 50mm f/2.5 and the 1:1 true macro EF-S 60mm f/2.8 USM. Both of these will fit the EOS 50D but the 50mm version lacks the faster and quieter Ultra Sonic Motor. The 50mm version can achieve 1:1 magnification with the addition of

EF 50mm f/2.5 Macro lens

EF-S 60mm f/2.8 Macro lens

EF 180mm f/3.5 L Macro lens

the dedicated four-element Life-size Converter or with the aid of extension tubes, the latter also being compatible with the 60mm lens to achieve magnifications even greater than life-size. The 60mm lens is the first true macro lens in the EF-S range, designed specifically for digital photography with APS-C sensors, and will focus as close as 8in (20cm).

Two longer close-up lenses are also available from Canon, allowing greater working distances: the EF

188

Tip

Another simple solution for close-up work involves the use of a reverse adaptor. This allows you to mount your lens back-to-front on the camera. Unlike bellows and extension tubes, there is no loss of light reaching the sensor when using a reverse adaptor. However, as the lens contacts are now at the front of the lens, all the information they normally transmit to the camera will be unusable.

EF-S 60mm f/2.8
Macro lens

100mm f/2.8 Macro USM and the EF 180mm f/3.5L Macro USM. Both of these lenses provide a reproduction ratio of 1:1 and, like Canon's two other conventional macro lenses, have a minimum aperture of f/32. The EF 180mm f/3.5L Macro USM is designated an L-series lens and as such comes with the build quality associated with these legendary pieces of equipment, though it does weigh in at over two pounds (1kg).

TEXTURE

Sometimes texture alone can be the subject of an effective close-up, without the need for a main subject as such. Diffuse sunlight brought out the wide range of shapes and textures of this lichen-encrusted tree bark.

Chapter **6**

Lenses

One reason why photographers choose a manufacturer like Canon is the extensive range of lenses and other accessories available. At the time of writing Canon offers no fewer than 70 lenses, including specialist items such as tilt-and-shift lenses. The range encompasses their standard EF lenses, which will fit all Canon EOS cameras; EF-S lenses, which have a smaller image circle and are optimized for APS-C digital bodies (from 20D and 300D onwards); and their renowned L-series lenses, which are popular with professionals due to their rugged design, weather-proofing and high optical quality. All three ranges feature USM ultrasonic motors on most lenses, and IS (Image Stabilization) is slowly being added model by model.

EF-S lenses

These lenses were developed to accompany the smaller 300D, 350D and 400D models and are consequently very light in weight. The EF-S mount was included on the 20D and retained for the 30D, 40D and 50D, though they will all accept EF lenses too. The only prime lens in this series is the 60mm f/2.8 macro and at first only wide–standard zooms were on offer. These have now been complemented by the superwide 10–22mm and more extensive 55–200mm models. The 'S' designation identifies them as having shorter back focus, a smaller image circle, a specific mount not compatible with a standard EF mount, and a difference in build quality in order to reduce weight.

EF lenses

This is Canon's standard range that stretches from a 15mm fisheye up to 400mm and includes the macro lenses, with the exception of the 180mm L-series macro. It also includes two of the three manual-focus-only tilt-and-shift lenses and the 1.4× and 2× teleconverters ('extenders' in Canon parlance). Zooms range from 17–55mm to several models that extend up to 300mm. It is worth studying their specifications because some EF lenses use L-series technology and are terrific value. These include the EF 70–300mm f/4–5.6 IS USM; this replaced the 75–300mm model that launched in 1995 – the first lens to use image stabilization technology.

L-series lenses

The L-series lenses are the cream of the line-up. The prime lenses stretch from 14mm f/2.8 to 600mm (the 1200mm has now been dropped). This range includes all the super-fast Canon lenses such as the 35mm f/1.4, the 50mm f/1.2, the 85mm f/1.2 (above) and

the 400mm f/2.8. The latest addition is the 200mm f/2 with its astonishing 5-stop Image Stabilization feature. Build quality is superb and later lenses have a rubber skirt to improve weather- and dust-proofing. Longer focal lengths and extended zooms are off-white in colour.

Focal length and angle of view

No matter how much is written, nor how often, about the focal length of lenses in this new age of 'less than full-frame' digital cameras, confusion and debate continue to fill internet forums with threads about related topics on a daily basis. These pages should clarify a few of those points.

Focal length

When parallel rays of light strike a lens that is focused at infinity, they converge on a single point known as the focal point. The focal length of the lens is defined as the distance from the middle of that lens to the focal point. Photographic lenses are a bit more complicated because the lens is comprised of multiple elements, but the principle holds good and the measurement is taken from the effective optical centre of

the lens group. The focal point is referred to in photography as the 'focal plane' and this is the plane on which the film or sensor lies. Focal length is an absolute characteristic of any lens and can be measured and replicated in laboratory conditions. The focal length of a lens always remains the same, irrespective of any other factor such as the type of camera it is mounted on.

Focal Point

Focal Length

Crop factor

This term has been coined as a simpler way of referring to the digital multiplier that must be used with 'less than full-frame' sensor cameras when making comparisons with 35mm/full-frame sensor cameras. The 'crop factor' on the EOS 50D is 1.6×. It refers only to the field of view that the sensor covers. Technically speaking, it should not be applied to the focal length of a lens used with the smaller sensor. (Remember, a 300mm lens is always a 300mm lens, no matter what type of camera it is used on.) The trouble is that it is mostly when discussing lenses that we need to use the term at all, and there simply isn't any way of getting around that issue.

Field of view

The field of view of a lens, in photographic terms, is the arc through which objects are recorded on the film or sensor. This arc of coverage, as with all geometrical angles, is measured in degrees (°). Although the image projected by the lens is circular, in photography we are only concerned with the usable rectangle within that circle, and consequently the field of view of a camera lens can be found quoted as three figures: horizontal field of view, vertical field of view and diagonal field of view. Where only one figure is quoted, it is generally assumed to be the diagonal field of view. The field of view of a lens is not an absolute measurement and depends on two factors: the focal length of the lens and the area of the sensor or film which is to record the image.

Camera lenses continue to be marketed using the focal length designation that would be applied to a full-frame (36mm × 24mm) sensor or 35mm film. As the focal length of a given lens is fixed, it would be helpful if the angle of view were to be quoted alongside the image area it is intended for. However, this practice is not followed by lens manufacturers, for the reasons outlined below.

Lenses designed to fill full-frame sensors can be also be used on smaller formats, necessitating several sets of figures: Canon's EF full-frame lenses can also be used with their APS-H (1.3×) and APS-C (1.6×) sensors, for example. To complicate matters, competing camera manufacturers use sensors which are slightly different in size: Canon's APS-C sensor (1.6×) measures 22.2mm × 14.8mm, whereas Nikon's equivalent measures 23.6mm × 15.8mm with a 1.5× crop factor. Finally, the angle of view for a given focal length may be slightly different from one lens manufacturer to another.

194

Focal length comparison

When the focal length is doubled, the area covered is one quarter of the previous area. The image on the right was captured using a lens with a focal length of 20mm. If a 40mm lens had been used, the image area would be that shown by the larger dotted rectangle. If an 80mm focal-length lens had been used, the image area would be that shown by the smaller dotted rectangle. The solid rectangle in the centre appears to be a logical progression (i.e. 160mm) but actually represents 320mm in focal length,

because as the focal lengths get longer, the numerical difference in the angle of view is reduced as you double the focal length.

Standard lenses

The term 'standard lens' dates back to the early days of 35mm photography, long before today's extensive range of prime lenses and, particularly, zoom lenses were even conceived of. The working photographer would carry three bodies equipped with a moderate wide-angle lens of 28mm or 35mm, a 50mm standard lens and a short telephoto of up to 135mm. The standard 50mm lens was sold with the camera and approximated the field of view of the human eye.

With APS-C sensor bodies like the EOS 50D, because of the crop factor explained on page 194, it is necessary to divide the 50mm focal length by 1.6 in order to arrive at a focal length that may be considered 'standard'. This means we're looking at a focal length of approximately 30mm. Today, the zoom lenses that are packaged with new cameras instead of the old 50mm prime lens tend to straddle this 30mm figure. Canon's 18–55mm EF-S lens is a classic example.

Historically, the standard lens was often the least expensive in any line-up, because it could be manufactured more cheaply. But standard zooms have come down in price, size and weight, and have increased in quality.

Add to this the huge numbers of APS-C bodies sold by Canon and it seems the 50mm standard lens is turning into a museum piece.

However, Canon still produce 50mm versions as standard lenses for 35mm film and full-frame sensor cameras. For the APS-C user, this means you can buy a lightweight, fast and high-quality portrait lens, with a field of view similar to that of an 80mm lens on a full-frame camera, for a very competitive price in the case of the 50mm f/1.4. And if you can afford it, the 50mm f/1.2 L is a world-beater.

Wide-angle lenses

Wide-angle users have suffered as a result of the APS-C sensor's crop factor. A 17–40mm lens only provides the field of view of a 27–64mm equivalent, and 27mm is definitely not considered wide-angle by today's standards. However, in 2004, Canon introduced the EF-S 10–22mm lens, the first affordable Canon option to offer real wide-angle characteristics.

Three independent manufacturers produce lenses to compete with the EF-S 10-22mm: Sigma, Tamron and Tokina. Their widest offerings are 10–20mm, 10–24mm and 10–17mm lenses respectively, but all are rather slow, even at their widest setting. However, Tokina have also produced an 11–16mm f/2.8. As well as being the fastest lens available, it has one feature which gives it a significant advantage: the focusing scale has a 7ft (2m) mark. Manually focusing on this will more or less guarantee that everything is in focus from 3ft (1m) to infinity, even at f/4, when set to 11mm or 12mm. Both Sigma and Tokina also manufacture 12–24mm lenses, the Sigma being a full-frame lens and the Tokina only suitable for APS-C bodies.

'Fisheye' lenses typically have a 180° diagonal field of view (full-frame fisheye), or even a horizontal, vertical and diagonal 180° field of view (circular fisheye). With these lenses, only straight lines which run through the centre of the frame are straight; all others are rendered as curved. In most cases, this effect is primarily due to their construction rather than their focal length. For instance, Canon produces a 'normal' rectilinear wide-angle 14mm lens but also a 15mm fisheye. Sigma

makes 4.5mm, 0mm and 10mm fisheye lenses. The 10mm gives 167° coverage on the EOS 50D and the 4.5mm will give 180° coverage in all directions, but the 8mm version will only give a full circular image with full-frame sensors or on 35mm.

The nearest Canon currently gets to a fast wide-angle lens, once the mainstay of the photojournalist, is a full-frame 24mm f/1.4. Today's wide zooms are really quite slow, so for the best performance it is usually necessary to stop down a couple of stops from the maximum aperture. This means working with an aperture of at least f/5.6 and more probably f/8 – which places limits on working in low light because the shutter speeds will be very slow. At the time of writing, few wide-angle zoom lenses offer image stabilization.

Telephoto lenses

Telephoto users, whether using prime lenses or zooms, gain hands down from using APS-C sensor bodies like the EOS 50D because the field of view is reduced by ×1.6. My favourite long lens combination is a 300mm f/2.8 with a ×1.4 converter, giving the equivalent field of view on the 50D as a 672mm f/4. Such possibilities are highly cost effective.

Telephoto lenses compress the different planes in an image, making distant subjects look closer than they are. The longer the focal length, the more this is true. Telephotos require faster shutter speeds, which is why you see sports photographers carrying such vast lenses. It is not the focal length alone that results in such huge lenses, but the combination of focal length and fast maximum apertures.

But doesn't image stabilization remove the need for fast maximum apertures? No. Image stabilization compensates for camera shake but has no impact on the need for a high shutter speed (and therefore fast maximum aperture) when trying to freeze a moving subject.

One of the bonuses of longer lenses is the attractive out-of-focus background (known as 'bokeh') they can create. This is determined partly by the number of blades in the diaphragm and the extent to which they create a perfect circle when open.

ON THE LIMIT
British television pundit and former Formula 1
star Martin Brundle takes his Jaguar E-type to
the limit through the chicane at Goodwood.
It is in situations such as this that fast prime
telephoto lenses are unbeatable.

Settings
300mm f/2.8 lens
Aperture priority
ISO 200
1/4000 sec at f/4
AI Servo

Perspective

There are several reasons why we might choose a particular focal length: angle of view, depth of field, and perspective chief among them. Perspective is the term used to describe the relationships between the different elements that comprise an image, particularly with regard to the apparent compression or expansion of planes.

Let's start with the most obvious examples. With a very wide-angle lens, taking a head and shoulders portrait will involve a very short camera-to-subject distance, and the nearest facial features will appear quite distorted and overly large. Conversely, try photographing a line of parking meters with a long telephoto and the image will give the impression that the meters are spaced only a couple of feet apart.

Between these two extremes are a host of options, especially if you use zoom lenses. There are no hard-and-fast rules except to say that if you want natural-looking portraits, it is best to opt for a slightly longer than

standard focal length, traditionally 85mm full-frame or 50mm on your EOS 50D. Canon's prime lenses in this bracket are excellent value (not counting the fabulous but pricey 85mm f/1.2), with wide maximum apertures and superb image quality.

The perspective with any given focal length will change according to the camera-to-subject distance and viewpoint. For example, looking downwards at a 45 degree angle will give a quite different perspective from approaching the subject at eye level.

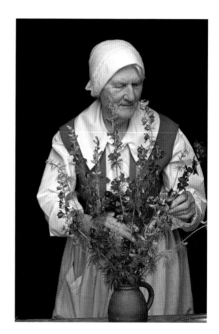

NATURAL-LIGHT PORTRAIT
The EF 50mm f/1.4 USM lens is highly recommended. It is invaluable in low light and for out-of-focus backgrounds and is frequently used for shots like this portrait.

Teleconverters

Canon use the term 'extender' to describe their two teleconverters. The first is the 1.4× extender which is fitted between the camera body and the lens to increase the focal length by a factor of 1.4 and causes the loss of one stop of light. The 2× extender doubles the focal length with a loss of two stops.

Teleconverters are an inexpensive way of increasing the pulling power of your telephoto lenses, but they do not provide the same quality as a lens of the same focal length. Autofocus will also be slower and you may find that the AF will 'hunt' unless it can lock onto a suitable contrasty part of the image.

Tip

If you are considering purchasing an extender, it is particularly important to pay attention to the maximum aperture of your lens. If the recalculated maximum aperture once an extender is fitted proves to be smaller than f/5.6, you will lose autofocus capability.

Only selected lenses can be used with Canon extenders without causing damage to the rear element of the lens. To check which current lenses can be used, visit the Canon website and check the specification of the lens concerned.

Teleconverter	Optical features and supported features	Dimensions: diameter × length	Weight
Extender EF 1.4× II	USM, I/R, Float, FT-M, CA, 1×S-UD, 3×AL, IS, DO	72.8 × 27.2mm	220g
Extender EF 2× II	USM, I/R, Float, FT-M, CA, 1×S-UD, 3×AL, IS, DO	71.8 × 57.9mm	265g

200

Tilt-and-shift lenses

One of the main drawbacks of using normal lenses for any architectural subject is that tilting the camera and lens to accommodate the height of the building results in the convergence of vertical lines, usually the sides of the building. You can get around this by finding a viewpoint that is at roughly half the height of the building. However, a more satisfactory solution comes in the shape of a tilt-and-shift lens.

Tilt-and-shift lenses adopt the same principles as a view camera but are much more portable. They work by allowing the lens to make different movements in relation to the plane of focus, with the additional benefit of improving (or reducing) depth of field without changing the aperture.

Canon manufacture three such lenses, with only the widest being an L-series version: the TS-E 24mm f/3.5L, the TS-E 45mm f/2.8 and the TS-E 90mm f/2.8. All of these lenses are manual focus only.

DOVER CASTLE, UK
This image clearly demonstrates the issue of converging vertical lines. The problem can be overcome by using a tilt-and-shift lens.

LENSES

Modern lens technology

Canon use a variety of different lens technologies to improve their performance in a number of respects, including optical quality, focusing and handling. This table describes the main features that Canon now incorporate into their range of lenses.

AF-S – Autofocus stop feature	The AF-S button prevents the lens from inadvertently refocusing on unwanted subjects that have impinged on the frame. **Main benefit** Saves time that would be wasted if the lens focused on unwanted intrusions.
UD – UD glass	Not as effective as either super-UD glass elements or fluorite elements, UD glass elements still offer more correction of chromatic aberration than standard glass elements. **Main benefit** Decreases fringing and increases colour clarity, particularly with long focal-length lenses.
Float – Floating system	The focusing mechanism adjusts the gaps between particular lens elements in order to minimize the occurrence of optical deficiencies when focusing on subjects close to the lens's minimum focus distance. **Main benefit** Improves image quality for subjects at close focusing distances.
FP – Focus preset	Focus preset stores a focus distance as a preset, allowing the lens to be switched almost instantly from any focusing distance to the preset focus distance. **Main benefit** Allows instant switching to a preset focus distance.

CaF2 – Fluorite elements	Incorporating fluorite in lenses brings the points of focus of the three primary spectral colours of red, green and blue to the same point in order to correct chromatic aberration. **Main benefit** Reduces chromatic aberration and reduces ghost flare to a negligible level.
DO – Diffractive optics	Diffractive optics concentrate image-forming light into a narrower beam than a standard lens. This allows a lens to be more compact and lighter than a normal lens of an equivalent focal length. Diffractive optics also provide high image quality. **Main benefit** Smaller and lighter lenses with high optical performance.
DW-R – Dust- and water-resistant construction	Lenses that have a dust- and water-resistant construction are more durable than standard lenses. There is also a rubber skirt that seals the lens-body connection, protecting both the lens and the camera body, as well as minimizing the risk of dust adhering to the sensor. **Main benefit** Enhanced protection for both lens and camera, useful in adverse conditions.
EMD – Electromagnetic diaphragm	A diaphragm drive-control actuator, which is comprised of a stepping motor and diaphragm blade unit. The integration of these components in one unit overcomes the problems of time lag and low durability, which are inherent in units that convert drive power from the camera body. All EF lenses (except TS-E and MP-E lenses) use an EMD for aperture diameter control. **Main benefit** Fast and reliable diaphragm control.

LENSES

203

FT-M – Full-time manual focusing	Overrides the autofocus, allowing manual focus in AF mode. Canon has two types: electronic manual focusing, which detects the rotation of the manual focus ring and drives the focusing motor electronically; and mechanical manual, where the rotation of the focus ring mechanically adjusts the focus. **Main benefit** Saves time switching between focus modes.
AS – Aspherical elements	Aspherical lens elements correct the inability of spherical elements to bring the various colours of the spectrum into focus at one point. This enables a lens to deliver a high-clarity image with reduced colour fringing and coma. **Main benefit** Particularly useful for correcting aberrations in wide-angle lenses, even at large apertures.
I/R – Internal focusing and Rear focusing	Internal focusing allows a lens to focus without changing its size. Rear focusing uses the elements behind the diaphragm to focus the image. **Main benefit** Produces a lens that is more compact and lightweight, particularly in long telephoto lenses. Rear focusing provides quicker and smoother autofocus operation.
IS – Image stabilization	Image stabilization lenses use internal sensors that detect camera shake and operate gyros and a shifting optical system to automatically adjust the lens elements to minimize blur. Canon claim that this technology allows you to hand-hold the lens at shutter speeds up to four stops slower than the same lens without IS, without camera shake becoming visible. **Main benefit** Reduces the occurrence of blur in images caused by camera shake.

204

CA – Circular aperture	Apertures' irises consist of a number of blades, so out-of-focus areas of an image take on a polygonal appearance. The closer the aperture is to a circle, the less noticeable the individual shapes. **Main benefit** Smoother out-of-focus areas.
L – L-series	Canon's top-quality lenses are given the designation L. L-series lenses incorporate a range of features that give them their characteristically excellent optical performance. **Main benefit** Extremely good image clarity.
S-UD – super-UD glass	While not quite as effective as fluorite elements, super-UD glass elements have almost twice the effectiveness of UD elements in suppressing chromatic aberration. **Main benefit** Increased colour clarity, particularly with long focal-length lenses.
SC – Super-spectra coating	This coating is common to all EF and EF-S lenses, ensuring sharp, high-contrast images with a colour balance that is consistent throughout the EF lens range. **Main benefit** Enhanced image clarity and colour consistency.
USM – Ultrasonic motor	Makes the motor in the lenses that drive the autofocus mechanism almost silent, yet autofocus is quick and precise. The direct-drive construction is very simple, making it both durable and efficient, while consuming little power. **Main benefit** Fast, precise and quiet autofocus.

LENSES

EF lens chart

Lens name	Optical features	Angle of view (horizontal) nearest 10th of a degree	Min. focus distance
EF 14mm f/2.8L USM	USM, 1×AL, I/R, FT-M, Float	76°48′	0.25m
EF 14mm f/2.8L II USM	L, USM, 1×AL, 1×UD, CA, SC	81°	0.20m
EF 15mm f/2.8 Fisheye	I/R	–	0.20m
EF 20mm f/2.8 USM	USM, I/R, FT-M, Float	58°6′	0.25m
EF 24mm f/1.4L USM	USM, 1×AL, 1×UD, I/R, FT-M, Float	49°36′	0.25m
EF 24mm f/2.8	I/R, Float	49°36′	0.25m
TS-E 24mm f/3.5L	1×AL	49°36′	0.30m
EF 28mm f/1.8 USM	USM, 1×AL, I/R, FT-M	43°12′	0.25m
EF 28mm f/2.8	1×AL, Float	43°12′	0.30m
EF 35mm f/1.4L USM	USM, 1×AL, I/R, FT-M, Float	35°12′	0.30m
EF 35mm f/2		35°12′	0.25m
TS-E 45mm f/2.8	Float	27°42′	0.40m
EF 50mm f/1.2L USM	L, USM, CA, SC	40°	0.45m
EF 50mm f/1.2L USM	L, USM	25°	0.45m
EF 50mm f/1.4 USM	USM, FT-M	25°	0.45m
EF 50mm f/1.8 II		25°	0.45m
EF 50mm f/2.5 Compact Macro	Float	25°	0.23m
EF-S 60mm f/2.8 Macro	USM, I/R, FT-M	21°	0.20m
MP-E 65mm f/2.8 1–5x Macro Photo	Float, 1×UD	19°24′	0.24m
EF 85mm f/1.2L USM	USM, 1×AL, FT-M, Float	14°54′	0.95m
EF 85mm f/1.8 USM	USM, I/R, FT-M	14°54′	0.85m
TS-E 90mm f/2.8		14°6′	0.50m
EF 100mm f/2 USM	USM, I/R, FT-M	12°42′	0.90m
EF 100mm f/2.8 Macro USM	USM, I/R, FT-M, Float	12°42′	0.31m

Min. aperture	Max. magnification	Filter size dia. × length	Dimensions	Weight
f/22	0.10×	rear	77.0 × 89.0mm	560g
f/22	0.15×	rear	80.0 × 94.0mm	645g
f/22	0.14×	rear	73.0 × 62.2mm	330g
f/22	0.14×	72mm	77.5 × 70.6mm	405g
f/22	0.16×	77mm	83.5 × 77.4mm	550g
f/22	0.16×	58mm	67.5 × 48.5mm	270g
f/22	0.14×	72mm	78.0 × 86.7mm	570g
f/22	0.18×	58mm	73.6 × 55.6mm	310g
f/22	0.13×	52mm	67.4 × 42.5mm	185g
f/22	0.18×	72mm	79.0 × 86.0mm	580g
f/22	0.23×	52mm	67.4 × 42.5mm	210g
f/22	0.16×	72mm	81.0 × 98.0mm	645g
f/16	0.15×	72mm	85.8 × 65.5mm	580g
f/16	0.15×	72mm	85.4 × 65.5mm	545g
f/22	0.15×	58mm	73.8 × 50.5mm	290g
f/22	0.11×	52mm	68.2 × 41.0mm	130g
f/32	0.50×	52mm	67.6 × 63.0mm	280g
f/32	1.00×	52mm	73.0 × 69.8mm	335g
f/16	5.00×	58mm	81.0 × 98.0mm	730g
f/16	0.11×	72mm	91.5 × 84.0mm	1,025g
f/22	0.13×	58mm	75.0 × 71.5mm	425g
f/32	0.29×	58mm	73.6 × 88.0mm	220g
f/32	0.14×	58mm	75.0 × 73.5	460g
f/32	1.00×	58mm	79.0 × 119	600g

EF 135mm f/2L USM	USM, 2×UD, I/R, FT-M	9°24'	0.90m
EF 135mm f/2.8 with soft focus	1×AL, I/R	9°24'	1.30m
EF 180mm f/3.5L Macro USM	USM, 3×UD, I/R, FT-M, Float	7°6'	0.48m
EF 200mm f/2L IS USM	USM, 5-stop IS, UD, FT-M, FP	10°	1.9m
EF 200mm f/2.8L II USM	USM, 2×UD, I/R, FT-M	6°24'	1.50m
EF 300mm f/2.8L IS USM	USM, 1×CaF2, 2×UD, I/R, FT-M, FP, IS, AF-S, DW-R	4°12'	2.50m
EF 300mm f/4L IS USM	USM, 2×UD, I/R, FT-M, IS	4°12'	1.50m
EF 400mm f/2.8L IS USM	USM, 1×CaF2, 2×UD, I/R, FT-M, FP, IS, AF-S, DW-R	3°12'	3.00m
EF 400mm f/4L DO IS USM	DO, USM, 1×CaF2, I/R, FT-M, FP, IS, AF-S, DW-R	3°12'	3.50m
EF 400mm f/5.6L USM	USM, 1×CaF2, 1×S-UD, I/R, FT-M	3°12'	3.50m
EF 500mm f/4L IS USM	USM, 1×CaF2, 2xUD, I/R, FT-M, FP, IS, AF-S, DW-R	2°30'	4.50m
EF 600mm f/4L IS USM	USM, 1×CaF2, 2×UD, I/R, FT-M, FP, IS, AF-S, DW-R	2°6'	5.50m
EF 800mm f/5.6L IS USM	USM, 4-stop IS, AS, UD, FT-M, FP	2°35'	6.0m
EF-S 10–22mm f/3.5–4.5 USM	USM, 3×AL, 1×S-UD, I/R, FT-M	96°–53°30'	0.24m
EF 16–35mm f/2.8L USM	USM, 3×AL, 2×UD, I/R, FT-M, DW-R	69°30'–35°12'	0.28m
EF 16–35mm f/2.8L II USM	L, USM, 3×AL, 2×UD, CA, DW-R, FT-M	98°–54°	0.28m
EF 17–40mm f/4L USM	USM, 3×AL, 1×S-UD, I/R, FT-M, DW-R	66°18'–31°	0.28m
EF-S 17–55mm f/2.8 IS USM	USM, 3×AL, 2×UD, IS	66°18'–22°48'	0.35m
EF-S 17–85mm f/4–5.6 IS USM	USM, 1×AL, I/R, FT-M, IS	66°18'–14°54'	0.35m
EF-S 18–55mm f/3.5–5.6 II	1×AL	63°18'–22°48'	0.28m
EF-S 18–55mm f/3.5–5.6 USM	USM,1×AL	63°18'–22°48'	0.28m
EF 20–35mm f/3.5–4.5 USM	USM, I/R, FT-M	58°6'–35°12'	0.34m
EF 24–70mm f/2.8L USM	USM, 3×AL, 1×UD, I/R, FT-M, CA	49°36'–18°	0.38m

f/32	0.19×	72mm	82.5 × 112mm	750g
f/32	0.12×	52mm	69.2 × 98.4mm	390g
f/32	1.00×	72mm	82.5 × 186.6mm	1,090g
f/32	0.12×	52mm drop-in	128 × 208mm	2,520g
f/32	0.16×	72mm	83.2 × 136.2mm	765g
f/32	0.13×	52mm drop-in	128.0 × 252.0mm	2,550g
f/32	0.24×	77mm	90.0 × 221.0mm	1,190g
f/32	0.15×	52mm drop-in	163.0 × 349.0mm	5,370g
f/32	0.12×	52mm drop-in	128.0 × 232.7mm	1,940g
f/32	0.12×	77mm	90.0 × 257.5mm	1,250g
f/32	0.12×	52mm drop-in	146.0 × 387.0mm	3,870g
f/32	0.12×	52mm drop-in	168.0 × 456.0mm	5,360g
f/32	0.14×	52mm drop-in	163 × 461mm	4,500g
f/22–f/29	0.17×	77mm	83.5 × 89.8mm	385g
f/22	0.22×	77mm	83.5 × 103.0mm	600g
f/22	0.22×	82mm	88.5 × 111.6mm	635g
f/22	0.24×	77mm	83.5 × 96.8mm	500g
f/22	0.17×	77mm	83.5 × 110.6mm	645g
f/22–f/32	0.20×	67mm	78.5 × 92.0mm	475g
f/22–f/32	0.28×	58mm	68.5 × 66.0mm	190g
f/22–f/32	0.28×	58mm	68.5 × 66.0mm	190g
f/22–f/27	0.13×	77mm	83.5 × 68.9mm	340g
f/22	0.29×	58mm	83.2 × 123.5mm	950g

EF 24–85mm f/3.5–4.5 USM	USM, 2×AL, 1×UD, I/R, FT-M, CA, DW-R	49°36'–14°54'	0.50m
EF 24–105mm f/4L IS USM	USM, IS, 1×UD, FT-M	49°36'	0.45m
EF 28–80mm f/3.5–5.6 II	USM, I/R	43°12'–30°	0.38m
EF 28–80mm f/3.5–5.6 V USM	FP, AF-S, 3×AL	65°–25°	0.38m
EF 28–90mm f/4–5.6 II USM	USM, 1×AL	43°12'–22°40'	0.38m
EF 28–90mm f/4–5.6 III	1×AL	43°12'–22°40'	0.38m
EF 28–105mm f/3.5–5.6 II USM	USM, I/R, FT-M	43°12'–12°6'	0.50m
EF 28–105mm f/4–5.6 USM	USM, I/R, 1×AL	43°12'–12°6'	0.48m
EF 28–135mm f/3.5–5.6 IS USM	USM, 1×AL, I/R, FT-M, IS	43°12'–9°24'	0.50m
EF 28–200mm f/3.5–4.5 II USM	USM, 2×AL, I/R	43°12'–6°24'	0.45m
EF 28–300mm f/3.5–5.6L IS USM	USM, 3×AL, 3×UD, I/R, FT-M, IS	43°12'–4°12'	0.70m
EF 35–80mm f/4–5.6 III	1×AL	35°12'–15°48'	0.40m
EF 55–200mm f/4.5–5.6 II USM	USM	22°48'–6°24'	1.20m
EF 70–200mm f/2.8L IS USM	USM, 4×UD, I/R, FT-M, IS, DW-R,	18°–6°24'	1.40m
EF 70–200mm f/2.8L USM	USM, 4×UD, I/R, FT-M	18°–6°24'	1.50m
EF 70–200mm f/4L IS USM	USM, 1×CaF2, 2×UD, I/R, FT-M, IS	18°–6°24'	1.20m
EF 70–200mm f/4L USM	USM, 1×CaF2, 2×UD, I/R, FT-M	18°–6°24'	1.20m
EF 70–300mm f/4.5–5.6 DO IS USM	USM, 1×AL, I/R, FT-M, DO, IS	18°–4°12'	1.40m
EF 70–300mm f/4–5.6 IS USM	USM, UD, IS	18°–4°12'	1.50m
EF 75–300mm f/4–5.6 III USM	USM	16°42'–4°12'	1.50m
EF 75–300mm f/4–5.6 III		16°42'–4°12'	1.50m
EF 80–200mm f/4.5–5.6 II		15°48'–6°24'	1.50m
EF 90–300mm f/4.5–5.6	CA	22°40'–6°50'	1.5m
EF 100–300mm f/4.5–5.6 USM	USM, I/R, FT-M	12°42'–4°12'	1.50m
EF 100–400mm f/4.5–5.6L IS USM	USM, 1×CaF2, 1×S-UD, I/R, FT-M, Float, IS	12°42'–3°12'	1.80m

210

f/22–f/32	0.16×	77mm	73.0 × 69.5mm	380g
f/22	0.23×	77mm	83.5 × 107.0mm	670g
f/28–f/38	0.26×	67mm	67.0 × 71.0mm	220g
f/22–f/38	0.26×	58mm	67 × 71mm	220g
f/22–f/32	0.30×	58mm	67.0 × 71.0mm	190g
f/22–f/32	0.30×	58mm	67.0 × 71.0mm	190g
f/22–f/27	0.19×	58mm	72.0 × 75.0mm	375g
f/22–f/32	0.19×	58mm	67.0 × 68.0mm	210g
f/22–f/36	0.19×	72mm	78.4 × 96.8mm	540g
f/22–f/36	0.28×	72mm	78.4 × 89.6mm	500g
f/22–f/38	0.30×	77mm	92.0 × 184.0mm	1,670g
f/22–f/32	0.23×	52mm	65.0 × 63.5mm	175g
f/22–f/27	0.17×	77mm	86.2 × 197.0mm	1,470g
f/32	0.17×	77mm	84.6 × 193.6mm	1,310g
f/32	0.21×	67mm	76.0 × 172.0mm	705g
f/32	0.21×	67mm	76 × 172mm	760g
f/32	0.16×	77mm	78.5 × 137.2mm	650g
f/32–f/38	0.19×	67mm	82.4 × 99.9mm	720g
f/32–f/45	0.26×	58mm	76.5 × 142.8mm	630g
f/32–f/45	0.25×	58mm	71.0 × 122.0mm	480g
f/32–f/45	0.25×	58mm	71.0 × 122.0mm	480g
f/22–f/27	0.16×	52mm	69.0 × 78.5mm	250g
f/38–f/45	0.25×	58mm	71 × 114.7mm	420g
f/32–f/38	0.20×	58mm	73.0 × 121.5mm	540g
f/32–f/38	0.20×	77mm	92.0 × 189.0mm	1,380g

Chapter **7**

Accessories

All photographers have a shortlist of accessories we wouldn't consider being without. Here we examine some of the most popular items, covering a range of techniques and photographic styles, but concentrating largely on filters, as these are very popular with almost all photographers.

Filters

There are essentially four types of filter: colour-correction filters used on the lens, colour-correction filters used on the light source, filters that help to enhance an existing characteristic but preserve a fairly natural feel to the photograph, and special-effects filters. Under some circumstances a mixture of these types may be used.

The materials commonly used in the construction of filters range from gelatine (usually reserved for lighting), through resins to glass. The quality of any of these may vary widely and, generally speaking, you get what you pay for. A major factor to consider when purchasing glass filters is the number of additional coatings to reduce flare. Glass filters come with no coating at all, single-coated or multi-coated, the latter being considerably more expensive.

The alternative to glass is one of the rectangular filter systems that make use of resin filters and a special holder into which the filters are inserted. The filter holder, which will accept two or three filters, fits onto an adaptor ring which screws into the lens's filter thread, and it is a simple matter to carry several adaptor rings for different lenses as well as numerous filters.

Vignetting

This is the term given to the loss of image detail at the outer edges of the frame, starting at the corners, and may have several causes – one of which is the use of filters on wide-angle lenses. Manufacturers expect filters to be used on their lenses or they wouldn't incorporate filter threads on them. The problems usually start when you 'stack' filters, using two or more screw-in filters together, especially if you then screw a lens hood onto the front of them. Vignetting can also occur when

> **Tip**
> A rectangular filter system is a highly versatile tool, and the same filters will fit multiple lenses using inexpensive adaptor rings.

using rectangular filter holders, especially if you add a second one to allow for rotation.

This problem is highly unlikely to manifest itself if you are using full-frame lenses on the EOS 50D because the sensor is not making full use of the image circle projected by the lens (see page 139).

Polarizing filters

Polarizing filters are best known for boosting the depth of blue skies and making white clouds stand out against them, and are most effective when used at 90° to the sun. Of the hundreds of filters available, the polarizing filter is the one that landscape photographers would

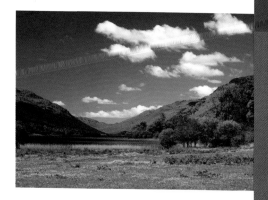

BREADALBANE, SCOTLAND
A typical situation for a polarizing filter. Breadalbane in Scotland is Rob Roy country, immortalized in Sir Walter Scott's novel.

least like to do without – and, coincidentally, it is also the most expensive. The filter is mounted in a holder that allows it to be rotated using a knurled ring on the front of the filter mount. The filter effect is transitional, shifting through maximum effect at 90° to the direction of the sun and minimum effect at 180°. The sun's height in the sky also plays its part.

A polarizing filter always reduces the light reaching the camera sensor and therefore requires a degree of exposure adjustment, though this will be achieved automatically in any auto-exposure mode. The degree of exposure adjustment required is not constant and will vary according to the extent to which the filter blocks polarized light waves.

> **Tips**
> Step-up or step-down adaptor rings can be used to make a glass filter fit lenses with different-sized filter threads, significantly reducing the cost of using the more expensive filters such as polarizers.
>
> Some manufacturers of rectangular filter systems produce filter holders with a circular thread on the front of the filter holder to take a glass polarizing filter, though this usually demands a large and therefore very expensive polarizer.

Sometimes the combination of side-lighting (i.e. the sun at 90°) and maximum filter effect can produce images which have far too much contrast with a lot of deep shadow. Remember that the polarizing filter's effect is not 'all or nothing' and it does not necessarily have to be rotated to achieve maximum effect when partial effect will do.

The other main function of a polarizing filter, particularly in landscape photography, is to control reflections in an image. While its most obvious use is to reduce unwanted reflections from shiny surfaces and water, it is also highly effective at reducing the light reflected by foliage, producing richer greens.

Tip
There are two types of polarizing filter: circular and linear. These terms refer to light-wave behaviour and have nothing to do with the shape of the filter, but linear polarizers don't work well with autofocus cameras that employ beam-splitter technology, so you should use a circular polarizing filter with the EOS 50D.

MULTIPLE FILTERS
These two images were captured on the same day, a couple of hours apart. The top image uses no filters at all; note the reflective surface of the pond. The second image uses a polarizing filter to cut out most of the reflection, and a graduated straw filter for the grasses in the immediate foreground. Two graduated neutral density filters were used on the top half of the image to bring out the brewing storm clouds. One was used to cover the skyline so that the mountain's profile was virtually a silhouette. The other was used in a second filter holder and was rotated to cover just the top left of the image.

216

Neutral density filters

Sometimes there can be too much available light. The most common scenario is when a very slow shutter speed is needed to create blur – when shooting a waterfall, for example. In these circumstances a neutral density (ND) filter, which reduces the light passing through the lens equally across the frame, is a valuable aid. Theoretically, ND filters should not affect the colour balance, but resin ones in particular can have a grey tinge to them.

ND filters come in a range of strengths and are available in 1- to 4-stop versions in both glass screw-in and resin varieties. Strength may be indicated as ND2 for 1 stop, then ND4 for 2 stops, and so on; or ND0.3 for 1 stop, ND0.6 for 2 stops and so on, with ND0.45 being 1½ stops.

Graduated neutral density filters

Second only to the polarizing filter in terms of importance in the landscape photographer's tool kit, graduated neutral density (GND) filters are half clear, with the other half having a neutral density coating which is increasingly dense as it approaches the upper edge of the filter. They are available in various strengths, as indicated for plain ND filters above. The filter's designation, in terms of strength, relates to the maximum light reduction at the upper edge. The area in the centre of the filter, where the clear half merges with the weakest edge of the neutral density coating, can have different gradings of transition: commonly soft, hard or razor. Hard- or razor-edged graduations are useful when you are photographing a flat horizon such as a seascape.

Graduated ND filters are used to balance exposure in different areas of the image and rectangular filter systems score more favourably for flexibility of use. You can vary the effect by how far you slide the filter into the holder, and you can insert a filter upside down to darken the bottom of the image. Furthermore, if you 'piggy back' two filter holders, you can rotate one of them to darken a corner of the image.

Tip

As an alternative to using a neutral density filter, a polarizing filter can reduce exposure by approximately two stops.

UV and skylight filters

These are designed to absorb ultraviolet light, reducing the blue colour cast which can be a nuisance in landscape shots at high altitude and on hazy days. The UV filter gives a natural result; the skylight version provides a warmer, pinkish tone. In reality, far more photographers use these to protect the front element of the lens from wear and tear than to filter out ultraviolet light. Others wouldn't dream of unnecessarily using a filter on their expensive high-quality lens as the optical quality of the filter cannot match that of the finest lenses.

Tips

To retain the best possible image quality, all filters should be treated like lenses and kept clean, free from dust, and protected from scratches and abrasions.

Filters can represent a considerable expense and it is worth spending time researching the different systems and their compatibility with your existing equipment. The outlay on a professional system such as Lee can be considerable, but it is a worthwhile investment.

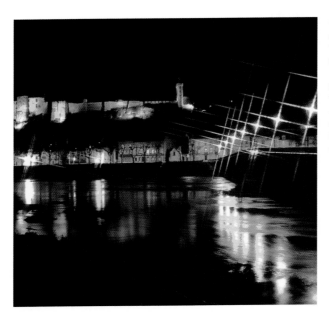

CHINON, FRANCE
A four-point star filter was used to pick out the streetlights in this shot. Like all images taken at night, differences in the types of lighting provide a variety of colour depending on which inert gases the lights use (e.g. neon or helium).

Warm-up filters

Warm-up filters are available in several densities, with 81A being the weakest and 81E being the densest, though the 81D and 81E versions are often only available to order. An 81A or 81B can provide a slightly tanned skin tone and can be useful for studio shots of models or for beach shots on holiday. An 81B or 81C can be very effective for landscapes, providing a distinct earthy appearance which also makes greens less cold. These are now largely redundant for EOS 50D users who have the option of colour-temperature correction in-camera.

However, several years ago, an American photographer hit on the idea of combining a polarizing filter with a warming filter; the combined effect is quite distinctive and not quite the same as using a polarizing filter with in-camera colour-temperature control.

Special effects filters

An astonishingly wide range of effects filters is available, far too many to describe here. It is worth exploring the websites of filter manufacturers such as Lee, Cokin, Hitech and Hoya to get some idea of what is available (see page 253).

Drop-in glass and gelatine filters

Some lenses have very large front elements which would necessitate equally huge filters. This caused manufacturers to seek an alternative, which they found in the form of drop-in filters. These are literally dropped into a slot in the lens which is located near the back and thus only requires a relatively small filter. Canon produces them in two sizes, 48mm and 52mm. They also make drop-in holders for gelatine filters in the same sizes. Unfortunately, the glass versions are restricted to polarizing filters.

Tip

The EOS 50D is capable of white-balance settings from 2,500°K to 10,000°K in-camera, or in post-processing using the Digital Photo Professional software provided with the camera if you are shooting RAW or sRAW files.

ACCESSORIES

Camera supports

Two aspects of digital technology that are continually being improved are image stabilization (IS) and noise reduction, both of which have some impact on the need to provide additional support for your camera.

Canon claim an effective 4-stop reduction in shutter speeds for their more affordable IS lenses, but the new 200mm f/2 L-series lens offers a staggering 5-stop IS facility.

Using a 4-stop IS lens means that a previous shutter speed of, say, 1/250 sec could now be reduced to 1/15 sec without significant loss of sharpness due to camera shake. Improved noise reduction also means that a higher ISO setting can be used, also reducing the need for additional camera support.

Tripods

Despite these advances, there will always be circumstances in which a tripod or other form of support is necessary. The tripod remains the photographer's primary and most popular form of support and relies on three things for its effectiveness: weight, appropriate feet for the situation, and leg-angle. Ironically, much recent development has gone into reducing the first of these factors using alternative materials like carbon fibre.

Tripod feet aren't something you think about about too often, but if you own a tripod that offers various alternatives, such as a Manfrotto, it is something you will be more aware of. Spiked feet are good for using on soft ground but no use on a wooden floor, for example, as they will scratch it and – more importantly in this context – they will mean that the entire set-up is balanced on three tiny points. The usual compromise consists of threaded spikes with rubber feet which can be screwed up or down according to your requirements. But there are also wider, flat feet designed for use on snow or soft ground.

As for leg angle, the broader the base of the extended tripod, the more stable it will be. This concept has been extended to produce tripods like the Benbo, which offers unlimited leg movement in any direction for absolute stability. Mini-tripods and table-top tripods

> **Tip**
> Image stabilization technology is effective in reducing the effects of camera shake at low shutter speeds, but will have no impact on blur caused by subject movement.

are a lightweight solution out in the field, and for lightweight cameras there are some intriguing versions with flexible legs which can be manipulated to improve stability.

Alternative supports

The monopod is a firm favourite for action photography, especially when used with the tripod collar that is attached part-way along some longer focal-length lenses. There are also clamps that can be mounted in birdwatching hides or over a partly opened car window; ball heads mounted on short columns with a large suction pad at the base; chestpods; clamps

Tips
Bean bags are a particular favourite of birdwatching enthusiasts as they can be filled with bird seed, some of which can also be scattered on the ground or on a tree stump to attract birds into a photogenic setting.

for screwing onto trees; and even bean bags on which to rest the lens or camera body when using a wall or other feature for support.

No single camera support will serve in every situation and most photographers end up collecting a variety over the years.

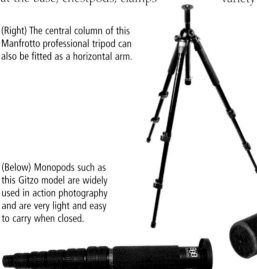

(Right) The central column of this Manfrotto professional tripod can also be fitted as a horizontal arm.

(Below) This tripod head has a three-way pan-and-tilt mechanism to allow easy adjustment in both the horizontal and vertical planes.

(Below) Monopods such as this Gitzo model are widely used in action photography and are very light and easy to carry when closed.

ACCESSORIES

Other accessories

Canon manufacture a wide range of accessories to support full usage of the EOS 50D and a full accessories brochure can be downloaded from their website (see page 253). Here we will examine some of the most useful accessories available.

AC Adaptor kit ACK-E2
A mains adaptor enabling the use of household power directly on the Canon EOS 50D.

Battery charger CB-5L
A mains charger for use with BP-series batteries.

Battery pack BP-511A
A rechargeable lithium-ion battery for the 50D with a capacity of 1390 mAh. Beware of using batteries that are not made by Canon or another trusted manfacturer. The EOS 50D will also accept BP-511, BP-512 and BP-514 battery packs.

CR2016 Battery
This battery is used separately on the EOS 50D for the date/time function.

Battery grip BG-E2N
An EOS 50D-dedicated grip which attaches to the base of the camera, doubles shooting time by carrying two batteries and provides an additional shutter release when shooting vertical images. It can significantly improve handling. BG-E2 also fits the EOS 50D.

EX Speedlites
Canon's range of hotshoe-mounted or off-camera flashguns, designed to work intelligently with EOS bodies using their own E-TTL II auto flash system. Details of models and their supporting accessories can be found in Chapter 4.

Speedlite transmitter ST-E2
This accessory can be used to control wireless flash using two groups of compatible EX Speedlites.

Focusing screens
The EOS 50D is fitted with an Ef-A Standard Precision Matte screen but will also allow use of the Ef-D Precision Matte screen with grid and the Ef-S Super Precision Matte screen designed for manual focus and optimized for lenses of f/2.8 or faster. Custom Function IV-5 must be changed to suit any change of focusing screen.

222

Angle finder C

Allows viewing at right angles to the camera eyepiece for low-viewpoint photography.

Remote switch RS-80 N3

A short electronic remote-release cable for which the 33ft (10m) Extension Cord ET-1000 N3 is also available. The shutter-release switch can be half-depressed to activate autofocus and metering, just as on the camera.

Timer/Remote Controller TC-80 N3

A remote release combined with a self-timer, an interval timer, a long-exposure timer and an exposure count setting function. The timer can be set from 1 sec to 99 hrs 59 mins 59 secs. Also accepts Extension cord ET-1000 N3.

Wireless Controller LC-5

Infra-red remote controller providing control over key camera functions from up to 328ft (100m) away.

E-Series Dioptric adjustment lenses

Dioptric adjustment removes the need to wear spectacles while shooting. Available in ten strengths between +3 and -4 dioptres.

Wireless File Transmitter WFT-E3

Enables secure wireless uploading of images to FTP servers and supports GPS tagging when used with a portable GPS device.

Portable storage devices

Small portable hard drives onto which memory cards can be downloaded. Can be much less expensive than carrying several CF cards, and also provide a means of viewing images. Canon manufacture the Media Storage M30 and M80 storage devices, each with 3.7in (9cm) LCD screen and offering 30GB and 80GB storage respectively.

Compact Flash cards/microdrives (non-Canon)

Both Type I and Type II CF cards, the latter being slightly thicker, will fit the EOS 50D. Microdrives are tiny hard disks which fit the CF card slot but contain moving parts so are more vulnerable to damage.

Eyepiece extender EP-EX15

Extends the eyepiece by 15mm to provide more comfortable viewing and also reduces contact with the LCD monitor.

Chapter **8**

Connection

If you want to save and organize your images, print them, or show them to others on your TV set, it's necessary to connect your camera to a variety of other devices. Using EOS Utility software, you can connect the EOS 50D to a computer and control shooting remotely from the keyboard. Your images can be also transferred wirelessly to an FTP server using the Wireless File Transmitter WFT-E3 (sold separately, see page 223).

Connecting to a computer

Screen calibration

Before manipulating images on your computer, ensure that your monitor is calibrated for brightness, contrast and colour using dedicated software or graphics freely available on the internet. You should be able to discern a good range of tones from pure black to pure white. If the dark grey tones blend into black, the screen is too dark. If the light grey tones blend into white, the screen is too bright.

When calibrating colour on your monitor, ensure that both RGB and CMYK colours are represented. A very useful screen calibration image – which includes a colour photo, grey scales, RGB and CMYK panels, and a colour chart – can be downloaded from Adobe's website.

Correct calibration

Too dark

Too light

Correct colour calibration

EOS Digital Solution Disk

1) Ensure that your camera is NOT connected to your computer.

2) Insert the EOS Digital Solution Disk (provided with the camera).

3) Click on **Easy Installation** and follow the prompts through the rest of the installation procedure.

4) When installation is completed, you will be prompted to restart the computer (leave the CD in the drive).

5) When your computer has rebooted, remove the CD from the drive.

EOS Digital Software Instruction Manuals Disk

1) Insert the disk into the CD drive of your computer.

2) Open the CD in **My Computer** (or in the Finder if using a Mac).

3) Click on **START.pdf files**.

4) Adobe Reader will display the Instruction Manuals index.

5) Save each PDF file to your computer as desired.

Warning!
All Canon's software instruction manuals are in PDF format so ensure that you have the necessary reader software installed before you start. You can download Adobe Reader free from www.adobe.com.

Note
Software updates for the programs on the EOS Digital Solutions Disk are available to download from the Canon website (see page 253).

CONNECTION

1) Ensure that the camera is switched off.

2) Connect the USB cable (provided with the camera) to the camera's ⟵⟶ terminal. Note that the ⟵⟶ symbol must face the front of the camera.

3) Connect the other end of the cable to a USB port on the computer.

4) Turn the camera's power switch to **ON**.

5) Select **EOS Utility** from the program selection screen.

6) The **EOS Utility** screen will be displayed on the computer and the direct transfer screen will be shown on the LCD monitor on the camera.

Warning!

Prior to connecting the camera to a computer, install the EOS Digital Solution Disk and ensure that the camera battery is fully charged.

Images will be saved in My Pictures (Windows) or Pictures (Mac) and organized by shooting date.

The **New images** option will select images which have not yet been transferred. The **Wallpaper** setting will not transfer RAW or sRAW images. If you choose **Select & transfer** you can use the **Transfer order** function in ▶ Playback Menu 1 to select the images.

If you wish to use **Transfer order**, select the images using Steps 7-8.

7) Select ▶ Playback menu 1 then **Transfer order**.

8) Select images one by one by pressing **SET** for each image to be transferred. A • icon will be added to each one. To remove the • icon, press **SET** again.

9) Select which set of images you wish to transfer and press the ⊡/⎙ button. The blue lamp will blink. When transfer is completed, the blue lamp will remain on. To exit after pressing ⊡/⎙, select **Quit** on the EOS Utility main window.

10) Press **MENU** to exit.

11) The transferred images will automatically open in Digital Photo Professional ready for editing.

228

Canon produces its own software specifically designed to work with its digital cameras. It is largely aimed at EOS digital SLR users but also works with certain Powershot models. Canon has also designed the software so that it is sometimes possible to launch one program from within another. Due to the complexity of this integration, and because programs such as Digital Photo Professional and Picture Style Editor now represent significant pieces of software in their own right, only a brief outline of their capabilities can be given here. For detailed information, refer to the instruction manuals on the CD provided with your camera.

Tip
Make sure you are using the most up-to-date version of each program. Updates can be downloaded from Canon's website.

Digital Photo Professional

Digital Photo Professional is designed as a standalone RAW workflow tool that links with or incorporates other Canon software such as PhotoStitch and Picture Style Editor. DPP can be used to adjust RAW images, apply Picture Styles, and convert RAW to JPEG or TIFF files both singly and through batch processing. It also supports the use of JPEG and TIFF files as base images with which to work. Digital Photo Professional includes sophisticated colour-management techniques including CMYK simulation.

Picture Style Editor

Picture Style Editor applies six Picture Styles to base images, saving you from repeatedly making the same adjustments to each one. Each Picture Style can be customized and registered in order to fine-tune the desired results. Changes to colour tone, saturation, contrast, sharpness and gamma characteristics can all be applied. Picture styles that have been defined in-camera can also be saved onto the computer. Picture Styles can be even applied to images that have been shot previously on cameras which do not support Picture Styles.

CONNECTION

EOS Utility

EOS Utility facilitates batch downloading of your images from the camera to the computer, also allowing you to only download selected images. It also enables the remote capture of images by controlling the camera from the computer. The latter supports Live View shooting in the EOS 50D. EOS Utility links with Digital Photo Professional in order to view and work with remotely captured images. It also links with Wireless File Transfer software and Original Data Security Tools.

ZoomBrowser EX

ZoomBrowser EX downloads images from the camera to the computer for editing and organizes them using a variety of windows. It also facilitates the printing of images with Canon inkjet printers. Secondary software such as Camera Window and Raw Image Task may be started from within ZoomBrowser. The programme's editing suite supports adjustments to brightness, colour, cropping, sharpness, red-eye correction, adding images to emails or using them as wallpaper or screensavers, and the insertion of text into images. It also facilitates the transfer of images to Canon iMAGE Gateway.

Canon iMAGE Gateway

Canon iMAGE Gateway provides 100MB of web space, allowing you to share photos with friends and family by creating online albums. It even supports the customization of your camera by adding start-up images and sound effects as well as downloadable Picture Styles.

PhotoStitch

PhotoStitch permits the opening and arranging of images to be merged, saved and printed.

File formats

A file is a collection of data stored as a single unit and identified by a file name with a suffix (referred to as an 'extension') which identifies the file-type. Files can be opened, saved, deleted, and moved to different folders as well as being transferred across network connections.

If you are a recent convert from film, the advantages of digital photography become clear very quickly, but so do a number of other factors. It is all too easy to have duplicate images in different folders (which can be an advantage, but also a nightmare, especially for the professional); you can lose an image through accidental deletion or file corruption; and you need to establish a management system very early on if you anticipate building a collection of images that might eventually run into tens of thousands. A safe back-up system needs to be put in place very quickly.

For those reading this guide who have just upgraded from a camera that could only record JPEG images, the whole subject of file types may be unexplored territory. But the EOS 50D brings with it the ability to shoot RAW and sRAW images too. Either of these formats will open up significant new horizons for the former JPEG shooter.

In fact, changing from shooting JPEG to shooting RAW or sRAW will introduce a completely different approach to processing images on computer and may well involve a complete overhaul of your shooting technique into the bargain.

The shortcuts to printing and displaying images, with little or no processing beyond what takes place in-camera, will be replaced by what RAW shooters in particular call 'digital workflow'. This is an individual's set of procedures that cover every stage between capturing the image and its final resting place – be that a print in a frame, in an online album, as a submission for a printed publication, or simply as a screensaver on your computer.

Tip
For definitions of every file format and details of their compatibility, go to www.fileinfo.net.

JPEG files

JPEG stands for Joint Photographic Experts Group, the committee that developed the format. A JPEG file uses 'lossy' compression, which means that image information is lost. If the image is compressed too much or too frequently, the image degrades significantly. A useful attribute of JPEGs for commercial purposes is that they are 'cross-platform', meaning that any file will look the same on both a Mac and a PC. Its file extensions are .JPEG or .JPG (in either upper or lower case).

JPEGs take up a lot less memory than any lossless format, regardless of whether they are saved at low, medium or high quality settings. They are useful at low resolution for use as thumbnails, for emailing, and even for use on a website when 72 ppi is sufficient. When saved at a resolution of 300 ppi they are good enough to be used for publication.

The disadvantage of JPEGs is that cameras tend to perform a number of processing tasks on them at the time of shooting and consequently there is far less control over the final result than with a RAW file, even using sophisticated post-processing software. To some extent, the EOS 50D works around this by giving the user some control over shooting parameters in Creative Zone modes.

RAW files

RAW formats leave images entirely unprocessed, making them popular with professionals who prefer to retain total control over their images. Because RAW files are uncompressed, they take up more space than typical JPEG images. This means using higher-capacity memory cards or downloading images from the camera more frequently.

The usual analogy is that RAW files are like negatives and the computer is the darkroom. With a RAW file you retain complete control over the colour temperature adjustments (for white balance), exposure, sharpness and contrast. However, RAW files cannot be opened by most image-viewing programs and require specialist software to process and save them to JPEG or TIFF. When you save a RAW image in another file format, you still retain the original file. The EOS 50D saves both RAW and sRAW files with the file extension .CR2.

TIFF files

TIFF stands for Tagged Image File Format. It is a lossless format that can handle up to 24-bit colour for a wider range of tones. Files use the extensions .TIF or .TIFF and are the preferred format for many professionals when converting RAW files.

RIVER CLYDE BY NIGHT
Complex lighting situations like this are best
captured using RAW or sRAW files. This gives
you maximum flexibility for adjustment when
processing the image on your computer. In
Digital Photo Professional, you can adjust RAW
and sRAW files in a multitude of ways while
retaining all the original shooting settings.

Settings
Aperture priority
(Av) mode
ISO 100
1/8 sec at f/8
Evaluative metering

Using a printer

You can connect the Canon EOS 50D directly to a printer and print the images from the memory card. The camera is compatible with PictBridge. The printing procedure is controlled directly from the camera using the LCD monitor to view the operation. With a compatible printer, you may also be able to simply insert the memory card into the printer without connecting the camera.

Warning!
Printers which are only compatible with CP Direct or Bubble Jet Direct cannot be used with the EOS 50D.

Any default settings referred to in this section are the printer's default settings and not those of the camera.

Connecting to a printer

1) Check that the camera's battery is charged or use the AC Adaptor Kit ACK-E2 (sold separately) to use mains power.

2) Ensure that the camera and printer are switched off.

3) Connect the USB cable (provided) to the camera's ⟵ terminal. The ⟵ symbol must face the front of the camera.

4) Connect the cable to the printer according to the printer's manual.

5) Turn on the printer.

6) Turn the camera's power switch to **ON** and press the ▶ button. The ⟋ symbol will show on the monitor at top left, indicating camera-printer connection.

At this point some printers may emit a beep. If this beep is prolonged, there is a problem with the printer. To discover the error, press the ▶ Playback button on the camera. When the image is played back, press **SET**. On the Print Setting screen, select **Print** and the error message should be displayed on the LCD monitor. Error messages include Paper Error, Ink Error, Hardware Error, and File Error.

Note
Photos remaining on the memory card after being shot on a different camera may not be compatible. Similarly, photos on the memory card which have already been adjusted on the computer may not print.

234

7) Press the ▶ Playback button to bring up the first image.

8) If this is not the image you wish to print, rotate the ◯ Quick Control Dial to select the image to be printed.

9) Press **SET**.

10) The LCD monitor will display the **Print Setting** screen with a list of settings (see page 236) covering printing effects, date, file number, quantity, trimming, paper size and layout. Amend these as desired using the ◯ Quick Control Dial and **SET** controls.

At this point you may wish to go to Step 11 on page 236, where you can find the full Print Settings procedure followed by trimming instructions. If you want to skip the full Print Settings procedure and Trimming at this stage, or are familiar with them, go to Step 27 immediately below.

27) When you are ready to print, rotate the ◯ Quick Control Dial to highlight **Print** and press **SET**.

28) The 📷/凸~ Print/share button's blue lamp will blink and printing will start.

29) While **Stop** is displayed you can stop printing by pressing **SET** and then **OK**.

30) To print further images using the same settings, select the first image to be printed and press the 📷/凸~Print/share button. Repeat as necessary.

31) When you've finished printing, turn off the camera.

32) Turn off the printer.

33) Disconnect the cable.

Tips
It is also possible to print RAW and sRAW images recorded with the EOS 50D.

More information about using Canon cameras with PictBridge can be found on Canon's website (see page 253).

CONNECTION

Paper Settings

11) From the **Print Setting** screen reached in step 10, rotate the ◎ Quick Control Dial to select **Paper Settings** and press **SET**.

12) The **Paper Size** screen will be displayed. Rotate the ◎ Quick Control Dial to select the dimensions of the paper to be used and press **SET**. (If you are intending to trim the image, choose an appropriate ratio.)

13) The **Paper Type** screen will be displayed. Rotate the ◎ Quick Control Dial to select the type of paper to be used for printing and press **SET**.

Note
The extent to which your printer supports different functions will determine whether or not some functions will be displayed or can be performed.

14) The **Page Layout** screen will appear. Rotate the ◎ Quick Control Dial to select the **Page Layout** to be used and press **SET**.

15) The display will now revert to the **Print Setting** screen.

Print Settings

Bordered	The print will have a white border along each edge.
Borderless	The print will have no white borders. (If your printer cannot print borderless prints, the print will still have borders.)
Bordered ⓘ	The shooting information will be imprinted on the border of prints that are 3½ × 5in (9 × 13cm) or larger.
xx-up	Option to print 2, 4, 8, 9, 16 or 20 images on one print.
20-up/35-up	On A4 or Letter size paper, 20 or 35 thumbnails of DPOF ordered images will be printed.
20-up ⓘ	Shooting information will be printed on the border.
Default	Page layout will depend on the printer type and its default settings.

Shooting information from the Exif data will include camera name, lens, shooting mode, shutter speed, aperture, exposure compensation, ISO speed, white balance.

16) From the **Print Setting** screen, rotate the ◌ Quick Control Dial to select the option on the upper right and press **SET**.

17) The **Printing Effects** screen will be displayed. Use the ◌ Quick Control Dial to select each item to change and press **SET**. Refer to the table below for information on the options available. The actual display will depend on the printer being used. The

table is based on the assumption that the full list of effects will be available.

18) If the ⊞ icon is displayed next to INFO on the **Printing Effects** screen, additional options are available if you press the camera's **INFO** button. The options available will depend on the choices you made from the table below. If no options are available, skip this step.

Preset Printing Effects	
Item	**Description**
⊡ Off	No automatic correction will be performed.
⊡ On	The image will be printed according to the printer's standard colours. The image's Exif data is used to make automatic corrections.
⊡ Vivid	The image will be printed with higher saturation to produce more vivid blues and greens.
⊡ NR	The image noise is reduced before printing.
B/W B/W	Prints in black and white with true blacks.
B/W Cool tone	Prints in black and white with cool, bluish blacks.
B/W Warm tone	Prints in black and white with warm, yellowish blacks.
▢ Natural	Prints the image in the actual colours and contrast. No automatic colour adjustments will be applied.
▢ Natural M	The printing characteristics are the same as the **Natural** setting. However, this setting enables finer printing adjustments than with the **Natural** setting.
⊡ Default	The printing will differ depending on the printer. For details, see the printer's instruction manual.

* The screen display may differ depending on the printer.
* When the printing effects are changed, the changes will be reflected on the screen. However, the actual result of the printing effects might look different from what you see on screen. The screen only shows an approximate rendition.

CONNECTION

Adjustable Printing Effects

Brightness	The image brightness can be adjusted.
Adjust levels	When you select **Manual**, you can change the histogram's distribution and adjust the image's brightness and contrast. With the **Adjust Levels** screen displayed, press the **INFO** button to change the position of the indicator. Turn the ◯ Quick Control Dial to freely adjust the shadow level (0–127) or highlight level (128–255).
Brightener	Effective in backlit conditions which can make the subject's face look dark. When **On** is set, the face will be brightened for printing.
Red-eye corr.	Effective in flash images where the subject has red eye. When **On** is set, the red eye will be corrected for printing.

* The **Brightener** and **Red-eye corr.** effects will not show up on the screen.
* When you select **Detail set.** you can adjust the **Contrast**, **Saturation**, **Color tone** and **Color balance**.
* When you select **Clear all**, all the printing effects will revert to the default.

Date / Time / File Number

19) Rotate the ◯ Quick Control Dial to select ♥, then press **SET**.

20) Use the ◯ Quick Control Dial to select the desired setting and press **SET**.

Number of copies

21) Rotate the ◯ Quick Control Dial to select ⬛ then press **SET**.

22) Use the ◯ Quick Control Dial to select the desired setting and press **SET**.

23) Go to step 27 on page 235 to start printing.

Trimming the image

Trimming should only be done after the other print settings are completed.

24) On the **Print Setting screen**, select **Trimming**. The horizontal: vertical ratio can be adjusted in **Paper setting**.

25) Use the ⊞/⊕ Enlarge and ✳/⬛• ⊖ Reduce buttons to adjust the size of the trimming frame and the ✳ Multi-controller to move the frame.

26) Press the **INFO** button to rotate the image through 90°. Use the ◯ Quick Control Dial to rotate the image by up to +/-10°. Press **SET** to exit Trimming and go to step 33 on page 235.

Commonly abbreviated to DPOF, this is a system for recording printing instructions to the memory card. The DPOF system is managed through the Print Order option in ▶ Playback Menu 1. With the camera connected to a compatible printer, it is possible to use the **Print Order** menu to manage the direct printing of your images from the memory card in the camera. Digital Print Order Format (DPOF) settings can be applied to all JPEG images on the memory card or to selected images. However, different settings cannot be applied to individual images. The same print type, date and file number settings will be applied to all print-ordered images.

Print ordering

Before printing with DPOF, you will need to select the images you wish to print. You can do this with single images displayed on the monitor or a group of three images. Use the ✲/⊞• ⊖ Reduce button and the ⊞/⊕ Enlarge button to toggle between the two different display formats.

When you have decided which image to print, press **SET**. This will automatically order a single print of that image. If you require more than one, rotate the ◌ Quick Control Dial to set the desired number of copies, to a maximum of 99.

You can create an index sheet from the menu, or select **All images** which will add all the photos on the memory card to the print order. Even if you select **All images**, any RAW or sRAW files on the memory card will not be included.

Common errors
RAW and sRAW images cannot be selected for DPOF.

You must use the memory card for which DPOF specifications have been set. Do not use a memory card for which DPOF specifications have been set on a different camera body.

CONNECTION

Setting the printing options

1) Select ⏻ on the camera power switch.

2) Press the **MENU** button and use the 🌤 Main Dial to scroll through the menus until you reach ▶ Playback Menu 1.

3) Rotate the ◯ Quick Control Dial to select **Print order** and press **SET**.

4) Rotate the ◯ Quick Control Dial to select **Set up** and press **SET**.

5) Rotate the ◯ Quick Control Dial to select the desired item and press **SET**.

6) Rotate the ◯ Quick Control Dial to select the option for that item and press **SET**.

7) Set the Print type, Date and File number options as desired (see table below).

8) When you have chosen the desired settings, press **MENU** and the Print order screen will reappear. Choose either **Select Image** or **All images**.

9) Use the Reduce ✳/⊞·⊖ and Enlarge ⊞/⊕ buttons to toggle between a single image or three images to be displayed on the monitor.

10) Rotate the 🌤 Main Dial to scroll through your images. Press **SET** to select an image to be printed. A tick will be added to that image. To deselect an image, press **SET** again.

11) When your images are selected, choose **Print** and press **SET**.

Note
With **Index** printing, both **Date** and **File no.** cannot be set to **On** at the same time.

Printing Options

Print type	⬤ Standard	Prints one image on one sheet.
	⊞ Index	Multiple thumbnail images are printed on one sheet.
	⬤ Both ⊞	Prints both the standard and index prints.
Date	On	**On** imprints the recorded date on the print.
	Off	
File No.	On	**On** imprints the file number on the print.
	Off	

240

The EOS 50D comes supplied with the leads necessary for this method of playing back your photos on a television, which is an ideal way of displaying them to large numbers of friends and family.

To connect to a television:

1) Ensure that both the camera and television are turned off.

2) Open the terminal cover on the camera's left side.

3) Insert the video cable (provided) into the **VIDEO OUT** terminal.

4) Insert the other end of the video cable into the television's **VIDEO IN** terminal.

5) Switch on the television and select the **VIDEO IN** channel.

6) Turn the camera's power switch to **ON**.

7) Press the ▶ playback button on the camera. When the images are displayed on the television, the camera's LCD monitor will remain blank. However, you can manage the playback options using the camera's controls just as you would when using the camera's LCD monitor.

8) To disconnect, turn the camera's power switch to **OFF**, turn off the television and disconnect the video cable.

Common problems

If the video system selected in ↑↑² Set-up menu 2 does not match that of the television, images will not be displayed properly. Change the camera setting.

Some televisions use different screen formats. You may need to consult your television's instruction manual to change the screen format.

Tip
Using the same camera/television connections it is also possible to take photos and to manage the camera's menus while connected to the television.

Chapter **9**

Care

Your EOS 50D will perform reliably in a wide range of circumstances, but it is not indestructible and the manufacturer's cautions regarding use and operating conditions should always be adhered to (full details can be found in the camera's manual). The greatest enemies of digital cameras are dust, moisture, excessive heat and sharp knocks, all of which can be avoided with a little forethought.

Tip
Never leave the camera close to anything which emits a magnetic field or strong radio waves that may affect the camera's electronics or damage data.

Basic camera care

The EOS 50D does not provide the same level of protection as Canon's EOS 1D series, which is designed for use by press photographers in all weathers. Instead, it offers limited moisture and dust protection on the battery compartments and memory card only, and these won't solve all the problems of working in damp and dusty conditions.

Out in the field, dust and sand can be a real problem, and more so if it is windy. Part of the solution is to keep the camera in your camera bag except when it is needed and to take extra care when changing lenses. Keeping dust from entering the camera via the lens mounting is the priority, but you also need to keep dust and sand off the lens elements. Sand will scour

GAPING GHYLL
If you are going to take your camera into challenging situations, make sure you look after it. Like the caver in this shot, I endured a 300ft (91m) winch ride underneath the waterfall to reach the floor of this huge limestone cavern.

244

the glass if you try to wipe it off, so careful use of a blower or blower-brush is recommended. A UV filter on the lens provides useful protection and can be replaced quickly and cheaply. Finally, avoid dropping the camera, or having it knocked out of your hand in a crowd, by ensuring that you use the camera strap or a wrist strap at all times.

In cold temperatures

The EOS 50D is designed to operate in temperatures between 32°F and 104°F (0–40°C) at a maximum of 85% humidity. However, you should always pay heed to the effective temperature, allowing for wind chill, rather than the still air temperature – at 32°F (0°C) a wind speed of just 25mph (40km/h) will make it feel like 18°F (-8°C). Once temperatures drop below freezing and wind speed increases, the effective temperature drops alarmingly.

Does this mean you have to put your camera away until the weather improves? No, it just means you have to work in a slightly different way. Batteries are notorious for their fall-off in performance when the temperature approaches freezing, so keep them inside your clothing when not needed. The camera, too, should be kept as warm as possible while not in use: if you need to keep it in a camera bag, you can always

wrap it in something that will act as an extra layer of insulation. I favour a spare woolly hat that doubles as a beanbag when the camera needs to be rested on a rough surface for extra support. Signs that the camera is becoming too cold, apart from reduced battery performance, are the darkening of the LCD monitor and sluggishness in moving parts, especially those which are lubricated.

In heat and humidity

Short of dropping your camera into the sea, the worst thing that can happen to it is excessive heat. The recommended maximum working temperature of 104°F (40°C) may seem to cover most situations, but if you've ever had to climb into a car which has been parked in the sun for some time in a hot country, you'll know that 104°F (40°C) is easily surpassed. As a result, you should never leave an uninsulated camera in the car on a very hot day. You can leave the camera in an insulated coolbox such as those used for picnics or camping, but don't use the freezer packs that would normally aid the cooling process.

The other issue which heat raises is the expansion of non-metal parts. This can be a very real problem with lenses, particularly newer, lightweight ones which make more extensive use of plastics. The infinity mark ∞

on many lenses has changed from being an absolute infinity position to ⌐∞, a variable position to allow for heat expansion.

Protecting the camera against humidity requires wrapping the camera in an airtight plastic bag or container, ideally with a small bag of silica gel. Silica gel absorbs moisture and a small bag of it usually comes in the box when you buy a new camera or lens – store it somewhere dry for occasions like this. In order to reduce condensation, allow your equipment and the bag or container in which it is stored to reach the ambient temperature before taking the equipment out.

Water protection

Prevention is better, and usually a whole lot cheaper, than cure. However, there are times when we get caught out by the unexpected, and especially by the weather. It is worth investing in a camera bag that will prove good protection against the elements, such as Lowepro's AW (All Weather) models which have a rain cover that tucks away discreetly when not required. Some models, such as the Stealth Reporter series, have two rain covers. The first is a thin showerproof cover that covers the lid of the camera bag, while the main rain cover wraps around the whole camera bag; it is stored on

the underside of the bag, which also stops moisture getting through when you put it down on wet ground.

Everybody's camera bag contains a few idiosyncratic items. A plastic bin liner can be useful when it is raining and the camera needs to be at the ready. One of my favourite items is a large Pertex travel towel which is light and compact but invaluable for drying equipment.

Finally, it pays to be extra cautious when you are working in a marine environment, as spray can be carried huge distances on a windy day. Likewise, the sea air can be laden with salt for some considerable distance away from the shore.

Tip
An excellent solution to the problem of changing lenses in a dusty environment is to use a changing bag – a lightproof bag about 2ft (60cm) square with zipped access for inserting equipment, and two elasticated arm holes. Originally designed for loading light-sensitive film in the camera or to load exposed film into a developing tank, it now serves a new purpose in the digital era.

246

HEAD FOR THE HILLS

A good fall of snow and clear blue skies will have the kids clamouring for some sledging. It's also a great time to take the camera out, but be sure to keep it dry and the batteries warm.

Settings

Manual (M) mode
Spot metering
ISO 100
1/250 sec at f/8
White balance:
6000°K

Function Availability Table

Mode Dial		Basic Zone								Creative Zone				
		⬭	👤	🏔	🌷	🏃	🌃	⚡	CA	P	Tv	Av	M	A-DEP
Quality	JPEG	○	○	○	○	○	○	○	○	○	○	○	○	○
	RAW	-	-	-	-	-	-	-	○	○	○	○	○	○
	RAW + JPEG	-	-	-	-	-	-	-	○	○	○	○	○	○
ISO speed	Auto	●	●	●	●	●	●	●	●	○	○	○	○	○
	Manual	-	-	-	-	-	-	-	-	○	○	○	○	○
Picture Style	Standard	●	-	-	●	●	●	●	○	○	○	○	○	○
	Portrait	-	●	-	-	-	-	-	○	○	○	○	○	○
	Landscape	-	-	●	-	-	-	-	○	○	○	○	○	○
	Neutral	-	-	-	-	-	-	-	-	○	○	○	○	○
	Faithful	-	-	-	-	-	-	-	-	○	○	○	○	○
	Monochrome	-	-	-	-	-	-	-	○	○	○	○	○	○
	User Defined	-	-	-	-	-	-	-	-	○	○	○	○	○
Colour space	sRGB	●	●	●	●	●	●	●	●	○	○	○	○	○
	Adobe RGB	-	-	-	-	-	-	-	-	○	○	○	○	○
White balance	Auto WB	●	●	●	●	●	●	●	●	○	○	○	○	○
	Preset WB	-	-	-	-	-	-	-	-	○	○	○	○	○
	Custom WB	-	-	-	-	-	-	-	-	○	○	○	○	○
	Colour Temperature Setting	-	-	-	-	-	-	-	-	○	○	○	○	○
	WB Correction	-	-	-	-	-	-	-	-	○	○	○	○	○
	WB Bracketing	-	-	-	-	-	-	-	-	○	○	○	○	○
Auto Lighting Optimizer		-	●	●	●	●	●	●	●	○	○	○	○	○
AF	One-shot	-	●	●	●	-	●	-	-	○	○	○	○	●
	AI Servo	-	-	-	-	●	-	-	-	○	○	○	○	○
	AI Focus	●	-	-	-	-	-	●	●	○	○	○	○	○
	AF point selection — Auto	●	●	●	●	●	●	●	●	○	○	○	○	○
	AF point selection — Manual	-	-	-	-	-	-	-	-	○	○	○	○	○
	AF-assist beam	●	●	-	-	-	●	-	-	○	○	○	○	○

● Set automatically ○ User selectable - Not selectable

248

Mode Dial		Basic Zone								Creative Zone				
		○	🐦	🏔	🌷	🏃	🌆	🌙	CA	P	Tv	Av	M	A-DEP
Metering mode	Evaluative	•	•	•	•	•	•	•	•	○	○	○	○	○
	Partial	-	-	-	-	-	-	-	-	○	○	○	○	○
	Spot	-	-	-	-	-	-	-	-	○	○	○	○	○
	Centre-weighted average	-	-	-	-	-	-	-	-	○	○	○	○	○
Exposure	Program shift	-	-	-	-	-	-	-	○	○	-	-	-	-
	Exposure compensation	-	-	-	-	-	-	-	○	○	○	○	-	○
	AEB	-	-	-	-	-	-	-	-	○	○	○	○	○
	AE lock	-	-	-	-	-	-	-	-	○	○	○	-	○
	Depth-of-field preview	-	-	-	-	-	-	-	-	○	○	○	○	○
Drive	Single	•	-	•	•	-	•	•	○	○	○	○	○	○
	High-speed continuous	-	-	-	-	•	-	-	-	○	○	○	○	○
	Low-speed continuous	-	•	-	-	-	-	-	○	○	○	○	○	○
	Self-timer 10sec	○	○	○	○	○	○	○	○	○	○	○	○	○
	Self-timer 2sec	-	-	-	-	-	-	-	-	○	○	○	○	○
Built-in flash	Auto	•	•	-	•	-	•	-	○	-	-	-	-	-
	Manual	-	-	-	-	-	-	-	-	○	○	○	○	○
	Flash off	-	-	•	-	•	-	•	○	-	-	-	-	-
	Red-eye reduction	○	○	-	○	-	○	-	○	○	○	○	○	○
	FE lock	-	-	-	-	-	-	-	-	○	○	○	○	○
	Flash exposure compensation	-	-	-	-	-	-	-	-	○	○	○	○	○
Live View Shooting		-	-	-	-	-	-	-	-	○	○	○	○	○

• Set automatically ○ User selectable - Not selectable

249

Glossary

Aberration An imperfection in the image caused by the optics of a lens.

AE (autoexposure) lock A camera control that locks in the exposure value, allowing an image to be recomposed.

Angle of view The area of a scene that a lens takes in, measured in degrees.

Aperture The opening in a camera lens through which light passes to expose the CMOS sensor. The relative size of the aperture is denoted by f-stops.

Autofocus (AF) A reliable through-the-lens focusing system allowing accurate focus without the user manually turning the lens.

Bracketing Taking a series of identical pictures, changing only the exposure, usually in half or one f-stop (+/-) differences.

Buffer The in-camera memory of a digital camera.

Burst size The maximum number of frames that a digital camera can shoot before its buffer becomes full.

Cable release A device used to trigger the shutter of a tripod-mounted camera at a distance to avoid camera shake.

Centre-weighted metering A way of determining the exposure of a photograph placing importance on the light-meter reading at the centre of the frame.

Chromic aberration The inability of a lens to bring spectrum colours into focus at one point.

CMOS (complementary oxide semi-conductor) A microchip consisting of a grid of millions of light-sensitive cells – the more sensors, the greater the number of pixels and the higher the resolution of the final image.

Colour temperature The colour of a light source expressed in degrees Kelvin (°K).

CompactFlash card A digital storage mechanism offering safe, reliable storage.

Compression The process by which digital files are reduced in size.

Contrast The range between the highlight and shadow areas of an image, or a marked difference in illumination between colours or adjacent areas.

Depth of field (DOF) The amount of an image that appears acceptably sharp. This is controlled by the aperture: the smaller the aperture, the greater the depth of field.

Dioptre Unit expressing the power of a lens.

dpi (dots per inch) Measure of the resolution of a printer or a scanner. The more dots per inch, the higher the resolution.

Dynamic range The ability of the camera's sensor to capture a full range of shadows and highlights.

EF (extended focus) lenses Canon's range of fast, ultra-quiet autofocus lenses.

Evaluative metering A metering system whereby light reflected from several subject areas is calculated based on algorithms.

Exposure The amount of light allowed to hit the CMOS sensor, controlled by aperture, shutter speed and ISO-E. Also the act of taking a photograph, as in 'making an exposure'.

Exposure compensation A control that allows intentional over- or underexposure.

Extension tubes Hollow spacers that fit between the camera body and lens, typically used for close-up work. The tubes increase the focal length of the lens, and magnify the subject.

Fill-in flash Flash combined with daylight in an exposure. Used with naturally backlit or harshly side-lit or top-lit subjects to prevent silhouettes forming, or to add extra light to the shadow areas of a well-lit scene.

Filter A piece of coloured, or coated, glass or plastic placed in front of the lens.

f-stop Number assigned to a particular lens aperture. Wide apertures are denoted by small numbers such as f/2; and small apertures by large numbers such as f/22.

Focal length The distance, usually in millimetres, from the optical centre point of a lens element to its focal point.

Focal length and multiplication factor. The CMOS sensor of the EOS 50D measures 22.3 × 14.9mm – smaller than 35mm film. The effective focal length of the lens appears to be multiplied by 1.6.

fps (frames per second) The ability of a digital camera to process one image and be ready to shoot the next.

Histogram A graph used to represent the distribution of tones in an image.

Hotshoe An accessory shoe with electrical contacts that allows synchronization between the camera and a flashgun.

Hotspot A light area with a loss of detail in the highlights. This is a common problem in flash photography.

Incident-light reading Meter reading based on the light falling on the subject.

Interpolation A way of increasing the file size of a digital image by adding pixels, thereby increasing its resolution.

ISO-E (International Organization for Standardization) The sensitivity of the CMOS sensor measured in terms equivalent to the ISO rating of a film.

JPEG (Joint Photographic Experts Group) JPEG compression can reduce file sizes to about 5% of their original size.

LCD (liquid crystal display) The flat screen on a digital camera that allows the user to preview digital images.

Macro A term used to describe close focusing and the close-focusing ability of a lens.

Megapixel One million pixels equals one megapixel.

Memory card A removable storage device for digital cameras.

Microdrives Small hard disks that fit in a CompactFlash slot, resulting in larger storage capabilities.

Mirror lock-up A function that allows the reflex mirror of an SLR to be raised and held in the 'up' position, before the exposure is made.

251

CARE

Pixel Short for 'picture element' – the smallest bits of information in a digital image.

Predictive autofocus An autofocus system that can continuously track a moving subject.

Noise Coloured image interference caused by stray electrical signals.

Partial metering A metering system that is unique to Canon, it meters a relatively small area at the centre of the frame.

PictBridge The industry standard for sending information directly from a camera to a printer, without having to connect to a computer.

Red-eye reduction A system that causes the pupils of a subject to shrink by shining a light prior to taking the flash picture.

RAW The file format in which the raw data from the sensor is stored wthout permanent alteration being made.

Resolution The number of pixels used to capture or display an image. The higher the resolution, the finer the detail.

RGB (red, green, blue) Computers and other digital devices understand colour information as combinations of red, green and blue.

Rule of thirds A rule of thumb that places the key elements of a picture at points along imagined lines that divide the frame into thirds.

Shading The effect of light striking a photosensor at anything other than right angles, incurring a loss of resolution.

Shutter The mechanism that controls the amount of light reaching the sensor by opening and closing

SLR (single lens reflex) A type of camera (such as the EOS 50D) that allows the user to view the scene through the lens, using a reflex mirror.

Spot metering A metering system that places importance on the intensity of light reflected by a very small portion of the scene.

Teleconverter A lens that is inserted between the camera body and main lens, increasing the effective focal length.

Telephoto lens A lens with a large focal length and a narrow angle of view.

TTL (through the lens) metering
A metering system built into the camera that measures light passing through the lens at the time of shooting.

TIFF (Tagged Image File Format)
A universal file format supported by virtually all relevant software applications. TIFFs are uncompressed digital files.

USB (universal serial bus) A data transfer standard, used by the Canon EOS 50D when connecting to a computer.

Viewfinder An optical system used for composing and sometimes focusing the subject.

White balance A function that allows the correct colour balance to be recorded for any given lighting situation.

Wide-angle lens A lens with a short focal length and consequently a wide angle of view.

252

Useful websites

CANON

Worldwide Canon Gateway
www.canon.com

Canon USA
www.usa.canon.com

Canon UK
www.canon.co.uk

Canon Europe
www.canon-europe.com

Canon Oceania
www.canon.com.au

Canon EOS
Site dedicated to the EOS range
of cameras and accessories
www.canoneos.com

Canon Camera Museum
Online history of Canon cameras and
their technology and design
www.canon.com/camera-museum

Canon Enjoy Digital SLR Cameras
A website from Canon with advice on
how to use digital SLRs
web.canon.jp/Imaging/enjoydslr/index.html

GENERAL SITES

Photonet
Photography discussion forum
www.photo.net

The EOS Experience
EOS-related seminars
www.eos-experience.co.uk

Bureau of Freelance Photographers
Expert advice and tuition for freelance
and aspiring freelance photographers
www.thebfp.com

ePHOTOzine
Online magazine with a photographic
forum, features and monthly competitions
www.ephotozine.co.uk

SOFTWARE

Adobe USA
www.adobe.com

Adobe UK
www.adobe.co.uk

EQUIPMENT

SanDisk
CompactFlash cards
www.sandisk.com

Speedgraphic
Mail order dealers in photographic
equipment and materials
www.speedgraphic.co.uk

PHOTOGRAPHY PUBLICATIONS

Photography books
www.pipress.com

Black & White Photography **magazine**
Outdoor Photography **magazine**
www.thegmcgroup.com

EOS magazine
www.eos-magazine.com

Index

254

Contact us for a complete catalogue or visit our website:
Ammonite Press, Castle Place, 166 High Street, Lewes, East Sussex, BN7 1XU, United Kingdom
Tel: 01273 488005 Fax: 01273 402866
www.ae-publications.com